"This calamity's crop features no fewer than four books. . . . If you need just one version of the story, go with *New York Times* staff writer Graham Bowley's *No Way Down: Life and Death on K2*, which cobbles a compelling narrative from interviews with most of the survivors. . . . The most complete report of the tragedy to date."

—Grayson Schaffer, *Outside* magazine

"With the pace of an avalanche, the book moves swiftly toward the moments when the climbers find their place in history: among the rescuers, the rescued, or the names on those tin plaques. . . . More than [an] exotic travelogue or simple tale of adventure and disaster."

—Randy Dotinga, *Christian Science Monitor*

"Graham Bowley's *No Way Down* does a great job of putting you on the mountain. It is a refreshingly unadorned account of the true brutality of climbing K2, where heroes emerge and egos are stripped down, and the only thing achieving immortality is the cold ruthless mountain."

—Norman Ollestad, author of *Crazy for the Storm*

"The year's best adventure book . . . disguises its morality tale beneath the plot of a high-octane thriller. . . . You're so ensnared by the terrifying tale of snapping ropes, tumbling bodies, and freezing bivouacs, you barely notice the subtext of the dangerous commercialization of modern climbing."

—Brian Schofield, *Sunday Times* (London)

"A detailed reconstruction of what happened. . . . The book is brisk and engrossing. . . . Mr. Bowley reveals a deep sympathy for his characters and their quest. . . . High on drama. . . . Entertaining."

—Michael J. Ybarra, *Wall Street Journal*

"The 2008 disaster on K2 was one of the worst tragedies in mountaineering history. Thanks to his assiduous research, Graham Bowley has put together the most comprehensive account of the mystifying chain of events leading to the catastrophe that we shall ever have. It's a gripping story, full of hope and heartbreak, folly and heroism."

—David Roberts, co-author with Ed Viesturs of *K2: Life and Death on the World's Most Dangerous Mountain*

"[A] step-by-faltering-step re-creation of the thin-air fight to survive, bristling with cinematic immediacy. . . . Bowley, a former *FT* journalist, uses his reporter's investigative skills to weave together an unputdownable narrative, based on hundreds of interviews and a trip to K2 base camp. . . . His book is a portrait of extreme courage, folly, and loss, leavened by a small dose of survival, as complete a version of the calamitous story as will probably ever emerge, including the tragic account of what may be 'one of the most selfless rescue attempts in the history of high-altitude mountaineering.'"

— Justin Marozzi, *Financial Times*

"Journalist Graham Bowley takes readers right onto the mountain, narrating the harrowing events on K2 as they unfold. . . . As avalanches shear away ropes, darkness falls, and rescue attempts succeed and fail, the book becomes impossible to put down. . . . The vivid story will captivate readers. *No Way Down* doesn't just tell a harrowing adventure story—it will also make you think."

—*BookPage*

"Both a gripping read and a clear-eyed investigation, *No Way Down* provides a compelling education in the game of climbing on the world's highest mountains to readers who have never tied into a rope, and is an essential addition to any mountaineer's bookshelf."

—Michael Kodas, author of *High Crimes: The Fate of Everest in an Age of Greed*

"Riveting and powerful; an extraordinary story of an extraordinary tragedy. Reading *No Way Down* is the closest you can come to being on the summit of K2 on that fateful day."

—Sir Ranulph Fiennes, explorer and author

"Harrowing. . . . Bowley is an intrepid journalist and gifted story-teller. . . . Thrilling and wrenching." —*Kirkus Reviews*

"K2 may be the world's second-tallest mountain, but it ranks first in terms of sheer terror. Through dogged reporting and vivid story-telling, Graham Bowley reconstructs K2's 2008 climbing season, one of the most disastrous in history. I read this book in a single, sweaty-palmed sitting, and not because I intended to. I simply couldn't put it down." —Nick Heil, author of *Dark Summit: The True Story of Everest's Most Controversial Season*

"Jon Krakauer's 1998 book, *Into Thin Air*, about a climbing disaster on Everest, reinvigorated the genre but is a hard act to follow. Despite never having climbed in his life, Bowley has managed to produce a worthy successor in this account of a 2008 tragedy on K2 that claimed eleven lives."

—Tom Robbins, *Financial Times* Books of the Year roundup

"A fascinating account that does justice to the history, allure, and heartache of K2." —Kurt Diemberger, author of *The Endless Knot: K2, Mountain of Dreams and Destiny*

NO
WAY
LIFE AND DEATH ON K2
DOWN

Graham Bowley

HARPER

NEW YORK · LONDON · TORONTO · SYDNEY

HARPER

A hardcover edition of this book was published in 2010 by HarperCollins Publishers.

HarperCollins books may be purchased for educational, business, or sales promotional use. For information, please write: Special Markets Department, HarperCollins Publishers, 10 East 53rd Street, New York, NY 10022.

FIRST HARPER PAPERBACK PUBLISHED 2011.

Map on pp. vi–vii © 2010 by Matthew Ericson.

The Library of Congress has catalogued the hardcover edition as follows:

Bowley, Graham.
 No way down: life and death on K2 / by Graham Bowley.
 p. cm.
 Summary: "A dramatic account of the worst disaster in the history of mountain climbing on K2, the world's second highest peak"—Provided by publisher.
 ISBN 978-0-06-183478-3 (hardback)
 1 Mountaineering—Pakistan—K2 (Mountain) 2. Mountains—Pakistan—K2 (Mountain)—Difficulty of ascent. 3. Mountaineers—Pakistan—K2 (Mountain) 4. Mountaineering accidents—Pakistan—K2 (Mountain) 5. K2 (Pakistan: Mountain)—Description and travel. I. Title.
GV199.44.P18B68 2010
796.52209549I—dc22 2010005706

ISBN 978-0-06-183479-0 (pbk.)

HB 02.21.2024

To my mother and father,
and to Chrystia

Beware of the man whose God is in the skies.
—George Bernard Shaw, *Man and Superman*

Take care to fly a middle course.
—Daedalus' advice to Icarus, Ovid, *Metamorphoses*

I long for scenes where Man has never trod.
—John Clare

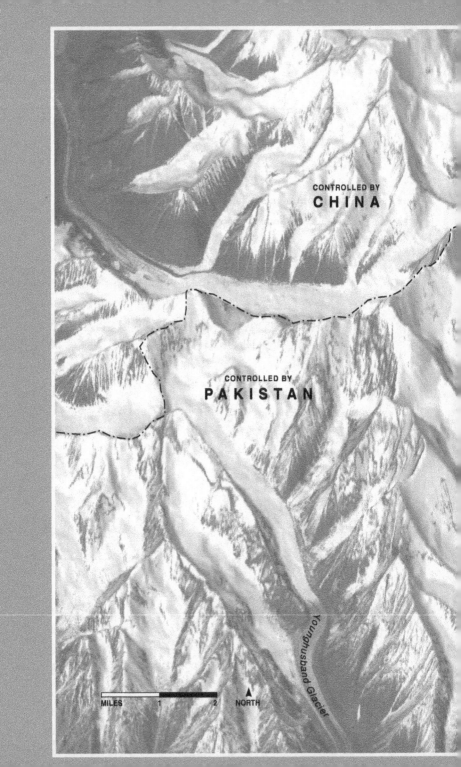

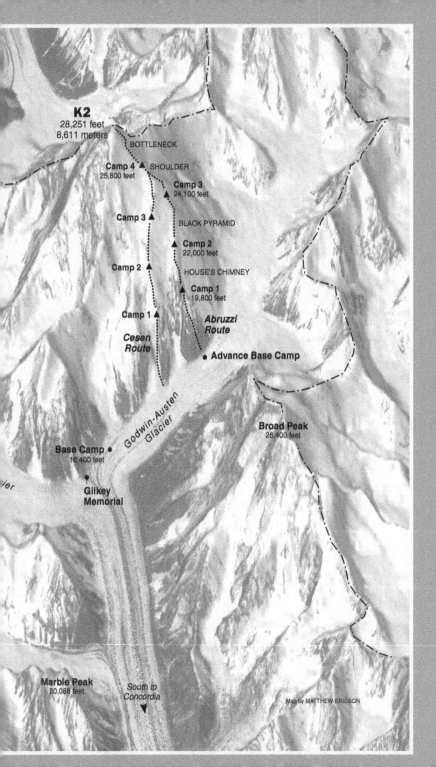

K2
28,251 feet
8,611 meters

BOTTLENECK

Camp 4 ▲ SHOULDER
25,800 feet

Camp 3
24,100 feet ▲

Camp 3 ▲

BLACK PYRAMID

Camp 2
22,000 feet ▲

Camp 2 ▲

HOUSE'S CHIMNEY

▲ **Camp 1**
19,800 feet

Camp 1 ▲

*Cesen
Route*

*Abruzzi
Route*

● **Advance Base Camp**

Godwin-Austen Glacier

Broad Peak
26,400 feet

Base Camp ●
16,400 feet

●
**Gilkey
Memorial**

ier

Marble Peak
20,088 feet

*South to
Concordia*
▼

Map by MATTHEW ERICSON

CONTENTS

AUTHOR'S NOTE

The story of how a multinational group of climbers became trapped by a falling glacier at the top of K2 flashed across my screen at the *New York Times* on August 5, 2008. Once it was confirmed that eleven climbers had died indulging a private passion for their expensive sport and three had finally come down frostbitten but alive after surviving several nights in the open, my immediate reaction was, Why should we care?

When my editor suggested I write about their ordeal for the newspaper, I balked at the idea—mountaineering had never interested me—although the next morning my story appeared on page one of the paper.

It was only after the *Times*'s website was deluged with comments from fascinated readers and after I took a trip abroad a week and a half later to the memorial service of one of the climbers that I began to entertain the possibility that there was more to the story. I interviewed some of the still-haggard survivors of the accident, saw their injuries, and, I must admit, was inspired by the charisma of the adventurers who had stepped into a world I could not understand and had faced down death.

I set about interviewing as many climbers as I could from the expeditions, as well as their families, and the mountaineering experts who had spent time on K2. As I talked to the survivors, I found their stories were often disturbing, painful, and occasionally incomprehen-

sible. On the face of it, a thirty-nine-year-old reporter who had never been to the Karakoram range was an unsuitable candidate to comprehend the fascination and dangers of modern mountaineering. However, some of the considerations that might seem to have disqualified me actually played to my advantage. Already, by this point, the accounts were contradicting one another and it was clear that memory had been affected by the pulverizing experience of high altitude, the violence of the climbers' ordeals and, in a few instances, possibly by self-serving claims of glory, blame, and guilt. I realized one of the advantages I had in making sense of the story was my objectivity and distance from the events. And some of the climbers seemed to agree. In Stavanger, Norway, after I had strolled for three hours around the city with Lars Nessa, a remarkable young Norwegian climber, he turned to me to say, "We think you are the one to tell our story."

Anyway, by then I was hooked. I had stepped with these men and women into a foreign world somewhere above the Baltoro glacier and I could not turn back.

When I began working on this book, I wanted to write a story that read dramatically, like fiction only real. I would bring K2 alive through the eyes of the courageous climbers who were pursuing their dreams on this incomparable peak in the Himalayas. Re-creating the final days of eleven people who would never return from K2 posed some challenges. The book I have written is based on hundreds of interviews with the many dozens of people involved directly or indirectly with the tragedy. If I couldn't determine exactly what happened on the slopes, I interviewed the climbers who had been close at pivotal moments, or experts who had been through similar situations, or families or friends who knew the climbers well. Never did I rely on conjecture; in cases where firsthand accounts were not available, I drew on my knowledge of the characters of the climbers and on as much evidence as I could gather over a year.

As my goal was to write a book re-creating the experiences of the

climbers caught up in this tragedy, I needed to report dialogue. With only a few exceptions, the dialogue was quoted to me directly by the speakers involved. In many of the important scenes I checked back to ensure accuracy and this often jogged memories or caused people to rethink. Right from the start I knew it was essential to interview the climbers early on, before memories faded, but in a very few cases, primarily those in which climbers did not survive, I have re-created the dialogue based on my impressions of the people involved as gleaned from my interviews.

I conducted the majority of the interviews in person, with follow-up conversations by telephone or email. Drawing on these resources, I have written as complete an account as possible of a narrative that involves multiple points of view. In the end, though, there are certain questions that I found impossible to resolve. My approach has been to set out as accurately as possible each climber's account, even where the accounts conflict. Some of the most crucial aspects of the tragedy turn on those points of conflict. The full truth of what actually took place in those August snows at 28,000 feet may never be known.

One June day, I followed the trail of the climbers to K2 and stood for a few hours in the cold sunshine on the Godwin-Austen glacier. I stared up more than two miles at the South Face, then climbed two hundred feet to the Gilkey Memorial, K2's monument to the dead. Seeing up close the peak, the Great Serac, and the Bottleneck, contemplating their beauty and their challenge, I could start to understand why this brave group of men and women would risk their lives to climb it.

CLIMBERS

Those names marked in bold denote climbers who made a serious summit bid on August 1, 2008.

NORWEGIAN K2 EXPEDITION 2008

Rolf Bae
Cecilie Skog (leader)
Lars Flato Nessa
Oystein Stangeland

NORIT K2 DUTCH INTERNATIONAL EXPEDITION 2008

Wilco van Rooijen (leader)
Cas van de Gevel
Gerard McDonnell
Roeland van Oss
Pemba Gyalje
Jelle Staleman
Mark Sheen
Court Haegens

ITALIAN K2 EXPEDITION 2008

Marco Confortola (leader)
Roberto Manni

SERBIAN K2 VOJVODINA EXPEDITION 2008

Milivoj Erdeljan (leader)
Dren Mandic

Predrag Zagorac
Iso Planic
Shaheen Baig
Mohammed Hussein
Mohammed Khan
Miodrag Jovovic

2008 AMERICAN K2 INTERNATIONAL EXPEDITION

Eric Meyer
Chris Klinke
Fredrik Strang
Chhiring Dorje
Paul Walters
Michael Farris (leader)
Chris Warner
Timothy Horvath

SOUTH KOREAN K2 ABRUZZI SPUR FLYING JUMP EXPEDITION

Kim Jae-soo (leader)
Go Mi-sun
Kim Hyo-gyeong
Park Kyeong-hyo
Hwang Dong-jin
Jumik Bhote
Chhiring Bhote
"Big" Pasang Bhote
"Little" Pasang Lama
Lee Sung-rok
Kim Seong-sang
Son Byung-woo
Kim Tae-gyu
Lee Won-sub
Song Gui-hwa

BASQUE INDEPENDENT CLIMBER

Alberto Zerain

FRENCH-LED INDEPENDENT K2 EXPEDITION

Hugues d'Aubarède (leader)
Karim Meherban
Qudrat Ali
Jahan Baig
Nicholas Rice
Peter Guggemos

SERBIAN INDEPENDENT CLIMBER

Joselito Bite

OTHER INDEPENDENT CLIMBERS

Nick Nielsen
Christian Stangl
George Egocheago

FRENCH "TGW" 2008 K2 EXPEDITION

Yannick Graziani
Christian Trommsdorff
Patrick Wagnon

SUNNY MOUNTAIN CHOGORI EXPEDITION

George Dijmarescu (leader)
Rinjing Sherpa
Mingma Tunduk Sherpa
Mircea Leustean
Teodora Vid

K2 TALL MOUNTAIN EXPEDITION

Dave Watson
Chuck Boyd
Andy Selters

SINGAPORE K2 EXPEDITION 2008

Robert Goh Ee Kiat (leader)

Edwin Siew Cheok Wai
Ang Chhiring Sherpa
Jamling Bhote

ITALIAN BROAD PEAK & NANGA PARBAT EXPEDITION

Mario Panzeri
Daniele Nardi

PROLOGUE

Eric Meyer uncurled his tired body from the Americans' tent into the jolt of the minus-20-degrees morning.

He was decked out in a red down suit and his mouth and nose were covered by his sponsor's cold weather altitude mask. A few yards in front of him stood the Swede, Fredrik Strang, Meyer's colleague in the American team, his six-foot, two-inch frame bulbous in a purple climbing suit, and his backpack weighed down by his thirteen-pound Sony video camera.

It was pitch black. There was no moon. Meyer put on his crampons and whispered a prayer. *Keep me safe.* "Let's do our best," he said out loud to Strang.

The two men nodded to each other, then kicked their boots into the tracks in the firm snow. The tracks led up the mountain, where they could see the headlamps of the twenty-nine climbers from the eight teams, bright spots on the steadily rising Shoulder.

"Don't let your guard down," said Strang. He tossed his ice axe in the air and caught it, just to make sure he was awake.

For nearly two months, they had waited for this moment. Now they were ready.

More than two thousand feet above them, the summit was still hidden in the night, which was probably a good thing. Soon the sun would rise over China. As the two men filed out onto the line above

Camp Four, at about 26,000 feet the final camp before the summit, their breath rasping in the low-pressure air, the winds of the past days had vanished, just as their forecasters had promised. It was going to be a perfect morning on K2, and Meyer, a forty-four-year-old anesthesiologist from Steamboat Springs, Colorado, possessed confident hope that his skills in high-altitude sickness and injury would not be needed.

Meyer's team was one of eight international expeditions that were setting off on the final day of their ascent of K2, at 28,251 feet the second-tallest mountain on earth. K2 was nearly 800 feet shorter than Everest, the world's highest peak, but it was considered much more difficult, and more deadly.

It was steeper, its faces and ridges tumbling precipitously on all sides to glaciers miles below. It was eight degrees latitude or 552 miles farther north than Everest, its bulk straddling the border between Pakistan to the southwest and China to the northeast, and, far from the ocean's warming air, its weather was colder and notoriously more unpredictable. Over the decades, it had led dozens of mystified climbers astray into crevasses or simply swept them without warning off its flanks during sudden storms.

Yet K2's deadliness was part of the attraction. For a serious climber with ambition, K2 was the ultimate prize. Everest had been overrun by a circus of commercial expeditions, by people who paid to be hoisted up the slopes, but K2 had retained an aura of mystery and danger and remained the mountaineer's mountain. The statistics bore this out. Only 278 people had ever stood on K2's summit, in contrast to the thousands who had made it to the top of Everest. For every ten climbers who made it up, one did not survive the ordeal. In total, K2 had killed at least sixty-six climbers who were trying to scale its flanks, a much higher death rate than for Everest. And of those who had presumed to touch the snows of its summit, only 254 had made it back down with their lives.

Waiting in his tent at Camp Four the previous night, Meyer had experienced a few dark hours of disquiet when the Sherpas cried out

that the other teams had forgotten equipment they had promised to bring; he could hear them hunting through backpacks for extra ropes, ice screws, and carabiners. Although ropes had been laid on the mountain from the base to Camp Four, the expeditions still had to fix the lines up through the most important section, a gully of snow, ice, and rock called the Bottleneck. The Sherpas had only just discovered that one of the best Pakistani high-altitude porters (HAPs), who was to lead the advance rope-fixing team, had coughed up blood at Camp Two and had already gone back down.

Eventually the Sherpas quieted down, and Meyer assumed they must have found what they needed. By now, everyone was waking up. In the surrounding tents, alarms were beeping, there was the sound of coughing, stretching, zipping of suits, ice screws jingling, headlamps snapping on. The panic was over.

Yet when the advance team eventually left, it seemed to Meyer, listening to the swish of boots over snow outside his tent, that they were already late, and time was the last thing they wanted to waste on the mountain.

It was past 5 a.m. as Meyer and Strang pushed ahead together up the Shoulder, a steadily rising ridge of thick snow about a mile long. They prodded the snow with their ice axes to test the way. The snow, hard-packed, didn't crack. They skirted the crevasses spotlighted in the arcs cast by their headlamps, some of the crevasses a few feet wide. Several yards off in the dark was a row of bamboo wands topped with ribbons of red cloth. The poles had been set out to guide climbers back to Camp Four later that night. But there was only a handful.

The two men didn't say much, but every few minutes Meyer made a point of calling out to Strang, checking for warning signs of high-altitude effects: a trip, or a mumbled answer.

"How you doing?"

"I'm fine!" said Strang loudly.

After half an hour, they came to the start of the ropes laid by

the advance team. The two men were surprised to find them placed so low in the route. *Weird.* The Bottleneck was still a long way off and these slopes were not dangerous for an experienced climber. The ropes had obviously been put there to guide the climbers on the way back down. The lead group must have calculated they would still have enough rope to reach where it was truly needed.

Meyer was carrying his own quiver of bamboo wands, which he had intended to plant at intervals for the return journey. Strang had brought three thousand feet of fluorescent Spectra fish line to attach between the poles. But now they left the equipment in their backpacks. *Not required.*

Exchanging shrugs, Meyer and Strang walked on. At 6:30 a.m., the sun rose, revealing the Bottleneck. It was the first time either of them had seen the gully up close. It was awesome, more frightening than they could have anticipated. About nine hundred feet ahead of them, its base reared up from the Shoulder, rising another few hundred feet later to an angle of 40 or 50 degrees and narrowing between stairs of dirty, broken brown rocks on both the right and left sides.

It was, Meyer could see, an unreliable mix of rock, ice, and snow. Another five hundred feet on, it turned up to the left toward a horizontal section called the Traverse, a steep ice face stretching a couple of hundred feet around the mountain, and exposed to a drop of thousands of feet below.

Directly above the Bottleneck was the serac—the blunt overhanging end of a hanging glacier—a shimmering, tottering wave frozen as it crashed over the mountainside, a suspended ice mountain six hundred feet tall, as high as a Manhattan apartment building and about half a mile long. It was smooth in places but large parts of it were pitted with cracks and crevasses.

This was the way to the summit, and for the whole of the Bottleneck and most of the Traverse, the mountaineers had to climb beneath the serac. There were other ways to the summit of K2—via

the north side from China, for example, or on a legendary, nearly impossible route on the south face called the Magic Line—but the path up the Bottleneck and beneath the serac was the most established route, the easiest, and possibly the safest, as long as the serac remained stable.

The glacier moved forward slowly year by year. When it reached a critical point, parts of the ice face collapsed, hurling chunks down the Bottleneck. No climber liked to imagine what would happen if they got in the way. In past decades, there had been many reports of icefalls from the glacier, but in recent years the Great Serac on K2 had been quiet.

The strengthening daylight revealed the changing shapes and textures of the glacier, transforming its colors from gray to blue to white as the cold shadows receded. It revealed to Meyer and Strang the serac's true nature, something the earlier climbers would have missed because they had entered the Bottleneck in darkness. It looked to Meyer like giant ice cubes stacked on top of each other, and the ice had pronounced fissures running down it.

"Man, that's broken up!" Meyer said in awe.

They had studied photographs in Base Camp taken a month earlier, which had shown cracking, but this was far worse.

As the outline of the mountain emerged from the dawn, Meyer could also make out clearly for the first time the snaking line of climbers up ahead. He had expected to find an orderly procession of bodies moving up the gully and already crossing the Traverse. Instead he was met with a sight that stopped him short: an ugly traffic jam of people still in the lower sections of the Bottleneck.

Only one climber seemed to have made good progress. He was sitting near the top of the Bottleneck in a red jacket, waiting for the muddle to resolve itself below.

What had caused the delay? As Meyer and Strang approached, there were distant calls from above for more rope.

"The rope is finished!"

Eventually it became clear: The advanced group had not yet managed to fix rope to the top of the gully, and the climbers following behind had already caught up to them.

During the previous two weeks, the expeditions had convened cooperation meetings down in the tents at Base Camp. They had made an agreement detailing the sequence of who would climb when. The crack lead group of about half a dozen of the best Sherpas, HAPs, and climbers from each team would fix ropes up through the Bottleneck and the rest of the expeditions would follow rapidly through the gully without delay. The arrangement was meant to avoid overcrowding in the Bottleneck. They knew it was critical to get out from under the serac as fast as possible.

Well, thought Meyer, *so much for that.*

Everyone seemed to be staring at one another and wondering what to do next. After a few minutes some of the climbers at the bottom began bending to cut the ropes and pass them higher. Soon the wait was over and the line was edging on up again, though still slowly.

Until that moment, Meyer had not appreciated the sheer number of people trying to climb the mountain: one of the highest concentrations of climbers to attempt a summit of K2 together on a single day. A few were already turning back, because they were feeling cold or sick or today was not to be their lucky day. Probably about twenty-seven or so were still heading for the summit. It looked like being another busy day, like the ones in the 2004 or 2007 seasons when dozens reached the top. Meyer imagined the conditions up there. Everyone getting in the way. Koreans, Dutch, French, Serbs, and a string of other nationalities. Few speaking the same language. And they were probably so intent on avoiding one another that they were not focusing on how late it was nor were they looking up at the glacier to study it properly. *Damn.* They were not seeing how dangerous it looked.

Meyer watched the line of climbers struggling higher and had an uneasy feeling in his stomach. Beside him Strang said it out loud.

"Shit, it's late."

They took off their backpacks and sat in the snow, staring up at the serac and, below it, the Bottleneck.

"There's no way around that crowd," said Meyer. "We're going to get stuck behind them."

They made a calculation. At the expeditions' current speeds, they would reach the summit in the afternoon, perhaps early evening. Sunset. The climbers would be coming back down through the Bottleneck in the dark.

As far as Meyer was concerned, that multiplied the risk a thousandfold. It was already the most dangerous climb in the world. Descending in darkness through the Bottleneck was a no-no. He knew that everyone up there had a deadline for reaching the summit no later than three or four o'clock in the afternoon. What were they thinking?

He felt his courage drain away.

Yet turning back was hard, so bitter after the weeks of toil on the mountain. Like everyone else, he had invested thousands of dollars and nearly a year of his life preparing to come to Pakistan.

He might be able to return to Camp Four and try again the following day. But in reality, climbing up to these altitudes sucked so much out of a person, exposed a body to such pain, that they would have to descend to lower camps to recover before trying again. But the climbing season was ending. They had already pushed back this summit attempt because of bad weather. There was no time left. It was probably going to be the only shot Meyer had. If they failed today, they would have to wait another year. And who knew if he could ever return?

Together, he and Strang went through all the scenarios. They had made it to the Shoulder of K2. Were they throwing away a lifetime's chance to climb the mountain of their dreams?

Strang unpacked his camera and started to film the serac and the climbers beneath it. Meyer took some snapshots. The climbers in the Bottleneck were still barely moving.

They remembered the rain that had fallen in their first week in Base Camp, an odd event for K2 in June. Then there had been the weeks of winds and the overcast sky and snow piling up. And today the sun had risen into a clear blue heaven. It would be baking hot up there soon. If the serac was going to crack, it was because gravity was pulling it lower. The ice was also susceptible to the differences between the heat of day and the cold of night, which could cause the ice to expand and then contract, making an avalanche more likely. They didn't trust the serac.

They packed up and slogged one and a half hours back down through the snows of the Shoulder to their tent at Camp Four. It was around 10 a.m. The day was perfect. Around them, hundreds of mountains stretched away in all directions, white and shining in the sun.

The camp was still and quiet. It perched on a flat part of the Shoulder and, relatively speaking, there was enough room for all the tents here, more than in some of the lower camps, where space was rationed and tents hung on ledges or were reinforced against the winds by ropes and poles.

They had expected to find a dozen or so climbers milling around the colored domes of nylon tents, taking in the rays, sharpening crampons, waiting around. Down at Base Camp, some mountaineers had said they thought the good weather was going to hold and so they had planned to climb up to Camp Four a day later than everyone else to avoid the main crowd and try for the summit on August 2. The second Korean team would be coming up soon, along with two Australians: one of Meyer's colleagues, and another from the Dutch expedition who had been left out of the first summit ascent by his expedition's leader.

But the other climbers were either inside their tents or still grappling with the slopes up from Camp Three. Meyer and Strang saw

only one other person, an Italian. He had turned back earlier because of altitude sickness. Now he stuck his head out of his tent, next to theirs. His climbing jacket was plastered with "Fila" and other sponsors' logos. He waved and then closed his tent.

Meyer could not help but peer back at the Bottleneck over his shoulder. Nearly a mile away, the climbers were distant dots, filing upward. They were higher on the gully now, about two-thirds of the way up. They were still crowded together dangerously. From this distance, they seemed to be not moving at all. Surely they would turn around soon. Did they have a death wish?

The two men ducked inside their tent. It was only four feet high, with no room to stand. They peeled off their down suits, the linings damp from sweat. They took out the radio, as big as a large cup of coffee, and crashed on top of the two sleeping bags that were spread parallel on the floor. They gulped at a bottle of melted water. It was hot in the tent. They didn't feel like talking much. Soon they would have to start thinking about descending. It would take them a full day to get down.

About twenty minutes later, they were resting when they heard a faint cry outside. It came from far away. Strang thought he heard it again.

They went out of the tent to check the mountain but nothing had changed from when they had last looked. The line of climbers was still stuck in the Bottleneck. The radio was quiet.

Then the Italian stumbled over. His name was Roberto Manni.

"I see!" he said, pointing at the mountain, his face red. "I see!"

Half a mile away, at the base of the Bottleneck, about six hundred feet below the main chain of climbers, a body was tumbling down the ice. A climber had fallen.

The small black figure slowed down and came to a stop just beneath some rocks.

Meyer and Strang ran a few yards and stared up intently at the Bottleneck.

The figure lay with its head pointing down the slope.

Immediately, excited chatter started up on the radio.

"Very bad fall!" Meyer heard someone say. "He is alive. He is still moving. It is one of the Serbs."

Part I

SUMMIT

Friday, August 1

"I wish everyone could contemplate this ocean of mountains and glaciers. The night will be long but beautiful."
—Hugues d'Aubarède, K2, July 31, 2008

"K2 is not to be climbed."
—Filippo de Filippi, from the authorized account of the Italian 1909 expedition

CHAPTER ONE

Walk east along dusty tracks from the village of Askole and within three days you will glimpse in the distance a wonder of the world, the rock-strewn Baltoro glacier and a giant's parade of ocher and black granite mountains, topped with snow and wreathed in clouds.

Eric Meyer and the other teams traveled this route in 2008, entering the inner Karakoram, the heart of the tallest mountain range in the world. The Karakoram range is part of the western Himalayas and forms a watershed between the Indian subcontinent and the deserts of Central Asia. Here, four peaks higher than 26,000 feet stand within fifteen miles of one another. Walk deeper into this dominion of ice and moraine and finally, after another three days, above all these lofty giants suddenly appears K2, the second-tallest mountain in the world.

K2's naming has become legend. In September 1856, a British surveyor of the Great Trigonometric Survey of India, Lieutenant Thomas G. Montgomerie, laden with theodolite, heliotrope, and plane table, climbed to a peak in Kashmir, his job to fix the imperial border of the Raj.

One hundred and forty miles to the north he glimpsed two formidable mountains, which he sketched in his notebook in ink, above his own wavy, proud signature. He named them K1 and K2. Montgomerie's "K" was for Karakoram. (He would log K1 through K32,

and recorded K2's height at 28,278 feet, only about 30 feet off.) K1 was later discovered to bear a local name and became fixed on the maps as Masherbrum. But K2 didn't and so Montgomerie's name stuck.

Five years after Montgomerie's visit, another tough, steely British empire builder, Henry Haversham Godwin-Austen, came closer to K2, becoming the first European to ascend the Baltoro glacier. In recognition of his feat, in 1888 a motion was proposed about K2 at the Royal Geographical Society in London that "in future it should be known as Peak Godwin-Austen." The motion was rejected but the name persisted, even into the middle decades of the twentieth century on some maps and in newspaper accounts. It carried colonial overtones, however, and in the end, "K2" won out, although Godwin-Austen's name still marks the glacier at the foot of the mountain.

After the imperial surveyors, Western explorers and travelers soon followed, encroaching ever deeper into this wondrous realm in hobnailed boots, tweed suits, and skirts. Two prominent visitors—an American couple, William Hunter Workman and his wife, the New England heiress and suffragette Fanny Bullock Workman—were making a bicycle tour of India in 1898 when they decided to visit the Himalayas. Years later, they explored the Siachen glacier to the southeast of K2, and they made first ascents of several Karakoram summits. The couple was notorious. William was a retired surgeon who believed no one could survive a night above 22,000 feet, and Fanny had an irritating habit of carving her initials and date of passage on mountain walls, as well as clearing foot traffic with whip and revolver.

In 1902, a six-man expedition made up of Swiss, Austrians, and Britons made the first serious summit attempt on K2. Among them was the English climber and occultist Aleister Crowley, who a few years later would assume the name "666," and whose wild-haired antics earned him the title "Wickedest Man in the World" in the Brit-

ish press and a place years after his death on the cover of the Beatles' album *Sgt. Pepper's Lonely Hearts Club Band*.

Following a nine-week trek, undertaken while carrying three tons of luggage, including volumes of Crowley's library, the expedition made as many as five attempts at the summit. Crowley preferred a route up the southeast spur of the mountain but the other climbers argued for a switch to the northeast ridge. They reached about 21,000 feet on K2's side. But the effort broke down when, among other things, one of the Austrians collapsed with pulmonary edema—an acute mountain sickness involving a buildup of fluid in the lungs. A disappointed and semidelirious Crowley, suffering himself from malarial fevers and chills, threatened one of his colleagues with a revolver and was disarmed by a knee to the stomach. The expedition made its retreat in disarray, although they had climbed higher on K2 than anyone before.

The mountain cast a wide spell. In 1909, seven years after Crowley's attempt, it was the turn of Prince Luigi Amedeo of Savoy-Aosta, Duke of the Abruzzi. A son of the king of Spain, and grandson of a king of Italy, Amedeo was a mountain climbing fanatic who a decade earlier had carried ten bedsteads up onto Alaska's Malaspina glacier. (He also hailed from the part of Italy that two decades later would be made famous by Ernest Hemingway in *A Farewell to Arms*.) When the duke visited the American Alpine Club at the Astor Hotel in New York, the ballroom was decorated in his honor: "great blocks of ice fashioned like mountains, with men roped climbing their steeps," according to a report in the *New York Times*. He chose K2 because it was relatively unmapped, but he had another objective. He wanted to set the world altitude record, which at the time was held by two Norwegians.

Surrounding his trip in great secrecy, he traveled incognito to London for supplies. Presumably the secrecy was due to the fact that he didn't want anyone to reach K2 first. But he may also, accord-

ing to some history books, have been fleeing a very public (in the American press) romantic entanglement with Katherine Elkins, the rich, auburn-haired, horse-riding daughter of a United States senator from West Virginia, Stephen B. Elkins. The duke had likely met the Elkinses in Rome, where they traveled in the summer to buy antiques, but the romance was opposed by both families.

The duke set sail from Marseille on the P&O steamer *Oceana* with six and a half tons of luggage, bound for Bombay and thence to K2, for the glory of Italy and the House of Savoy. He was accompanied by a fifty-year-old mountain photographer, Vittorio Sella, whose glass plates and emulsions would yield some of the most beautiful pictures ever taken of K2.

The duke's ten-man team passed through Srinagar, where he was seen off by the local British governor with a royal escort of brightly decorated shikaras, or riverboats, each rowed by fifteen oarsmen. He traveled in luxury: The expedition's four-layered sleeping bags consisted of one layer of camel hair, one of eiderdown, one of sheepskin, and an outer layer of waterproof canvas. He first caught sight of the mountain from Concordia, a junction of two sweeping glaciers a few miles away at the center of an amphitheater of peaks. The duke's awe shines through his description. It was, he declared, *l'indiscusso sovrano della regione:* "the indisputable sovereign of the region, gigantic and solitary, hidden from human sight by innumerable ranges, jealously defended by a vast throng of varied peaks, protected from invasion by miles and miles of glacier."

Supplied from Urdukas, a camp several miles away down the Baltoro glacier, with a stream of fresh eggs, meat, water, fuel, mail, and newspapers, the duke and his entourage ascended partway up the southeast ridge, a rock rib rising directly above what would be named the Godwin-Austen glacier. The route he followed would become the main path for future ascents of the mountain and would forever bear the duke's name, the Abruzzi Spur. In his wake as he passed, he

named other K2 landmarks in his expedition's honor, like a modern Adam discovering a new world: the Negrotto Pass, after the duke's aide-de-camp; the Sella Pass; and the Savoia Glacier.

The duke eventually set the world altitude record by climbing to 24,600 feet on another, nearby peak, Chogolisa. But he was frustrated by K2's seemingly insuperable steepness, and turned back at 20,000 feet, declaring that K2 had defeated him and it would remain forever unconquerable.

"After weeks of examination, after hours of contemplation and search for the secret of the mountain, the Duke was finally obliged to yield to the conviction that K2 is not to be climbed," wrote Filippo de Filippi, a biologist and doctor who accompanied the duke and authored the expedition book.

It was up to another Italian expedition to prove the duke wrong, years later.

In the years immediately following World War II, military hostilities may have ended around the world but national rivalries were still playing out in the arena of the Himalayas. In 1950, an expedition of French climbers was the first in the world to scale a peak above 26,000 feet when it reached the summit of Annapurna I in Nepal. In 1953, Mount Everest, the highest of them all, fell to the British, news of the event reaching London on the eve of the coronation of Queen Elizabeth II and prompting national celebration.

In the spring of 1954, it was Italy's turn to embellish its national standing, and recast its postwar funk, when an expedition arrived in Pakistan to lay siege to the slopes of K2.

The expedition comprised eleven climbers, four scientists, a doctor, a filmmaker, ten high-altitude Hunza porters, and five hundred additional porters. Altogether, they shouldered more than thirteen tons of supplies, including 230 cylinders of supplementary oxygen.

The expedition's autocratic leader, Ardito Desio, was a geographer and geologist from Palmanova, in northeast Italy. An ambitious

man, he was nicknamed Il Ducetto, or Little Mussolini, by the team's members. To signify his serious intent, before approaching on foot Desio and three companions circled the mountain in a DC-3. The Pakistani army aided his approach by building bridges across ravines, and, in an echo of the preceding war, through his radio in Base Camp he urged his climbers on the slopes to become "champions of your race." On the trek in, through the unpeopled terrain of the surrounding valley, some of the porters went snow-blind after Desio refused to issue them proper sunglasses. The porters later staged a revolt but were placated by the Italians' cigarettes and baksheesh, and by the intervention of the military liaison officer, Colonel Ata-Ullah, although some of the porters then stole the team's flour and biscuits.

The climb itself was notable for the use of a steel windlass and a thousand-foot steel cable to winch heavy supplies up the mountain. And after sixty-three days of preparation—and the death of one climber, Mario Puchoz, thirty-six, a mountain guide from Courmayeur, due to complications that were initially diagnosed as pneumonia but were later accepted as pulmonary edema—by the evening of July 30, 1954, two climbers had reached 26,000 feet and were within a day or so's climb of the top.

At first light, the two men, Achille Compagnoni, a forty-year-old climber from Lombardy who was Desio's expedition favorite, and his partner, twenty-eight-year-old Lino Lacedelli, from Cortina d'Ampezzo, climbed up toward the summit. At one point Compagnoni slipped and fell but he landed in soft snow. At another, Lacedelli, removing his gloves to clean his glasses, found his fingers were white and without sensation. The two men were carrying heavy oxygen canisters. Within six hundred feet of the summit, however, they felt dizzy; the gas had run out and they wrenched off their masks.

They believed that life without oxygen above around 28,000 feet was impossible beyond about ten minutes; they waited for the end. When it didn't come, and they found they could breathe, they trudged

on, though they were plunged into a hallucinatory state, both men believing their late colleague, Puchoz, was following close behind.

At a few minutes before 6 p.m., the slope flattened, they linked arms, and with a "Together" they stepped onto the summit. K2 had been defeated. The *New York Times* ran the story on August 4, 1954: "Italians Conquer World's Second Highest Peak; Mt. Godwin Austen in Kashmir Is Climbed in 76-Day Effort."

———

Back in Italy, the expedition was predictably greeted by a wave of patriotic fervor, a postage stamp was issued in the climbers' honor, and they were received by Pope Pius XII. There also followed decades of acrimony over the manner of the summit victory.

On the evening before their summit attempt, Compagnoni had pitched the final camp higher than had been agreed with the rest of the team and concealed it behind a rock. He did this because there were limited oxygen sets and he did not want another climber, Walter Bonatti, who was coming up from below with a Hunza porter called Mahdi, to take his or Compagnoni's place. Bonatti was a talented, younger mountaineer, less favored by the leader, Desio, and the Italian climbing establishment.

As a result of the concealment, Bonatti and Mahdi were forced to spend the night out in the open on a small ice shelf on the side of the mountain. They had actually carried the oxygen sets for the summit and they left them in the snow. Mahdi, who was without proper climbing boots, ran back down desperately at first light. He survived but lost half of both his feet from frostbite and almost all his fingers.

The rancor lasted for years in Italy. Bonatti went on to become one of the most successful and respected climbers of his generation, and mountaineers generally side with his version of events. In the 1960s, Compagnoni fought back, claiming that Bonatti had siphoned off oxygen from the tanks, thus endangering the lives of the two

summiteers. He said that Bonatti had also convinced Mahdi to accompany him to the final camp by falsely promising him a crack at the summit. Bonatti won a libel victory in court against a journalist who had aired Compagnoni's claims. Desio would return to Pakistan in 1987 to settle finally the question of which peak was higher, K2 or Everest. (A University of Washington astronomer had announced that new data from a navy satellite showed K2 might be 800 feet higher than previously believed and taller than Everest; using better technology, Desio and his colleagues found otherwise.) He also faced questions about whether he had concealed the truth about what had happened on the mountain.

Despite the rancor, the Italian team's achievement still stood. Nearly one hundred years after the first sighting by Thomas Montgomerie of the Royal Engineers, men had finally reached the snows at the top of K2.

CHAPTER TWO

10:30 a.m.

It was so crowded near the top of the Bottleneck that Dren Mandic was nervous.

The lone mountaineer near the top, the Basque Alberto Zerain, had climbed in front of everybody up the steep gully, then disappeared quickly around into the diagonal passageway of the Traverse. A few Sherpas and a line of South Koreans had followed behind him. But the Koreans had gone so slowly and after half an hour they had stopped moving, causing this backlog down the Bottleneck.

Mandic was waiting near the top of the gully. He stood on a little rock shelf on the right-hand side while he waited to cross over to the mouth of the Traverse on the opposite side. Standing stiff and impatient in a black down suit and a red coat, he waited amid a small group of climbers—four, five, six, more—who were resting, some sitting, their coats unbuttoned and their harnesses unclipped from the rope, basking in the mid-morning warmth.

He glared up at the backs of the mountaineers lined up ahead of him in the Traverse. After the Traverse, the teams would have to climb up onto a long snowfield at about 27,500 feet, which after another three or four more tiring hours would bring them to the summit.

Mandic turned and looked below at the longer line of climbers stretching down the Bottleneck like dominoes. The climbers wore big

jackets, clutched ice axes and ski poles, and had backpacks weighted with phones and radios. They were strangers to each other behind shaded glasses and frosted beards and eyebrows; some were wearing oxygen masks.

Mandic noticed that the crowd was making the Sherpas uneasy. In one place, they had thrust two axes into the rocks above an ice screw and wrapped two short rope lengths around the axe handles and down to the screw to take some weight off it.

The climbers at the bottom of the queue a few hundred yards below were still moving slowly higher. They stabbed their axe handles into the snow and moved their jumars—metal ascending devices that bit into fixed lines—up the rope. But soon the inevitable happened and they ran up against the crowd. Everyone's frustration was boiling over. The leader of the Dutch expedition, Wilco van Rooijen, snapped.

"What's going on?" he yelled. A professional mountaineer, Wilco had been one of the dominant figures over the past few months at Base Camp, one of the chief organizers of the cooperation between the teams. He was dressed today in an orange down suit, a thin, broad-chested man with spiky silver hair, blue eyes, and a silver earring in his left ear. This summer represented his third attempt to climb K2. He had first tried to climb it in 1995 but had been knocked unconscious in a rock fall; he broke his shoulder and lost one and a half liters of blood. This year he had returned with an eight-strong team and a 100,000-euro sponsorship deal from a Dutch water purification company, Norit. He was an impatient man and wanted success.

"Hurry up!" he hollered, in his Dutch-accented lilt.

Above them all, not fifty feet from Mandic's head, loomed the brow of the serac, blue and sweating in the heat. It was barely the middle of the morning and the sun already blazed above them in the blue sky.

The thirty-one-year-old Mandic had come to the mountain with a regimented five-man Serbian team with their three Pakistani HAPs, one of the first Serbian expeditions to K2.

There was Predrag, or Pedja, Zagorac, and Iso Planic, who was probably the most experienced among them. Zagorac was from Belgrade and Planic from Subotica. Then there was Milivoj Erdeljan, their gray-haired leader, who didn't climb but guided his charges like a father from Base Camp. His calming voice was always on the radio. A fifth member of the team, who helped with sponsorship, had joined them in July.

Of the three Serbian climbers, Mandic had the least experience. At home he belonged to the "Spider" Subotica mountaineering club. He had climbed Mount Ararat in Turkey, and the previous summer he had summitted Broad Peak, K2's big neighbor, but that was his only Himalayan achievement.

None of the Serbians was a professional climber—few people in Serbia were. Mandic worked as a carpenter in Subotica. But they had prepared well, he was convinced. They had financing from the Ministry of Sport as well as from private companies in Belgrade. They had a mobile weather forecast station, and back in Serbia two meteorologists were on call. They felt they couldn't be in better physical condition. After all, their fitness had been tested and approved at the Provincial Institute for Sport in Novi Sad; and in Base Camp, Erdeljan had sent his men out most days to keep fit by climbing up and down the steep cuts of the Godwin-Austen glacier. The Serbs had brought ten tents to the mountain, and 5,600 feet—more than a full mile—of rope.

Like most of the teams on K2 this year, the Serbs had traveled five hundred miles from Islamabad, the Pakistani capital, to Skardu, a dusty town in the country's northeastern territory. From there they had gone on by cramped jeep for another day to Askole, a mud-brick village and one of the nearest habitations to K2. After that they had trekked in for a week by foot over gushing streams and brittle gla-

ciers, forever craning their necks to glimpse the distant peak. On the Serbs' trail in from Askole, one of the mules broke its leg.

In the following weeks, the different national expeditions had gotten to know each other well. They had worked side by side on the slopes, enduring rock falls and storms, loosened ice screws, scraped shins, and snow-crushed tents. In the Base Camp at the foot of K2, a small town of multicolored tents perched on the Godwin-Austen glacier at 16,400 feet above sea level, they had shot the breeze over yak's meat and the Hunzas' sweet tea. They had learned techniques from one another, bragged and swapped stories of conquests of lesser peaks—Annapurna, Chogolisa, Masherbrum—while the frozen tides of the Godwin-Austen shifted outside and cracked.

K2 had provided blunt reminders of its dangers. In Base Camp, one of the Pakistani military liaison officers—each team had to have one to qualify for a permit—got fluid in his lungs from the altitude; one of the Serbians' porters had had to push him by wheelbarrow to the military camp at Concordia. Then on a practice climb to one of the higher camps, a rockfall had showered down on the three Serbs. Mandic had simply lain down and put a knapsack over his head as the biggest stone—at least a hundred pounds— bounced over him.

Mandic and Zagorac were often in the kitchen tent, where they cooked Serbian specialties, Vojvodinean homemade plum dumplings and doughnuts, without plums, however; they had to make do with strawberry jam. It was still delicious. In the evenings, Mandic was invariably at the mess tent table, playing cards raucously with the Pakistani porters. Mandic, who had a special love of nature, told them about the volunteer work he did at the local zoo back in Subotica. He kept spiders, birds, all sorts of exotic creatures in his apartment, where he lived with his girlfriend, Mirjana. He had completed military service in Serbia. He had never moved away from Subotica, but he was restless and liked to travel, especially to places like K2.

Over the weeks, the Serbians and the other teams had established higher and higher camps so that they gradually became used to the altitude and felt more comfortable breathing the rarefied air. Then the altitude headaches were not so debilitating, at least when washed down with a cup of pills.

During the days, the teams fixed thousands of feet of rope to the rock and ice like a handrail so that they did not have to face the mountain unassisted. They followed two routes up—one on the Abruzzi ridge and another called the Cesen route, both of which met near the Shoulder. The teams bound the mountain, just as the yaks the porters led in from Askole had been bound in rope by the Pakistani cooks, their throats slit on the ice, the meat stashed in ice holes in the glacier for the mountaineers to eat. And the dance of the Balti porters in the glare of the torchlight on the festival of Aga Khan was like the celebration of the vanquishing of some mythic beast.

Then the leaders of each expedition team had convened the cooperation meetings, held in the Serbians' and Koreans' mess tents, to discuss logistics. The climbers knew they were too many to ascend in an uncoordinated rush. Around a large green table, they worked out who would bring the ropes, even who would supply what precise number of ice screws or bamboo sticks or lengths of fish line.

"We are working like one team," said Pemba Gyalje, a Nepalese Sherpa in the Dutch team who attended the meeting. They had turned the crowd to their advantage, it seemed. It was quite an achievement among so many competing languages and egos.

Gyalje banged his fist for emphasis.

"One team," he said. *Not many.*

On the way up the mountain during the final summit push to Camp Four, the teams had climbed up the ropes and rickety aluminum wire ladders suspended in House's Chimney, a 150-feet-high crack in a

huge red-rock cliff below Camp Two. It was named after an American, Bill House, who had climbed it in 1938. And they had scaled the notorious Black Pyramid, a large promontory of broken rock and shingles below Camp Three.

Around this time, unforecast winds had swept in. In the night the gusts had nearly lifted the flapping tents off the ground. The climbers had clung to their sleeping bags, convinced they were going to die. The winds had ripped open one of the tents to toss a backpack full of equipment belonging to another independent Serbian mountaineer into the chasms.

It was the Serbian team's lead guide, a man called Shaheen Baig, who had vomited blood in their little tent on the narrow ledge at Camp Two. While some of the teams, such as the South Koreans, had flown in Sherpas from Nepal, the Serbs had hired three local HAPs—the HAPs were generally drawn from nearby northern areas such as Shimshal. During the storm, the Serbians listened, above the roar of the wind, to Baig's hacking cough. Baig possessed the valuable experience of having summitted K2 four years earlier. But there had been no other option; he had had to climb back down.

The rest of the Serbian team pushed on but the next morning the Serbians' two other porters, Mohammed Khan and Mohammed Hussein, slyly admitted that during the storm they had forgotten to pack everyone's food, so then there were no sausages or biscuits for Mandic and his colleagues, though they found candies and soups in a rucksack and borrowed a bowl of pasta from Alberto Zerain. At that altitude, though, they discovered they were not really hungry after all.

Then, on the steep mountainside at Camp Three, Khan complained of a headache. They gave him ibuprofen and he reached Camp Four; and he had set off with the Serbs this morning. He was to carry two bottles of oxygen for them to the top of the Bottleneck and then turn around. The Serbs were using supplementary oxygen—the breathing apparatus was a Russian-made system—and each climber had two

five-kiloliter bottles. But Khan had stopped about 150 feet before the top of the Bottleneck and refused to go on, complaining he could not breathe. Planic insisted he had to continue, but Mandic and Zagorac took the two oxygen bottles the HAP was carrying and divided his backpack between them so he could descend. The Serbs were two HAPs down. That left just Hussein.

Mandic felt the extra weight he was carrying now as he shifted on the rope at the top of the Bottleneck. He and Zagorac had agreed they would change over to the full oxygen bottles somewhere at the top of the gully. If Zagorac ever made it up there. Mandic's friend was stuck below in the line in the Bottleneck.

Why was everything going so slowly? These were not hard slopes. Steep, yes. Fifty, sixty degrees. But no more difficult, really, than the ones the Serbs had scaled on Broad Peak.

It was the altitude that made the climbing tough. This was high, 27,000 feet. They were in an area climbers called the Death Zone, the region at or above about 24,000 or 25,000 feet where the air pressure is much less than at sea level and a lack of oxygen rapidly depletes human muscle strength and mental functioning. Human life can barely be sustained up here. Many climbers dared venture into these altitudes—well into the stratosphere—only with the protection of oxygen tanks in their backpacks and the nozzles of masks fixed over their mouth and nose. Others, like the American and Dutch teams, chose to confront the mountain unaided. They wanted to take on the mountain on its own terms. Otherwise, why do it? Even those climbers like Mandic who used supplementary oxygen were aware they had to be up to the summit and down in just a few hours. They could not delay; there was a ticking clock before their oxygen ran out. The altitude affected some people more than others, but after a short while even the hardiest found it difficult to think more than a few steps ahead. Bodies shut down. You could no longer trust your own mind.

And besides simply being in the Death Zone, you couldn't rely on

the snow up here. Mandic looked at the rough surface beneath his boots. You could see blue ice shining under the snow. If a climber was unprepared, he could slip, easily, and it was a long way down. Probably sensible to go slowly. But then again this delay was ridiculous. The Serbian team had calculated they would be on the summit by 9:30 a.m. That is what Shaheen Baig had told them was possible. Mandic wished Shaheen was still with them.

Mandic checked his watch. It was already 11 a.m. In his down suit, he could hardly stand the warmth of the day. He stared out at the sea of white mountains around him, their slopes striped by brown and black rock and coverings of snow, with trails of clouds spreading between the peaks.

It was so hot, Mandic noticed, that a Norwegian climber called Cecilie Skog, who was standing only a few yards away from him, had taken off her purple jacket. Diminutive and pretty, the Norwegian woman was wearing dark sunglasses, and her long hair curled from beneath her helmet down onto her shoulders. From Norway's western oil coast, the thirty-three-year-old climber had come to K2 with her husband, Rolf Bae, who was not far below in the line on the rope in the gully.

About twenty or thirty feet below the little rock ledge where Mandic was waiting, three climbers finally let their frustration get the better of them and took matters into their own hands. They unclipped from the rope and began free-climbing in a snow channel up the side of the Bottleneck—as if there were no ice to worry about, and no drop below them.

"What the hell's going on?" Wilco van Rooijen called, as he clambered up the side, passing some of the climbers still on the rope. He made it clear to anyone who would listen that he had invested a lot of time and money to get to K2 again, and that he didn't think highly of the expertise of some of the other expeditions.

In his rush, he tried to pass Mandic's colleague Iso Planic. As he

did so, he fell off balance and slipped backward, catching the Serbian's jacket with the sharp crampons on his boot. He was stopped by the arms of a Sherpa standing behind him who grabbed Van Rooijen's jacket around his waist. Open-mouthed, Van Rooijen stared up in shock at Planic, whose coat had been ripped on the left shoulder; the inner lining was coming out. The Serb's skin was also cut.

Mandic noticed the small confusion below and tried to see what was happening. But the next second his attention was diverted away when the line of climbers suddenly began to move ahead across the Traverse.

He saw his chance at last and scrambled across from the rock shelf where he had been standing, then moved up onto the tall ice wall. Then, to his frustration, within a few minutes the line of climbers stopped and he was blocked again by the knot of bodies in front of him.

Looking back, he saw that his friend Planic had climbed up onto the ledge among the waiting crowd. Instead of turning left toward the Traverse, his colleague had climbed over to the opposite side to a free space where it looked like he was going to try to change his oxygen bottle. He had already begun to wrestle the cylinder from his backpack.

Mandic decided that was a good idea; he would escape the crowd and join his friend. But when he turned around, he immediately came face to face with Cecilie Skog. There had been calls for more rope from the Traverse, and Skog, who was carrying a length of rope over her shoulder, was marching toward the Traverse like she meant business. Two thin oxygen pipes looped from her backpack to her nose. She said something about wanting to stash the rope in her backpack while she climbed across.

"I'll help you," Mandic said, mouthing the words through his frozen balaclava and indicating with his hand.

She nodded. *Thank you.*

Mandic unclipped his carabiner from the line so Skog could get

past him. He stepped gingerly behind her while she turned her back to him to offer her rucksack. He pulled his sleeve across his forehead, which was damp from sweat.

As Mandic took another step to pass her, he felt his boot slide on the ice beneath the snow and suddenly his leg flew from under him. He fell forward onto Skog, pushing her down onto the ice, his body slumping heavily on top of hers.

Shouts of alarm filled the air around them. From below, Skog's husband, Rolf Bae, cried, "Hey Cecilie!"

Bundled together on the ice slope, Mandic and Skog began to slide. They were on a steep slope and within a few seconds they would be going too fast to stop themselves. Below them was the three-hundred-foot drop of the hard Bottleneck and its sharp rocks.

Skog fell for about three feet but her harness was still clipped to the rope and it stopped her. Mandic, however, had unclipped. As Skog stopped, he continued to slide, quickly.

Out of the corner of his eye, Pedja Zagorac saw something falling. It shot along the side of the line of climbers and down the gully like a bullet.

Then he heard the yelling, "That's Dren! Dren! Dren!"

He watched as the figure slipped farther down the Bottleneck, turning around and at one point cartwheeling all the way over, head over heels. After about four hundred feet, Mandic slowed and stopped.

Mandic was going to be all right, one of the climbers assured Zagorac; in the Alps, people fell like that all the time. It was no worse than a tumble on a ski slope. A few said they would climb down to help the fallen climber.

But as they were talking, Mandic stood up. Was he waving at them? Zagorac's whole body flushed with relief. Thank God! On the way down, his friend hadn't hit any rocks or anything.

The next moment Mandic seemed to fold over and he slid again. Not so far this time, maybe three hundred feet, but he went down over some rocks and when he stopped he lay on the ice and didn't stand up.

Zagorac strained his eyes to see. Someone on the line shouted, "He's moving! He moved his leg. I saw him."

He could hear people shouting into their radios. *He's moving.*

Zagorac felt himself shouting too, but he wasn't sure what he was saying. He was crying. The Serbians' HAP, Hussein, who was standing near him, was also shouting at the top of his voice. Zagorac wasn't going to waste any more time. The climbers waiting around him moved aside, and he turned to face the mountain and rappelled down, praying under his breath and hoping he was not too late. He focused on breathing steadily and moving his legs fast. *Let me be in time.*

It took him about fifteen minutes, but he eventually reached the end of the second length of fixed rope, where Mandic lay in the snow, his body pointing down the mountain. Panting heavily, Zagorac knelt down beside his friend. He stared at Mandic's gray face. His head was beaten up. There was a lot of blood.

"Dren!"

He couldn't believe that this was what had become of his friend. Zagorac quickly turned Mandic over and gave him mouth-to-mouth. *Oh God. Help me. Help Dren.*

Mandic's skin was warm. Zagorac waited for him to breathe. He put his mouth over the open lips once again. *Come on, Dren.* He pressed his fingers against Mandic's neck, searching for a pulse, but he could feel nothing. As soon as he had seen him, Zagorac had known his friend was dead.

After a few minutes, Hussein and Planic rappelled down to join Zagorac. They all stared blankly at Mandic's body, catching their breath, looking at one another.

What do we do?

They felt sick. They got on the radio to tell Erdeljan the news. Erdeljan knew right away what to do.

"Down now!" His voice crackled on the radio. "The expedition is over! Get down!"

From a backpack, they unfolded some sponsors' flags and a Serbian flag they had intended to take to the summit and laid them over their friend, trying to cover his injuries from view.

Zagorac and Planic knotted a thirty-foot rope to Mandic's safety belt. They were going to get him down and give him a decent burial. It was unusual and dangerous to lower a corpse from a 28,000-foot peak—a first rule of mountain rescue was never allow an injured or dead person to become the cause of multiple casualties. But they were not leaving him there.

Preparing to set off took longer than they had expected. They felt so numb and shaken. They always knew death was a possibility on the mountain, especially on K2. But they never imagined it would happen to them.

Hussein took the backpacks and they stepped down the slope toward Camp Four, Zagorac and Planic carefully letting the rope out before them. It was hard work and they said little.

It was not long before they saw a figure walk out from Camp Four and begin moving toward them over the Shoulder.

Meanwhile, up on the Bottleneck, a single climber in yellow emerged from the people waiting on the ropes and began to climb down. He was a Balti HAP working for the Frenchman, Hugues d'Aubarède. Up close, it looked to some of the climbers on the ropes as though he was slightly disoriented, like he might have had altitude sickness. As the HAP passed the teams on the line, opening and closing the small metal clip of his jumar ascending device, he elicited calls of protest from some who said the jumar should really only be used for climbing up.

He replied tartly that he did it all the time, and carried on awkwardly down the gully toward the group surrounding Mandic.

CHAPTER THREE

11:30 a.m.

S ince the record for climbing the tallest mountain on each of the seven continents had already been claimed, Fredrik Strang had traveled to K2 from Sweden as the first stop in an attempt to climb—and make a documentary about climbing—the *second*-tallest summit on each continent. Up at Camp Four, one of the first things he did, as news of Mandic's fall spread, was set up his video camera and point it toward the Bottleneck. He zoomed in, trying to locate the fallen mountaineer.

A few of the other climbers who rushed out from their tents also felt compelled to capture the moment, including a twenty-three-year-old American from Los Angeles, Nicholas Rice. Nick Rice had turned back from a summit attempt five hours earlier after he spilled melted water on his socks and had never warmed up again, and now he began snapping photographs. Other people held up their digital cameras, peering through the lenses to get a better look.

Swearing in the zero-degree air, Strang interviewed Eric Meyer in front of his video camera.

"People are dying up there and we are doing nothing!" Strang said.

He and Meyer took a break from filming to gaze up the long, slanting avenue of the Shoulder. Mandic had tumbled down the Bottleneck and was lying prone at the bottom tip of an outcrop of rocks.

If he was dead, they knew, they were not going up. But if there was
hope he was still alive, they would try to rescue him.

"Looks grave," said Meyer.

He waited and watched. The doctor's climbing coat was unzipped
and he was chewing gum. He said he thought he could see movement
in Mandic's arms and legs.

A voice came on the radio from up in the Bottleneck. It was Chhir-
ing Dorje, the Sherpa from the Americans' team.

"Yes, Chhiring, this is Eric at Camp Four. What's happened?"

Like Pemba Gyalje in the Dutch expedition, Dorje was in his thir-
ties and an established Sherpa, with his own guiding business back
in Nepal. He had come to K2 as a climber in his own right and more
or less on equal terms with Meyer and the other members of the
American team, although Meyer had loaned him several thousand
dollars to get there.

"One of the Serbs, he fell down," said Dorje over the radio. "His
leg is still moving."

Meyer had the radio pressed to his mouth and communicated the
news to everyone on the frequency. "We can see a lone figure down at
the bottom of the Bottleneck. He is moving, over."

After a few minutes, however, the body appeared still. Voices on
the radio were now saying he was probably dead. But Meyer thought
they could be mistaken since it was possible to miss a pulse if it was
low in these temperatures.

They tried to figure out what they should do. *Should we go up?*
They had already climbed out toward the Bottleneck once today
and they had to think of their own survival at this altitude. Yet on
the other hand, a human being was out there and needed help.

Strang got on the radio again and spoke with climbers still down
at Base Camp whose minds were not as clouded as their own by alti-
tude. He asked them whether a rescue attempt was wise. He was told
they should try to help. *Go fast. Take care.*

They knew it was the right thing to do.

"If he is alive, he won't be ambulatory," Meyer said to Strang.

They packed extra rope, oxygen, tubular nylon webbing, and a mattress pad for a sled to drag Mandic down. They also threw in a flask of warm water with electrolytes, a foil sleeping bag, and some energy bars. Strang packed his smaller lightweight Canon camera. Meyer spent a few extra minutes in his tent getting his medicines together—amphetamines, to help against the altitude, pain pills, suture supplies—so Strang set off first.

He was in good shape and moved fast up the Shoulder, blowing out his cheeks, feeling the cold ripping through his lungs. Some people, when they reach the Shoulder, see the Bottleneck and then the serac and the upper mountain beyond, and say it looks like another mountain stacked on top of the first below. Strang was glad he didn't have to go any higher than the Shoulder to drag the Serb down.

After about half an hour, he noticed the three climbers from the Serbian team who had descended from the Bottleneck. They had already reached their fallen colleague. Strang hoped he would be in time to help the poor guy.

———

It took Strang one and a half hours to ascend from 25,600 feet to 26,600 feet. When he was less than two hundred feet away from the group, he realized they were already dragging the Serb down.

He was breathing hard when he reached them. The two Serbians, Predrag Zagorac and Iso Planic, were holding a rope, which was tied around Mandic's harness, and they were sliding the body down the mountain in front of them, or sometimes behind. Their faces were mostly covered in balaclavas and goggles. Two yards to their left, their Pakistani porter, Hussein, was keeping his distance, unable, it seemed, to look at the corpse.

Strang told the Serbians who he was but they reacted dully. He

also took out his camera to film the scene. When the Serbs looked up questioningly, Strang said he needed the film for the record.

"So we don't repeat this!" he said. "So we learn about human nature." He also wanted to avoid being accused later of doing something wrong. "Everything is recorded now," he said. "Every single word."

The group took a rest, drinking some water and eating the chocolate the Swede gave them. Strang asked what had happened. He knelt down and felt Mandic's cold skin but it was clear the Serbian was dead. A terrible fracture cut across Mandic's skull. He was only half covered.

One of the Serbs said they wanted to take the body at least to Camp Four, and perhaps all the way to Base Camp.

Strang thought he must have misheard him, or that the Serb was delusional. Getting the body to Base Camp would be next to impossible. He would rather have left the body where it was but the Serbs were insistent and he felt sympathy for them. Their friend had died. They were in shock.

"Look, you guys are tired," he said, trying to reason with them. They stood in front of him, while beside them Hussein crouched in the snow. They were on a steep slope and the mountains were beautiful all around them.

"You are on oxygen but I am not," Strang said. "Let's just focus on reaching Camp Four and we can give him a proper burial there. Even that's dangerous."

The two Serbians agreed. Strang took out the pieces of rope and the mat and the nylon webbing and the foil sleeping bag to wrap the body.

He looped the ropes around Mandic's chest. He told the others they could take one end of the rope and he would hold the other. But he warned the Serbs that if there was any sign that Mandic was slipping out of control, they had to release him, unless they wanted to be dragged off the mountain.

"Guys, if you do fall, you release. Okay? It's our lives too. Okay?"

As they had been resting, a figure dressed in yellow had approached

slowly down the slope from the Bottleneck. The Serbs said the lone climber had been following them for some time but that he had stayed about 100 feet behind them. From the way he was dressed—hand-me-down hat and boots, secondhand suit, it seemed—they thought he had to be one of the Pakistani HAPs. When he came up to them, they saw it was Jahan Baig, a thirty-two-year-old HAP, one of three who had been working for Hugues d'Aubarède.

Baig was a farmer, with two sons and one daughter. He was a cousin to Shaheen Baig. He came from the same village, Shimshal, as Shaheen and several of the other HAPs. It was such a small village that Jahan, Shaheen, and d'Aubarède's other porters, Qudrat Ali and Karim Meherban, shared the same grandfather. Qudrat, the most experienced, had started a climbing school in Shimshal, which his cousins had attended. Shimshal was about one hundred miles from K2, close to the Chinese border. Baig had been taken on by d'Aubarède after a Singaporean expedition fired him for refusing to carry equipment up to one of the high camps in bad weather. No Nepalese Sherpas were being asked to climb up, which Baig had said was unfair.

Commercial mountain guiding had less of a tradition in these western flanks of the Himalayas than it did in Nepal, where the Sherpa reputation had grown over the years. But HAPs like Baig and Qudrat Ali were trying hard to develop a local industry and make it pay. It was a chance to make a decent living, and bring in foreign currency, in what was a poor region. Still, the HAPs were generally regarded as inferior to the Sherpas and sometimes there was rivalry between the two groups.

Unlike most of the other HAPs, who often seemed overeager to please their clients, Jahan Baig was less accommodating. He rarely ate with the mountaineers in their tents, though that may have been because his English was poor; he spoke mostly Balti or Urdu.

His job for d'Aubarède had been to carry oxygen cylinders up to the top of the Bottleneck, and once he completed his task, the Frenchman had allowed Baig to climb back down again. He now looked as

though he had altitude sickness. Earlier that morning, even before the teams had left from Camp Four, Baig had complained of feeling sick.

At altitude, as you climb higher into the Death Zone and air pressure diminishes, the amount of oxygen in the air drops. For human beings, the shortage of oxygen results in a condition called hypoxia, which has a range of debilitating symptoms. These include headaches and insomnia, vomiting and stumbling, loss of motor skills and cognitive ability, poor judgment, even hallucinations.

That morning, one of the other HAPs had pointed out that Baig was acting strangely. D'Aubarède, who didn't know his new porter well, noticed nothing out of the ordinary. Then, in the dark tent at Camp Four, Baig announced he had a headache. D'Aubarède gave him aspirin and Diamox, a medicine to combat altitude sickness. Baig said he felt better. But when they were hastily preparing to leave for the summit, he took forty-five minutes to attach his crampons, even with the other HAPs' help. "Why is it taking you so long?" d'Aubarède had demanded, standing above him and becoming increasingly impatient. "Do you even know how to climb?"

Now, as Baig joined the group gathered around the dead Serb on the Shoulder, he stared nervously at Zagorac's jacket, which was blotched with Mandic's blood.

"I am sorry," Baig said, shaking his head. "I haven't come to help."

Zagorac said that was fine. "We're okay. We don't need your help. Thank you."

"I never saw a dead body."

Zagorac shrugged, and the others ignored the Pakistani porter. But just as the group was setting off, Baig stepped forward and said he wanted to help after all.

Strang looked at him suspiciously. "Sure you are okay?"

"I am fine!" Baig said, nodding. He spoke quickly, proudly, as if afraid to admit to a Westerner that anything was wrong.

Strang stood on the right side of Mandic's body. The Swede was a dramatic man, whose self-aggrandizing antics on the slopes with his camera sometimes irritated other climbers. He was a self-declared Indiana Jones fanatic. What he liked about mountaineering was that actions mattered; here in the crucible of the wilderness decisions had consequences. Now he had found a situation where a man had lost his life and the safety of those bringing down his body was still at risk.

There were two ends of rope on either side of Mandic. Zagorac and Planic held the ends on the left side of the body and Strang and Baig held them on the right side. This arrangement left the Serbs' porter, Hussein, free to carry their bags. Strang put a loop in the end of his rope for his ice axe handle and issued precise instructions about taking it slowly, keeping a safe distance between each of them and pulling in a balanced fashion. Their lives depended on the four men working together. They nodded enthusiastically, especially Baig.

The slope was about 30 degrees, although farther ahead it grew less steep on a saddle of ice. This part of the Shoulder was about 650 feet across and on either side it slanted away and ended abruptly over a sheer drop, to the east toward China and to the west.

The crunchy ice crust was like glass and the men took it one measured step at a time. Strang spat out commands, plainly irritating the Serbs. But the Swede was satisfied that everyone was working as a team, staying level so that the body didn't slide to the left or right. Behind Strang, Jahan Baig kept a distance of about sixteen feet, just as Strang had instructed him.

The four climbers were silhouetted against the big blue sky as they edged slowly down the white Shoulder. They slid the body down for thirty feet to test things out, then they stopped to eat some more chocolate. Their system of descent seemed to be working, and they set off again.

After about fifty yards, Strang felt something snag on his boots. It was Baig, who had suddenly come up close.

"You trying to push me off the rope?" Strang shouted, pushing Baig off him forcefully.

"Not my fault!" said Baig, stepping back and beginning to argue.

Strang turned around but there was something strange, he felt, something out of place, in the porter's voice. Before Strang could remonstrate—*Whose fault is it, then?*—an extra weight seemed to fall onto Strang's rope as though Baig were no longer pulling on his rope.

"Get behind me!" Strang shouted.

Without the equal pressure on all of the ropes, Mandic's body began to slide slightly faster and move to the left.

"Stop!" Strang shouted. "Stop!"

The Serbs were pissed off at Baig, too, and they shouted at him, but the porter didn't seem to register any of them. Something was seriously wrong with the HAP, they realized. He had obviously been in worse condition than he had admitted, than he himself had realized. He was trying to do the right thing, but the altitude had gotten to him. Or he was also in shock after Mandic's death, as they all were.

Strang saw that Eric Meyer was now only about sixty yards away down the Shoulder. As soon as he reached them, he thought, his American colleague could take Baig's place on the rope.

Suddenly, however, Strang was jolted forward as Baig tripped in the snow and crashed into the Swede's back. When Strang swung around, Baig was sprawled on the ice.

Strang had had enough. "Get up!" he said. "Get up!"

As Baig began to slide, Strang expected the porter to flip over and stick an ice axe into the ice or do something to stop himself but he remained sliding on his back. The rope he was still holding snagged around Strang's legs and began to pull the Swede over.

"Let go of the rope!" Strang shouted.

The Serbs were now shouting at the HAP as well but Baig merely looked up at them with a bewildered expression.

"Release the rope!" Strang shouted again. He didn't care what happened. He just wanted him to let go. "Release the rope!"

Baig dropped the rope. Within a few seconds, he slipped away ten feet, then eleven. He was sitting down and slid boots first. The ice was slick and he traveled fast. Strang couldn't believe it. Why didn't he stop himself? Why didn't he do something?

"Stop yourself!" cried Strang. *Jesus Christ. Stop. Stop.*

Instead, Baig's crampons caught and he flopped over awkwardly onto his stomach. It seemed he would lose momentum as the saddle evened out. But Baig slid down the slope to the left, shedding his equipment, his oxygen bottle, gloves, and then his rucksack, all the while picking up speed.

The others could see that Baig was heading toward the eastern side of the mountain. At the end of the slope was a well-defined lip. Beyond that, they could see the glacier far below.

Everyone was yelling, urging Baig to stop himself or pull to the right in the direction of Camp Four. Meyer had almost reached them by now and he was standing there, yelling manically, too.

"Turn!" Meyer shouted. "Over there!"

But Baig kept on going. At the edge, he screamed. Then he was gone and silence engulfed them all.

Strang, Zagorac, Planic, and Hussein stood around Mandic's body and stared at the space between the lip of ice and the blue sky where the Pakistani porter had fallen. They were breathing hard, coughing, and trying to work out what had just happened.

They were all dazed. No one wanted to believe that now there had been two deaths on their K2 expedition.

"What the hell is this?" said Strang, weakly, his voice tightening.

He began to shake. He covered his face and started to cry. "One guy died. I came here to help you guys."

When Meyer joined them, they considered going to search for Baig but they realized straightaway it would be suicide. It was a drop of about a thousand feet to the glacier below.

"Let's go down," Meyer said. His voice was tired and resigned.

But he first had a duty as a doctor, and he examined each of the Serbs in turn, peering into their eyes as he asked questions about how they felt. They had been through a lot and he wanted to make sure they were not showing signs of cerebral edema. They nodded. They were barely coherent. He rifled through his backpack and handed everyone a vitamin energy bar, then he lined them up and gave each of the Serbs a four-milligram tablet of dexamethasone, a quick-acting, anti-inflammatory steroid. It would reduce any swelling in the brain and be enough to to get them down.

The Pakistani porter, Hussein, walked out toward the edge of the slope to collect the gloves, rucksack, and other equipment that Baig had dropped. It was dangerous, and if he had slipped he would have disappeared over the edge before the others could have stopped him, but Hussein wanted to collect his friend's belongings and the others let him go.

There seemed no question now that they would leave Mandic's body where it was. Strang tied the rope attached to Mandic's harness to an axe and stabbed the axe securely into the ice. Mandic would stay there forever at 26,000 feet, or until the storms swept him away.

Meyer got on the radio to Base Camp and announced somberly that Baig had died. Then they followed each other in a line down toward Camp Four. The Americans wanted to tie a rope between themselves and the two Serbs but the latter said they could manage on their own. Hussein, however, was uncertain on his feet and so for a while Strang strung a rope between his own harness and that of the HAP.

They reached the tents near the bottom of the Shoulder at about 4 p.m. A number of people were milling around. The South Korean

B team and their two Sherpas had climbed up the Abruzzi and were waiting for evening and their chance to leave for the summit after midnight. There was the Australian climber from the Dutch team and Paul Walters, the Australian from Meyer and Strang's expedition. They wanted to hear what had happened.

Strang was overcome. He threw his rucksack on the ice, knelt in the snow, and cried.

"It's meaningless!" he said.

But then he saw the Serbs sitting down just a few feet away, silent and stony-faced, and he felt ashamed. They had more reason than he did to be upset. When one of the HAPs brought him a cup of warm tea, he waved him away guiltily.

The Serbs trooped off to their tent to make calls on their satellite phone and radio, to talk to Erdeljan in Base Camp; he would telephone Mandic's girlfriend in Subotica. Strang and Meyer debriefed the other teams.

It was still a warm afternoon, warm enough that they could stand outside in their Windbreakers. Up on the mountain, the line of climbers still heading for the summit had moved on and was stretched across the Traverse and up into the diagonal ascent to the summit snowfields. The mountaineers were a line of black dots against the white snow.

Even after the deaths, Strang and Meyer felt a pang of envy and wondered whether they had done the right thing by turning back after all.

Their teammate, Walters, pointed to the distant line of climbers and remarked on what good time they had made.

Meyer shook his head. "They are still going up," he said.

Walters couldn't believe it. He was surprised and disappointed. After fourteen hours of climbing, they were still hours from the top.

In their tent, the two Serbs, Pedja Zagorac and Iso Planic, sat alone. They couldn't rest, couldn't help staring at Zagorac's jacket, stained with Mandic's blood. Their friend was dead. Never again, Zagorac resolved, would he go on such a long expedition, so far from home.

CHAPTER FOUR

At dusk on July 19, 1939, Fritz Wiessner, a thirty-nine-year-old German-born American and a superstar climber of his era, put one hobnailed boot in front of the other to reach 27,500 feet, within three or four hours of K2's summit.

Wiessner was seemingly close to the end of a single-minded quest to become the first mountaineer to conquer the world's second-highest peak and the first to scale any mountain above 26,000 feet.

It would have been a stupefying feat for an American, and a German-American at that, just as most of the world spiraled toward war. It was not to be—it would take another sixteen years before Achille Compagnoni and Lino Lacedelli climbed to the summit. Instead, Wiessner's benighted expedition would come to illustrate the folly of relying too heavily on complicated logistics, including teams of unsupervised porters and Sherpas. It would have echoes in the 2008 expedition, in which, among other things, too many climbers relied on a seemingly foolproof cooperation agreement only to see it fail. Wiessner's expedition ended with four deaths, the first known casualties on K2.

Though night was falling, Wiessner wanted to continue to the summit. He believed he could get to the top, wait for dawn, and return in the morning light. But his climbing partner, a Sherpa called Pasang Lama, was already tense and warned Wiessner that going on at such a late hour risked waking the fury of the mountain gods that he believed inhabited the summit snows.

When Wiessner began a traverse that would have taken him up onto the summit snowfields, the Sherpa refused to play out his rope.

"No, sahib," he said. "Tomorrow."

Reluctantly, Wiessner climbed back down to their tent, which was pitched on the top of a rock pillar at 26,050 feet. He was confident he could make a second try the following morning or at some point over the next few days. Over the course of the previous month and a half, he had established a series of nine well-stocked camps below him. The camps were tended by a team of nine Sherpas and stretched the entire way to Base Camp. This elaborate network, he believed, would ensure he would continue to be well supplied and sheltered. He took the next day off, and as he rested in the sunshine, naked on his sleeping bag in the open tent, he expected a porter to appear at any hour carrying fresh food and supplies.

That did not happen.

Wiessner, a chemist, was born in Dresden and left for the United States in 1929. He was an inspirational climber but also domineering, autocratic, and single-minded—traits common to many of the world's most successful climbers and perhaps especially mountaineers who have been attracted to K2.

His difficult character was one reason why he struggled to gather the best of America's climbing talent, though he was also trying to put together an expedition during years when America was suffering the economic effects of the Depression and few mountaineers were willing to invest money to join. In the end, his indifferent K2 team was selected mainly for having the private wealth to finance the adventure. It included two twenty-year-old Dartmouth undergraduates, along with an independently wealthy, middle-aged New Yorker named Tony Cromwell, and, most curiously, a large, clumsy, but rich playboy called Dudley Wolfe. At the last minute, the American Alpine Club also added Jack Durrance, a twenty-seven-year-old Dartmouth medical student, who was also a powerful and competent climber.

Wolfe was a man who frequently required the help of guides to push or pull him up easy ascents. But despite his apparent lack of ability he was determined and strong and devoted to Wiessner, and he had doggedly managed to follow his leader and Pasang Lama near to the top of K2, until he was stopped by the deep snows covering a bergschrund, or crevasse, at around 25,300 feet. He waited at Camp Eight, below the Shoulder, while the two other men had gone on to Camp Nine for the summit attempt. (The early K2 expeditions had as many as eight or nine camps, but modern attempts have tended to employ an established system of four camps up the main routes as knowledge of the mountain has grown.)

Although Wiessner did not know it, his expedition had begun to fragment and communications between the lower and upper mountain had more or less broken down. Even while Wiessner, Pasang Lama, and Wolfe were waiting up near the summit, some of their disaffected colleagues in Base Camp were preparing to depart for the United States (and the fall semester at Dartmouth). Cromwell, the second in command, was giving orders for the lowest three camps to be dismantled. Ostensibly this was so that the climbers up above would have less to carry when they descended, but the prevailing sense was that they wanted no more part of Wiessner's personal summit quest. They were already thinking of home.

Although the lower camps were being put out of action, the Sherpas were still manning the higher tents. As the days dragged by, however, they heard nothing from Wiessner. When a Sherpa ventured up a few hundred feet past Camp Seven, he called out but received no reply, even though Dudley Wolfe lay asleep inside one of the tents at the camp above him. Seeing no trace of footprints in the storm-blasted snow, the Sherpa concluded that Wiessner, Wolfe, and Pasang Lama had been lost under an avalanche. He retreated down the mountain with the remaining Sherpas, and they gathered up everything they could carry—mattresses and sleeping bags, food, anything worth

salvaging—or threw equipment away in order to avoid carrying it down. The elaborate supply chain Wiessner believed stretched below him was in fact a tenuous line of abandoned or broken tents blowing emptily in the wind.

In their first summit attempt, Wiessner and Pasang Lama had avoided the couloir—the gully that would later become known as the Bottleneck—thinking that it looked too dangerous, and had instead climbed an amazingly difficult route up the broken rocks to the left of the gully, a route that no one would dare try again. For his second attempt, Wiessner was thinking of climbing directly up the Bottleneck. But after waiting two days and with no new supplies having shown up, Wiessner and Pasang Lama descended to Camp Eight. They expected to find either porters or bountiful supplies. Instead they discovered Wolfe, still alone, and with only a few days of rations remaining.

"Those bastards," Wolfe told them. "They never came up here."

He had no matches to light his stove and had been forced to melt snow in the folds of his tent.

The three men roped up together and started down, but Wolfe tripped on the rope, pulling Wiessner off his feet, and the three men began sliding. They were only saved when Wiessner slammed the pick of his axe in the ice just sixty feet short of a 6,000-foot drop onto the Godwin-Austen glacier. It was an amazing rescue. They had, however, lost Wolfe's sleeping bag, and Wiessner had left his at the higher camp. They spent the night beneath a single bag, thinking unkind thoughts of their teammates farther down the mountain.

The next day, Wiessner and Pasang Lama left Wolfe in a tent at Camp Seven and descended rapidly to get help. They found camp after camp deserted until a day later they finally lurched half dead into Base Camp.

A rescue mission was decided upon for Dudley Wolfe. Wiessner was too exhausted to go up himself, and the first rescue attempt

involving Jack Durrance was aborted when one of the Sherpas fell sick. Five days later, three brave Sherpas—Pasang Kikuli, Pasang Kitar, and Phinsoo—reached Wolfe at Camp Seven. They found him barely sensible and lying in his own excrement. He had been above 21,500 feet for forty days. They managed to get him outside his tent and gave him tea but he refused to descend with them and they felt they could not challenge him.

The three Sherpas retreated to a lower camp, vowing to return the following day. Delayed by a storm, they climbed back but neither they nor Wolfe were ever seen again.

Fourteen years later, after the interruption of World War II and the partition of India, another American team would become the first expedition to venture up the slopes since Wiessner's fateful quest. At the site of Wiessner's camps, they discovered torn tents, three neatly rolled sleeping bags, and Ovaltine, along with a stove, fuel, and a bundle of Darjeeling tea wrapped in a blue handkerchief, some of them the poignant remains of the Sherpas' last effort to save Wolfe.

CHAPTER FIVE

1 p.m.

The nineteen climbers in the tightly pressed line beneath the serac had spent an uneasy few minutes considering whether they should go on in the wake of Dren Mandic's fall.

Below them, the Serbs were distant specks dragging Mandic back toward the Shoulder. The Americans were climbing out from Camp Four. What more could *they* be expected to do? If they descended, they were only going to get in the way of the rescue operation.

Some thought Mandic was still alive. And if he was dead—well, they were used to death. Every one of them had good friends who had been killed in the mountains.

Among them, an Italian climber named Marco Confortola was determined to continue on. The determination seemed to shine in the thirty-seven-year-old professional mountain guide's sharp triangular face, in his brown eyes.

Confortola had grown up in Santa Caterina Valfurva, a ski resort town three and a half hours north of Milan in Lombardy, on the Swiss border; he came from the same valley as his hero Achille Compagnoni, and naturally Confortola had chosen to climb up on the Abruzzi route. Strong as an ox and flamboyant, he had come to K2 to burnish his professional curriculum vitae, but he also wanted to conquer the peak again for Italy. He said he wanted to "bring it back" to his valley.

Before coming to K2, Confortola had worked at a meteorological

station on Mount Everest for fifty days. He had flown back to Milan and spent a week in Valfurva before hopping on another flight to Islamabad. From Askole, he had trekked to Base Camp with a team of eighty porters and their chickens and other supplies.

The ascent from Base Camp had been tougher than he had anticipated. His boots had gotten wet. His HAP had forgotten some of the rope Confortola was expected to supply as part of the cooperation agreement. But still, now, in the group on the ropes beneath the serac, he was determined to go on.

Some of the other climbers shifted uneasily on the lines. The Sherpa in the Dutch team, Pemba Gyalje, said Mandic's fall was bad karma. For him, as for Dorje, the American team's Sherpa, reaching the summit of K2 was going to be a significant marketing coup for his business—these two commercial rivals wanted to beat the other to the top. But the teams were late and Gyalje said he was prepared to turn back if anyone else wanted to.

When he saw the others still looking pensive, Confortola said they had to decide quickly whether to continue higher or go down, but they couldn't simply stand waiting beneath the serac.

As the line turned away up into the Traverse, those who heard him felt a little bit stupid to have harbored any doubts in the first place.

They arrived now at what in some ways was the most challenging part of the day's ascent. The Traverse was a band of steep ice and snow at a slope of between 50 and 70 degrees. It cut directly and horizontally to the left for 200 feet and then, after it, the route rose diagonally for a further 400 feet on a less steep slope of between 35 and 50 degrees covered with deeper snow. As the climbers stared up at the Traverse, they could see that the ice itself was hard and shiny, and when they touched it, it seemed almost alive under their gloves.

The serac hung above, while down to their left were humps of brown rocks, past which was nothing but thin air and, nearly two miles away, the lower gullies and buttresses of K2.

To go across the Traverse, the teams clipped on to the rope with the carabiners on their belts and heaved themselves along the face. The looping rope was secured into the ice at intervals by ice screws. There was the occasional place to rest, a jutting rock or ice lip to lean against. But when the line of climbers was moving, the mountaineers chopped in their ice axes, kicked in the front points of their crampons, and stepped—axe, crampons, step—their breathing coming hard. As they shuffled along, they avoided staring up at the serac directly above or the tiny lines of the Godwin-Austen glacier 10,500 feet below.

By this point, some of them had been climbing nonstop for nearly twenty-four hours, except for the few hours' rest at Camp Four. The midday sun was high in the sky. The Traverse was exposed, and though they had gauged their clothing carefully to avoid overheating and dehydrating—dehydration meant they would need water, and they had left their burners behind at Camp Four—they were dripping with perspiration inside their jackets.

Yet though they were hot and tired, they couldn't dwell on their problems for long. The view was just too beautiful. It made everything right. To their left were the heads of mountains, shining in the sun or wreathed in little trains of cloud. The world was on a gigantic scale. They could see the curving line of the earth's horizon. *They were on K2.*

This view, this feeling, this achievement is what they had come for. Despite the nagging anxiety about how long things were taking and the frustrations caused by the crowd, the climbers felt a sort of inner transcendence, an inner peace. When space opened up on the rope and they could start marching up and across the ice wall, they felt truly alive. The summit was a few hours above them. Now at last, after weeks, months, years of preparation and toil, they were closing in.

About one hundred feet across the Traverse, the line stopped again. Up at the front, four climbers from the South Korean team

converged in pairs to change their oxygen tanks. Helping one another to unbuckle the empty cylinders, they started to refix full ones.

With fifteen members, the South Korean expedition was the largest on the mountain this year. Its proper title was the "Korean Flying Jump" team and its tents, national flag, and sponsor flags had dominated Base Camp.

It was divided into two teams—an A and a B team—and they were in the process of trying to bag all fourteen of the world's 26,000-foot peaks. The expedition was led by a prickly, ambitious mountaineer named Kim Jae-soo and his star woman climber, Go Mi-sun. The forty-eight-year-old Kim was president of a company called Power Heat, which manufactured heated mattresses and insoles for shoes.

There was no doubt a distinction between the Korean and the Western—American and European—teams. In the modern mountaineering age, the Western expeditions no longer climbed for their country—that belonged to a different, old-fashioned era. Their teams were sometimes organized along national lines but more than ever they were a loose multinational collection of friends.

But for the South Koreans the idea of bearing a national responsibility in these mountains resonated. They recognized a broader cultural mandate, and success was essential. Failure was to be avoided as humiliating.

They generally climbed in bigger groups than the Europeans and Americans and, certainly in the eyes of the other expeditions, they were more aggressive and took greater risks. Mr. Kim had told some of the other climbers his departure date for leaving K2 was whenever he climbed it.

He was a man who believed in protocol and the superiority of his climbers. Go had earlier moved swiftly and easily up the rocks beside the Bottleneck, shadowed by Kim like a bodyguard. But some of the other Flying Jump climbers were struggling in the Traverse.

The painstaking maneuver with the oxygen bottles caused another

backup down the rope. The climbers waiting behind found places to perch and catch their breath. They expected the Koreans would resume climbing any moment, but it was as if they were moving in slow motion. The minutes dragged.

Eventually the South Koreans hung the empty orange oxygen bottles on an ice screw and moved on up. The other teams climbed past the bottles, which dangled delicately and precariously on the side of the mountain.

They were climbing once more but it was still slow going, and the delay allowed resentments to simmer, repeating the frictions that had arisen during the months at Base Camp. The truth was that climbing attracted strong characters, egos, oddballs, and they rubbed up against one another. Some of the climbers cursed the tardiness of other foreign expeditions. Outwardly they had respect for each other but in truth each considered the others slightly ridiculous—inferior, unprofessional, ignorant of the kind of monster K2 could be.

Now, they cursed the state of the ice screws, or the condition of the rope or the way it had been tied. Some in the big groups resented the small teams for parachuting in at the last moment on their weeks of preparations, while some in the smaller independent teams resented the space the larger expeditions occupied on the mountain and the way they had tried to dominate the slopes.

Some had brought only one ice axe, rather than the usual two, because they knew the fixed ropes would be in place to help them descend. This practice earned the scorn of other climbers, who believed two axes were essential, not least because you might drop one.

Those climbing without the help of supplementary oxygen quietly looked down on those who were relying on it; and the teams that climbed alone without Sherpas or HAPs believed they were purer climbers than those who were paying thousands of dollars for help. The HAPs could have a bad day. The oxygen could run out. A person who relied on aides like that, some thought, should not be tackling K2.

As they continued to wait, most of the climbers on the Traverse realized that the cooperation agreement, which had filled everyone with hope about teamwork and sharing, had in reality reduced them to the lowest common denominator. The ones waiting behind could pass the slower climbers but the ice made it dangerous. If one person stopped for a drink, or to adjust a backpack, they all stopped. Yet despite these misgivings, a kind of groupthink had set in. They continued anyway—because everyone else was still going on. They resented the other teams and at the same time felt protection in numbers. There was a manifest lack of leadership, no one to tell them to go back.

Rolf Bae had been more shaken than Cecilie Skog by her collision with Dren Mandic when the Serb fell.

The fair-skinned, red-bearded Bae was a good rock climber and experienced polar explorer. Yet, today on the Traverse, for all of his prowess, he was having a difficult time. Sweat glistened on his red beard and he looked pained.

"Not a good day for me," he said to the others around him on the line, wincing. "I am having problems."

Like his wife, he was breathing supplementary oxygen. The thin pipes from a new British-made system—it released oxygen on demand rather than piping it constantly—curled like transparent straws around the side of his face to his nose.

He had spent the early summer rock climbing on Great Trango Tower, a 20,618-foot spire of rock about twenty miles down the Baltoro glacier from K2, and so he had arrived at Base Camp a few weeks after Skog. Maybe Trango had taken it out of him or maybe he hadn't given himself enough time to get used to the height on K2, though Skog knew he was never really comfortable at extreme altitudes.

He and Skog had tried to summit K2 once before, in 2005 on the

Cesen route, but they had turned back, and they were eager this time to reach the top. Still, Bae said he was thinking of turning around, although he would try to go as far as he could with Skog.

The two climbers had been husband and wife for little over a year. They had met in Russia in 2003 after an expedition to Mount Elbrus. She had trained as a nurse and guide and Bae was working as a professional guide. He was a well-traveled man. He had lived in the United States; when he was seventeen, he had spent a year in Amherst, Massachusetts, living with a local family and studying. Between 1999 and 2001, he had spent seventeen months in the Antarctic in a naval base on Queen Maud Land.

Skog had soon learned that this was the sort of thing Rolf Bae did. He was also a serious bird-watcher; he knew the Latin names and most springs took the train to northern Norway on special bird-watching trips. When they were on an expedition, he loved to sing Bob Dylan songs as he walked along the trail. In the camp at night, he sat and played his guitar or his harmonica.

A week after they had got to know each other, Skog and Bae flew to the Himalayas and spent three months climbing in Tibet and Nepal. When they returned to Norway, they moved in together and started their own travel company, Fram Expeditions, named after the ship that took Norwegian explorers to the Arctic and Antarctic in the late nineteenth and early twentieth centuries. They began a life of guiding, writing books, and giving talks about their expeditions in the wilderness. It was a wonderful way of making a living, doing what they loved. They had a little apartment in Stavanger but they were rarely at home. In 2005, they traveled together to the South Pole. In 2006, they reached the North Pole.

Skog, dubbed the Polar Princess in the European media, had become the first woman to stand at both poles and on the tallest peaks of every continent, including Everest. She had wanted the achievement of climbing Everest; Rolf hated the crowds on Everest these

days and had chosen not to go with her. Their fame at home in Norway was just taking off, Cecilie's especially.

———————

Ahead of Bae and Skog on the line, the dark-haired Frenchman Hugues d'Aubarède crouched on an ice ledge beside his Pakistani HAP, Karim Meherban. Both men were concerned about d'Aubarède's condition.

D'Aubarède, who was wearing a dark yellow climbing suit, was getting tired. The sixty-one-year-old was a stubborn, proud, noble man, neat and cultured, and he had invested a lot in his expedition to get to K2. He had left behind his partner, two daughters, and a grandchild in France to pursue his dream in the Himalayas. It was his third attempt to reach the summit of K2, and he thought it would probably be his last try. He was not the oldest to climb on K2, but he was close—a sixty-five-year-old Spaniard had summitted in 2004.

It had been a long climb up from Base Camp. When the storm hit around the night of July 29, some of the other expeditions had waited at an intermediate camp, forcing d'Aubarède to wait, too. He had used up valuable energy, food, and also gas for melting snow for water. The wind had whistled up inside his glasses, the slopes too steep even to stop to put on his goggles. He had had to wade through snow that drifted around his knees, by carving a corridor with his hands.

But then finally, at Camp Four, after the long ascent up the Cesen, he had climbed onto a flat space on the Shoulder on the afternoon of July 31, pitched his tent, and gazed down on the gallery of peaks around him. Taking out his satellite phone, he had sent a text message to his family in Lyon. He had been keeping a blog of his days on the mountain so that all his friends could follow his progress.

"I wish everyone could contemplate this ocean of mountains and glaciers," he had written, impressed by the beauty of what lay below him. "I drooled it was so beautiful. The night will be long but beautiful."

In the twenty-four hours since then, however, things had gone less well. D'Aubarède was feeling the effects of the altitude and heat. He told the climbers who passed him that, like Bae, he was also thinking of going down.

"My oxygen bottle has run out," he said, shaking his head sadly.

Farther along the rope, the Dutch expedition was making better progress. For Wilco van Rooijen, climbing was an obsession. When he first met the woman who would become his wife, Heleen, he told her his ambition was to climb Everest without using supplementary oxygen, a feat he considered one of the most difficult in the sport.

She replied that she would never marry him while he was trying to do it, or have his children.

In 2004, when Van Rooijen finally sat on the summit of Everest, he called Heleen on his satellite phone—"Will you marry me now?"—and they wed the following year. But as soon as their honeymoon was over, he began to dream of the next challenge, which was K2. Just seven months before he left for Pakistan in 2008, his son Teun had been born.

Van Rooijen complained there was never enough money in the Netherlands for mountaineering. Not the sponsorship available for football players or skaters or sailors. But he was sponsored in the Netherlands by Bad Boys, a Dutch clothing line, and for K2 he managed to raise money from Norit. The company manufactured water purification systems, and so the K2 expedition adopted the slogan "In Search of the Source of Clean Drinking Water," the source in question being the pure water glacier on top of K2. From North Face he got tents and sleeping bags; from Canon the team received high-definition cameras.

Van Rooijen tried to climb K2 in 2006 but had turned back in storms. However, there he had met a an Irishman named Gerard Mc-

Donnell, who worked as an engineer in Alaska, and the two men vowed to return with an expedition this year that would be assured of success.

While Van Rooijen had focused on the financing, the thirty-seven-year-old McDonnell had assembled more of the equipment for the mountain from his home in Anchorage. The Irishman hailed from a dairy farm in County Limerick, southwest Ireland, but in 1994 he had won a visa for the United States and moved to Baltimore. After trying to settle for three years, he took a motorcycle trip across the country to Alaska and liked what he saw. He realized he could be near wild places and the mountains. He found a job as an electronic engineer in the Alaskan oil industry on the North Slope. He made a new life, met a girl, Annie, and played the bodhran, the Irish drum, in an Irish band, Last Night's Fun. One day, he said, he would return to Ireland. He dreamed of starting a mussel farm in County Kerry. After the big Himalayan climbs he went back home. His family was waiting for him now, in the green fields beneath the gray skies: Margaret, or Gertie, his mother; his three sisters, Martha, Stephanie, Denise; his brother, J.J.

He had visited Ireland after he conquered Everest. He was treated like a hero and later met the Irish president. When he drove into Kilcornan and stopped near the church, hundreds of well-wishers greeted him. He had walked along the main road, accompanied by the parade and a bagpiper, past the shrine to the Virgin Mary, to the Kilcornan school and community hall where McDonnell gave a speech and everyone tried to understand why their Ger was so intent on leaving them to climb into the clouds. He didn't climb to be famous. He normally preferred not to talk much about what he achieved in the mountains. But later, at a big hurling game in Munster, the announcer declared on the loudspeaker that Ireland's climbing hero was in the stadium and thirty thousand people applauded.

His father, Denis, had died when McDonnell was twenty. McDonnell had told his mother that his father was one of the reasons he

climbed to the top of the world's tallest mountains. On the summit of Everest in 2003, he ran his father's rosary beads through his fingers, and later he said, "I felt close to my dad up there." At 26,000 feet, below the peak on Everest's South Col, he took out a *sliotar*, or Irish hurling ball, and pucked it from the mountain with a hurley.

On K2, he had taught Van Rooijen and the other climbers in the Dutch team some Irish sayings, such as "Tiocfaidh Ar La," which was pronounced as "Chukky Are Law," an old Irish Republican Army phrase meaning "Our day will come." Climbing the slopes, Cas van de Gevel and Wilco van Rooijen shouted it back at him in fun.

From Alaska, communicating with Van Rooijen by email and Skype, McDonnell had found a special 5mm white, lightweight rope for K2. It was stronger and lighter than the so-called plastic 10mm or 11mm ropes that expeditions usually picked up in Pakistan or Nepal. Its white color meant it reflected sunlight and so was less likely to melt grooves in the ice. He also found himself a strong helmet. In 2006, he had fractured his shull in a serious rockfall on K2, just above Camp One, and after descending was airlifted off the mountain.

As they put together the other members of the team, McDonnell insisted on including Pemba Gyalje, the trusted Sherpa he had climbed with on Everest, an erudite, traveled Nepalese. Van Rooijen advertised in the Dutch climbing press and circulated an email to Dutch Alpine climbers, and recruited two young mountaineers in their twenties: Roeland van Oss and Jelle Staleman, a former Dutch marine. They were the *jonge honde*, or young dogs, of the expedition.

They also included Cas van de Gevel, a tall forty-two-year-old mountaineer from Utrecht. He had made many expeditions with his friend Van Rooijen but he had never climbed above 26,000 feet before.

Years earlier, after university, Van Rooijen and Van de Gevel had started out in business together, mainly fixing up houses. Van de Gevel was a carpenter, Van Rooijen an electrician. They earned enough money to take off regularly together to the Alps in Cas's

Citroën 2CV or Van Rooijen's Volkswagen. One day, Van Rooijen found himself beneath the floorboards and realized he couldn't do that sort of work any longer; he began a career as a professional mountaineer, courting sponsors and the media, showing slides, giving talks to companies about mountaineering as a metaphor for business leadership and teamwork, and eventually writing books. But carpentry was enough for Van de Gevel—it paid for his trips to the mountains and for a monthly visit to his girlfriend in southern Spain.

Van de Gevel, McDonnell, Van Rooijen, and the rest of the Dutch team had enjoyed the weeks in Base Camp in the big strip of tents on the rocks. The cooks ran down to the right over the mangled ice of the glacier to fetch water for the kitchen. The toilet tents dotted the rocks to the left, closer to the mountain. The climbers hung clotheslines between the tents. Their camp was a few yards away from an independent Serb climber who had mounted a goat's head on a pole outside his doorway and a sign that read, "Come Please Slowly Slowly Inside."

Van de Gevel liked the simplicity of the work, the up and down, the carrying and making camps. Life was straightforward. There were eight climbers in the Dutch expedition, as well as their three Pakistani cooks. They were divided roughly into two teams, alternating the working days so there was always one team on the slopes. Learning how to "sniff" the route: That was how Van de Gevel thought of it. If it was your day on, you woke up early and worked on the mountain. On your rest day, you got up later, drank coffee, had a laugh with Gerard McDonnell, and gazed through your binoculars to see the progress the other men were making.

Such a life gave the Dutchman a lot of satisfaction. Their team worked well, he thought. There was pride in their efficiency, even if sometimes that pride turned into a sense of superiority over the other teams, which they did not always try to conceal. Occasionally, he admitted, there was niggling between the expeditions of the "you-are-

doing-less-than-me" variety, and also within the Dutch team itself. But that was part of mountain life. Van Rooijen expected a lot of his climbers and he made the rules. Van de Gevel was content to leave the organization to his friend. If he, Cas, had been in charge, he knew, things would start to fall apart. He just wanted to climb.

During the bad weather, the Dutch teammates had crammed together in the mess tent to watch DVDs. And they had Isostar protein powder to keep Jelle bulked up; you simply added water for a protein shake. Olives, anchovies, or peanut butter on crackers for Van Rooijen. They taught the cooks how to fry hamburgers, and the cooks also made a tasty pancake mix. They had the dried food you simply stirred with boiling water, such as chili con carne or chocolate mousse. These actually didn't taste too bad. Up in the higher camps, they had soups and sausages.

Then there was the yak, bought for fifty-five thousand rupees in Askole and herded by the Balti porters up the dusty tracks past the great rock at Korophone, past Julah and Paiju and over the blasted glacier below Urdukas. The animal came unwillingly, tugging at its rope. When the expedition tired of dal or chicken and hungered for red meat, the porters bound its legs one day and, as it lay on the ice, they slit its throat.

The blade was blunt, and it took several minutes to hack through the skin. The climbers who had gathered around to watch the ceremony cringed. One of them, Rolf Bae, offered his own knife but the Sherpas warned that no man should give away his knife unless he wants to invite bad luck. Spilling the blood of an animal in such a fashion was disrespectful to the mountain, the Sherpas said; instead they should butcher the yaks and goats at a lower altitude, farther down the glacier, and carry the meat up for the climbers. In the end, the yak bled to death and was skinned and its head was mounted on the rocks outside the cook's tent.

The Dutch expedition was well organized and ambitious and when

one of the *jonge honde*, Roeland van Oss, collapsed from carbon monoxide poisoning while he was using a burner in a tent at Camp Two and had to be helped down, there was no question that they would stay. The weeks of preparation were not all smooth going, however. Van Rooijen was a master organizer but he was not a very beloved leader. He was ambitious, competitive, demanding, and dismissive of others. His abrasiveness and self-focus had seemed to intensify the higher he climbed on the mountain. Some of the other members might be useful to Van Rooijen for ferrying supplies up the routes, but he did not hesitate to rule them out of the final summit group when he thought including them jeopardized his plans. This caused frictions, and even upset his friend McDonnell.

One day in Base Camp, Van Rooijen had clashed with Hugues d'Aubarède, marching into the Frenchman's tent to demand that he lend his two HAPs to the Dutch team to carry and fix ropes all the way to Camp Four. "There is good weather and we are going to go for the summit," Van Rooijen had said, determinedly.

D'Aubarède had declined, insisting that the porters were not used to the altitude yet and that in any case he needed them for himself. Van Rooijen felt the porters were not doing their share of work but d'Aubarède resented Van Rooijen's presumption that he could just use other people's HAPs. The Dutchman had already charged d'Aubarède and Nick Rice five hundred dollars each for using the ropes the Dutch team had fixed on the route.

"We will carry the ropes up when we are ready," d'Aubarède said. "We need to conserve their energy for our summit bid."

Afterward, d'Aubarède felt that Van Rooijen ignored him on purpose sometimes when they passed on the route and he feared he held a grudge.

While Van Rooijen possessed qualities that didn't endear him to everyone, most of his teammates accepted that those were probably what it took to be a great climber. As part of his effort to ensure the

expedition's success, Van Rooijen had hired a support team back in the Netherlands, including a doctor, webmaster, press spokesman, and a high-end weather forecaster. He wanted good forecasting to avoid a scenario such as the notorious series of disasters on K2 in 1986, when thirteen people died from storms and avalanches over the course of the summer, and again in 1995, when another seven climbers were killed on K2 in a single storm.

The webmaster back in Utrecht, Maarten van Eck, had been posting regular updates about the team's progress on the Dutch team's website. The site had become the main source for news about what was happening on K2 this year and was being watched by the families of many of the climbers around the world, especially today, the summit day.

Now, from the Traverse, the Dutch team radioed down to Base Camp, and news of their progress was communicated back to the Netherlands. Within a few minutes, the latest update went live on Van Eck's website.

"Gooooooood Morning Netherlands!" Van Eck wrote. "Wilco, Cas, Gerard and Pemba are way above the Bottleneck and in the Traverse."

CHAPTER SIX

3 p.m.

From where they were standing, the climbers still could not spy the summit. At the end of the Traverse, the great ice face curved up to the right beneath the western edge of the serac, and then the route cut back on itself in a diagonal onto the top of the final summit snowfields.

From this position, they could hear a voice calling out from above around the edge of the glacier, urging them to hurry. They realized it was Alberto Zerain, the lone Basque climber, who had earlier climbed ahead of everyone up the Bottleneck. He had fixed the rope across most of the Traverse but had then gone on. He had rounded the curve after the Traverse and was now waiting out of sight.

"Come on!" he cried. They heard the frustration in his voice. "Come quickly! Watch for those ice screws. No good."

After a while, Zerain's voice fell quiet. The South Koreans at the front now fixed the remainder of the rope up the ice slope. They took a long time, forcing the climbers behind them to wait again patiently. The route was less steep and covered with deeper snow than farther down the Traverse—and some of the climbers eyed it warily. A massive slab of snow had unloosed from this section of K2 just two years earlier, crushing four Russians.

As they waited, the climbers drank deep drafts of water from bottles they were carrying up. Some had brought flasks of warm tea, which was even better. Keeping their bodies well hydrated was essential in the

mountains—they lost a lot of water through exertion and stress—not least because it helped combat the symptoms of high altitude. The Sherpa in the American team, Chhiring Dorje, shared a sausage—warm from an inside pocket next to his chest—with Pemba Gyalje.

As they waited, a few felt disquiet at the time that was passing but no one was concerned enough to turn around—even though their bodies were deteriorating with each minute from the effects of altitude, dehydration, and exhaustion, the day was moving on, and the oxygen tanks were running low

Gerard McDonnell used the downtime to tell Rolf Bae and a couple of the others about his accident on the mountain in 2006, when the rockfall punched a gash in his skull and he was flown by helicopter to the military hospital in Skardu. He had undergone emergency treatment in a dirty operating room without anesthetic, he said. A cruel hospital official had taunted him, asking, "Where are your friends now?"

McDonnell, Bae, and the others talked about the chances of the good weather holding and whether they still had time to make the summit.

McDonnell spoke of the delight they would feel when they finally climbed up onto the summit snowfields. "Just wait until you're up there and you can see the top," he said, speaking with some relish. "Then it'll look like it's reachable. No problem." He added: "You will want to go for it."

The ropes were gradually fixed and the line of climbers moved higher, but a final vertical ice wall proved too much for some of the Koreans up at the front. Two of the Korean climbers pawed at the ice, thrashing ice flakes into the air, unable to find any purchase with their crampons.

The Koreans' two Sherpas did their best to lift the climbers up, issuing frantic instructions. They were two of the four less experienced Sherpas on the mountain. These four Sherpas were all drawn from the same poor region in northern Nepal. In contrast to Pemba Gyalje and Chhiring Dorje, they had only started out in the guiding business in the last few years and were trying to establish themselves.

One of them, Jumik Bhote, a tall, smooth-faced man, had recently been promoted to the position of lead Sherpa for the South Korean team, a big achievement, though it had put him on a busy schedule. He had climbed with the Flying Jump team on Lhotse, the fourth-highest mountain on earth, that spring, then returned to Kathmandu for only a few days before he had flown back out to K2, leaving his partner at home, even though she was expecting their first baby any day. His younger brother, Chhiring Bhote, was also on the expedition to K2. Chhiring was somewhere down the mountain with his clients in the Flying Jump B team, which was due to set off for the summit from Camp Four later that night.

The climbers behind could have passed but the two Sherpas were working so diligently that they waited politely, and anyway it was easier to wait for the Sherpas to fix the ropes. One of the Koreans was trying to scale the bank with only one ice axe and he kept slipping back, so Wilco van Rooijen loaned him his axe.

Some of the climbers were again raising doubts about continuing. Marco Confortola assured them that if everyone worked together, and shared the task of breaking the trail, they would reach the summit. "Compagnoni and Lacedelli got to the top in 1954 at six p.m.!" he said in his halting English, as he pointed up toward the summit. "And they came down okay. If they could do it then, so can we."

At last, Bhote hung a rope down from the ice wall, and the two climbers dragged themselves up with a shout. Finally everyone on the line could see a way forward. Forgetting their frustrations, they surged over the top of the serac and into the summit snowfields. From here, for the remaining three or four hours to the top, there was no need for any more fixed lines. They passed the last anchor and unclipped from the rope, feeling free.

For the first time, they could see the final summit ridge, although the actual summit was still not visible. It was what they had waited for and it was a wonderful sight.

Sometimes the jet stream blasted the top of K2, creating a furious white summit plume, but today the top was clear. At the end of the long summit snowfield, it rose up in a hump against the blue sky. The climbers began to move up toward it in a line. Soon the first climbers appeared to those following behind as dots on the plane of white.

Breaths of snow swept across the snowfields, on this, the upper mountain. On this section, the climbing was less steep, the slope about 30 degrees. The snow was deep, however, and some of the climbers were worried about avalanches, or crevasses. They were on top of the hanging glacier and as it inched forward it left yawning gaps behind it. A few of the climbers were carrying ski poles, just like snow sticks, and they reached forward with them and prodded the snow. The area was deadly—a French couple, Liliane and Maurice Barrard, had disappeared somewhere between here and the bottom of the Bottleneck after reaching the summit in 1986.

At this point, they discovered that Alberto Zerain's patience had run out and he had gone on ahead. The sight of the summit, however, gave many of them fresh encouragement. Despite his exhaustion and empty oxygen cylinder, Hugues d'Aubarède decided to continue. He slogged away toward the distant peak beside Karim Meherban.

Wilco van Rooijen climbed onto the snowfield and rested for a while to let his colleagues in the Dutch team catch up. He was tired but he urged them onward.

"Let's go!" he cried. "Let's not hesitate now!"

Rolf Bae, however, had emerged from the Traverse shaking his head. He felt no better.

Whenever he led an expedition, Bae had three iron rules the team had to follow. One: Get home. Two: Stay friends. Three: Reach your goal. In that order. Today, it just wasn't working for him. If he was going to get home, he had to stop there.

"I am not going to the top," he told Skog reluctantly.

"Are you sure?" Skog was worried about him.

He nodded. Skog saw it was a brave decision. He had come a long way to get this far but he could not go on. Rather than descend immediately, though, he said he would wait for Skog and meet her when she came back down. He wasn't going to leave her. He intended to climb a little higher before stopping.

Having made up his mind, Bae bid farewell to Gerard McDonnell. The two men had become good friends a couple of years earlier on an expedition to South Georgia.

"It's been nice climbing with you today, mate!" Bae called. There was disappointment but also certainty in his voice as he watched the others go on.

Skog was already climbing ahead and he waved to her. His oxygen tank had nearly run out, so Skog dropped hers in the snow by the side of the route for him to collect as he climbed up. She could go on without oxygen. And then she waved to him one last time and was gone. For his part, Bae took a spare headlamp from inside his jacket and asked a Sherpa to give it to Skog at the summit. Just in case she needed it on the way down.

———————

Alberto Zerain had pushed on ahead, and now he sat at the summit of K2 staring at his wristwatch. The watch was his father's, a gold-faced Zodiac. He had made perfect time, but the climbers below him were late.

Zerain was forty-six years old but he looked younger. He had short black hair and his suntanned skin showed off his fine cheekbones. He came from Subijano, a land of rocky hills, pine trees, and yellow stone houses on the southern edge of Basque country in northern Spain. He gazed down the length of the snowfields toward the distant lip of the diagonal that led down to the Traverse. Surely, he thought, the others would emerge soon. When they did, what would they see? A man in red crouched on the edge of a snowy ridge, sipping tea.

Back down the mountain, he had waited for two hours at the end

of the Traverse. He had had to wait. When he began to climb across the ice face, he had handed his camera to one of the Sherpas—he wasn't sure of his name—so that the man could take a picture of Zerain opening the trail on the Traverse. He was the first person to cross it this year. But the Sherpa hadn't followed him across straightaway, and so Zerain had to wait. He felt he could not go to the summit without it; these days, sponsors wanted proof you had actually been to the top. He also didn't want to lose the camera. It was an Olympus, and he had bought it in Skardu on the journey in.

Eventually his patience ran out, and he had stood up and gone down a little way to look along the Traverse. The scene shocked him.

Earlier, Zerain had fixed the rope along the Traverse. On the way up, at the top of the Bottleneck, another one of the Sherpas had brought the length of rope to him, and though Zerain had thought it looked old, not fit to tie his shoes with, he had fixed it up along the ice face anyway.

He knew there had been meetings down in Base Camp but he had kept away from them so he knew nothing of what they had decided.

He also had three screws, though for a while he thought he had lost the third screw, and at one point he had had to dangle from his ice axe until he managed to find it in his backpack.

Now five people were bunched together on a single section of that old rope, edging slowly up and across in the bright sunshine, all their weight on the same screws he himself had rammed in. The Sherpa to whom Zerain had given his camera was back down in the line.

Fine, he thought. *No camera*.

By that time, it was 11 a.m., and Zerain had turned and climbed up onto the snowfields. At last he could see how far he had to go to the summit. Reaching it was possible, he told himself, nodding, psyching himself up. He was feeling good but he had to tell himself this. He felt a burning inside, the *gusanillo*, the passion to go on. It looked so close.

He was barrel-chested, with a confident, strutting gait. When he

walked, his arms swung at his sides, and he gave the impression he could walk forever. He ran mountain marathons in the Basque hills. He had climbed in the Alps and in the Andes, where he met his wife, Patricia, a translator. He had been to the Himalayas. He had raised two sons; now that they were both nearly teenagers he could travel the world and climb again. But climbing was only part of his life, and not the most important thing.

He was attracted to K2 because of its shape, a beautiful pyramid. You could fit sixty Matterhorns in it. And he was attracted because of its dangers; only the most extraordinary climbers dared to challenge it.

He had arrived in the Himalayas in June with a team sponsored by, among others, Marqués de Riscal, the Basque wine company. He had intended to climb Broad Peak, a nearby mountain, first but two friends were airlifted out and Zerain also got headaches near the top. He knew when a mountain didn't want him—he had an inner voice that told him when to go up and when to go down—so he decided to switch to K2, an hour's walk along the glacier.

Alone among the other teams, he gravitated to the Pakistani HAPs in the Serbian expedition, who made him welcome. He helped to fix the ropes on the Abruzzi route and in return they let him share their tents.

The porters worked hard, each day shouldering heavy loads of oxygen tanks, ropes, and the Serbs' food up the mountain. They mostly had only wheat and dried apricots to eat so Zerain shared his cheese from his Tupperware container and sometimes made them a treat of strawberry-flavored milkshake. One night, he cooked risottos and pastas—though they gave these away to their Serbian clients.

Now, as Zerain waded through the thick snow on the summit snowfields, he discovered that despite his hope the summit wasn't close and the going was tough, intense, far harder than he had anticipated. His boots packed fresh snow at every step. He went from side to side, looking for ice or harder snow to walk on. His aching legs strained forward only to slip back. Sometimes he found nothing at all

beneath him and was suddenly swallowed to his waist in cold snow. He scrambled quickly to his feet.

Only once had he witnessed death on a mountain. It was 2000, he was making a film for Spanish television, and he was on his way down from the top of Everest when he was told someone had fallen. He could see a body six hundred feet below, and when he rushed down, the climber was lying on the snow, unable to speak, and there was blood everywhere. Zerain did not know who he was. He tried to put some gloves over his hands but they were rigid. Then he tried to take his rucksack off because the straps were suffocating him, but the climber stood up and then fell and began to slide. The backpack came away in Zerain's hands and the climber fell nine hundred feet toward the Rongbuk glacier.

His name was Stolz, he later found out, and he was from Denmark.

Zerain crisscrossed the summit snowfield from left to right, prodding gingerly with his ice axe. He had wrapped its handle in silver tape to prevent the skin of his fingers from freezing onto the cold metal. He was tempted to escape the clinging deep snow by crossing far to the right, onto the ice of the serac. He strode across, his back bent under the sun. But then he left the serac behind him and was forced to plunge back into the soft snow.

As he had done since the base of the Bottleneck, he was opening the trail alone, and the snow was deep. The going was so slow that he had thought it would be only a matter of minutes before the pursuing group caught up with him. The ones who were using supplementary oxygen would be faster. Before long, they would be speeding along behind him and then they would share the work of opening the route.

But no one had appeared. He had gone on, feeling weary, keeping every unnecessary effort to a minimum, because even stopping to open his backpack cost energy. About three hundred feet before the summit, he had watched carefully for hidden crevasses. Then at last, he had climbed the final steep, diagonal ridge and had come out alone onto the summit of K2. The first climber to reach the top in 2008.

The afternoon was perfect. Not the slightest cloud. The summit was a 150-foot sloping snow ridge. He climbed up the ridge to get to the highest spot. About fifteen feet below the top on the other side was a comfortable flat area of about eighteen square yards where he could sit.

The surrounding mountains receded into the distance, lesser giants of the Karakoram compared to K2. On one side, they marched northeast into China, on the other into Pakistan. India, China, Pakistan—they all seemed close from up here. And Zerain could see the back of Broad Peak, the Gasherbrums, Nanga Parbat, and many more mountains, all of them wondrous sights. So too were the swirling patterns of the glaciers, like patterns on butterfly wings, 11,800 feet below on the valley floor.

Wait until he told his friends and family back home, Zerain thought. He wished he had his Olympus. He opened his eyes wide and scanned the horizon so that even without his camera he would remember every detail. He gloried in the view; he felt he could see every brushstroke.

The summit was broad, but he eyed it warily. He couldn't be sure of the safety of the snow. Maybe it was rock he was treading on or maybe it was an overhanging lip of snow waiting to collapse under him. He didn't trust it. Although his gaze wandered far, he drank some tea and stayed sitting and didn't move around much.

Down below, at the lip of the long snowfield, the other climbers were at last spitting up out from beneath the serac. Zerain checked his watch and frowned. He was surprised that they were still intending to shoot for the top.

He knew what they were feeling. Up here, on the summit slopes, you were close to the gods, or at least you felt you were. But you forgot there was work to be done to get up and down again.

Watching the climbers ascend the mountainside toward him, Zerain closed his eyes and felt sleepy. He lay back on the snow. The tea was warming him. The sun was on his face. He had had no sleep for more than twenty-four hours, since he had woken up at Camp Three.

To avoid the crowds going up the Abruzzi and Cesen routes, Zerain had climbed directly from Camp Three the previous night, arriving in Camp Four at midnight. He had waited under the quiet stars for people to leave for the summit. There had been no moon and, when he had gazed along the Shoulder, Zerain could barely make out the Bottleneck. He didn't want to be up there alone.

Soon he had noticed movement and a Sherpa approached from one of the tents.

"Namaste!"

It was Pemba Gyalje, the strong Sherpa in the Dutch team. Gyalje peered forward to see who was lurking near the tents, and Zerain explained who he was.

A few other climbers gathered with Gyalje at the edge of the camp and then headed out onto the Shoulder. Zerain joined them, third in line. Not far out of Camp Four—they had been walking for probably forty minutes—the two climbers ahead of Zerain stopped abruptly and started to pull rope from their backpacks.

Zerain was confused. At this point the Shoulder was as flat as a cow's meadow. Why were they doing this now? He couldn't see the other climbers' faces behind their balaclavas and hoods. Maybe, he thought, the Sherpas and HAPs were concerned their clients were not skilled enough for this terrain. Grasping the rope, he realized that if he helped them, they would be faster.

He went over the fresh snow up the Shoulder, the other climbers passing more rope to him from behind as he marched on. He went to the right, to the rocks, a little way out of the full glare of the serac above.

Finally, as the sun rose higher, Zerain had fixed two screws near the top of the Bottleneck and then waited for the others to bring more rope for the Traverse. He had 100 feet of rope in his backpack but they said they were bringing extra rope of their own, so he had waited, perched beneath the serac, so close then that he had been able to study it properly for the first time.

That was hours ago now. Abruptly, Zerain forced his eyes open again. He was still sitting on the summit. If he took a nap now, he might never wake up. He checked his father's watch: 3:40 p.m. Time to go down. Forcing himself upright, he climbed down from the summit.

When, about an hour later, he reached the other climbers and began to pass them, they greeted him warmly. Those who were using oxygen had made the quickest time. The Sherpa returned the Olympus. The South Koreans' leader, Kim, so far as he understood, thanked Zerain for placing the rope on the Bottleneck and for opening the Traverse.

In return, Zerain smiled and said thank you, but all the while he wanted to tell them to turn back. *It is late!* he wanted to shout. *Turn back with me. Is it worth the risk?*

One figure in the line was waving especially enthusiastically. He was wearing an oxygen mask and goggles and his face was partly covered by his hood. Hugues d'Aubarède took off his mask and wrapped his arms around Zerain.

"Alberto!"

"Bonjour, Hugues." But Zerain looked at d'Aubarède and thought that he would rather be seeing him in Base Camp already.

"How was it?" said d'Aubarède, speaking in French. He seemed tired, but excited.

"Be careful," Zerain said. "It is very bad."

He wanted to say more. Just a few words might have persuaded d'Aubarède to turn around. But the Frenchman's burly HAP hovered at his shoulder and Zerain did not want to interfere. The HAPs were being paid to get their climbers to the top.

He felt sorry for his friend because going down would be hard.

"Good luck, Hugues!" Zerain said.

"I will see you," said d'Aubarède, smiling.

Zerain passed Cecilie Skog, who asked him how far it was to the summit. The first time Zerain had met Skog was three weeks earlier at Camp

Two. It was soon after he had arrived on the mountain, while he had barely been able to speak because he was so tired after a day of climbing, Skog had marched into the camp, calling out greetings to her teammates. Her voice had seemed so happy. He had thought, *This is a strong woman.*

Skog still looked full of energy, even now. But Zerain knew he had to answer her carefully since he might give her false hope or wrongly discourage her.

"With a good rhythm, it should take you no more than two hours," he said.

She grinned, seeming to take heart. She looked so beautiful in the sunlight.

After saying good-bye, Zerain climbed down in the direction of the Traverse. Up above him, the line of climbers was spreading out, still meandering on toward the summit.

He wanted to shout, "It's okay if you turn around!" He hoped none of them would become the latest name on the Gilkey Memorial, the monument at Base Camp to the people who had lost their lives on K2.

On the Traverse, he found the old rope and the screws that he had punched in still fixed to the ice. No one had replaced them after all.

About two-thirds of the way across toward the Bottleneck, six orange oxygen bottles dangled from one of the screws and Zerain wondered who could have left them there.

At last he reached Camp Four. Outside one of the tents, a single climber was sitting and brewing some tea. One of the Americans, he thought.

Although the tea looked tempting to Zerain, he wanted to push on down. He nodded at the other climber and waited for a moment, still hoping perhaps for an invitation because the tea looked so good. But the climber said nothing, so Zerain left the tents behind. He climbed down the steep ridge to Camp Three, where he had spent the previous night and where he found two of the Pakistani HAPs from the Serbian team and was glad to share their tent.

CHAPTER SEVEN

5:30 p.m.

Ahead of Cecilie Skog, one of the South Koreans' Sherpas climbed up the final steep ridge and disappeared over the crest onto the summit.

A few minutes later, Skog's lanky Norwegian colleague, Lars Flato Nessa, overtook four members of the South Korean team and followed the Sherpa onto the top. Alberto Zerain had told Skog the last stretch up the snowfields would take two hours and they had done it in two and a half. She was relieved.

Fifteen minutes later, she joined Nessa on top of the world. She relaxed in the warm sunshine.

"Congratulations, Cecilie," Nessa said. The fair-haired Norwegian was grinning.

"We have done it." Rolf would be pleased.

The day was so hot that Skog had gone without gloves and jacket since the Bottleneck. She was wearing the purple down ski pants that were a gift from Stein Peter Aasheim, a friend who was on the first Norwegian expedition to Everest in 1985.

After the breathless exertions of the ascent, the conditions on the top were perfect. There was no wind. Skog took off her woolen hat and concentrated on the peaks around her. This was the first time she and Nessa had been able to see the Chinese side of the mountain. The ranges of perfectly formed peaks surprised them. They could have

been standing in the Alps. Above them, the sky still shone a brilliant blue but the heat of the day was gone and the air was cooling.

The summit ridge was crisscrossed by footprints. Proudly, Skog and Nessa took out the Norwegian flag and posed in front of Nessa's Sony Cyber-shot. Skog also held up an orange banner from her hometown soccer team, Alesund. Skog was a soccer fan and a decent player; she had spent eight months as an au pair in Britain, in Bromley in Kent, and she had played for the Millwall Lionesses, one of the country's women's teams.

They followed a few more rituals planned for this special moment. The Norwegians had left their clunky satellite phone behind in one of the lower camps—they joked it was the size of a shoe box; it was like something out of the 1980s—so they had no way to call to tell anyone of their triumph even if they had wanted to. They took out three plastic red roses that they had kept around Base Camp to make the tent look pretty. They also unpacked a special hat that Bae had given them to carry to the summit—a pink rabbit hat with long, floppy ears. Bae had carried it with him on his expeditions to the North and South Poles, and when he stopped after the Traverse he had asked Skog to take it with her. Now, Nessa pulled it over his head with a big smile as Skog took a picture.

This one is for Rolf.

They shot some video. Skog said she was glad to reach the summit but she felt exhausted and was eager to start the descent. She was not celebrating yet.

By now, the other members of the South Korean team were arriving and spreading across the summit. Earlier, while he had been waiting for Skog, Nessa had spoken to the South Koreans' Sherpa. The Sherpa introduced himself as Pasang; he looked like he was in his early twenties. There was another Pasang in the South Korean expedition so he was called Little Pasang.

Even though they had been on the mountain together for weeks, Nessa had never spoken to him before. They talked about the peaks

around them and Little Pasang described the countryside in Nepal, and his family. They took photographs and Nessa shared some water with him.

Now, Skog and Go Mi-sun posed for a few shots side by side, two women together on the peak of K2, a mountain that at times in its history had been unkind to women. Of the first five women who had climbed K2, three had died on the descent, and the remaining two had died on other mountains shortly afterward. This was a moment Skog and Go wanted to celebrate.

The Koreans took photographs of themselves with their sponsor flags. They called their sponsor, Kolon Sport, in Korea and a press release was sent out to announce that Flying Jump had successfully made it to the top. They were going to wait for the slower climbers in their team, who were still coming up the summit snowfield; Skog said good-bye. The heat of the day was ending and the air was cooling. She wanted to get down to her husband.

———

On the way up the long snowfield from the Traverse, Wilco van Rooijen hadn't been sure he was going to make it. He was not using supplementary oxygen like the Koreans or Norwegians, so it was hard going at twenty-eight thousand feet. He felt emptied. Everything he had was gone.

All he could do was focus on the tracks in the deep snow in front of him and on going forward. Somewhere nearby he heard the high-pitched voice of the Sherpa from the American expedition, Chhiring Dorje, shouting out that they should hurry. Unless they wanted to be buried in a sea of snow.

"There is avalanches here sometimes," Dorje shouted.

Van Rooijen tried to speed up but it was hard. The route seemed to take them up one hill of deep snow after another. It wound to the left up a steep ridge. *Almost there*, he thought.

He leaned forward to see if any of the specks up ahead had reached the summit yet. The top, still hours away, was rounded against the deep blue sky.

After the ridge, he arrived at a steep climb, so steep he could no longer see the top of the mountain. As he got closer, he heard a voice encouraging him from somewhere out of his range of vision. He recognized it: Cecilie Skog. "Keep going."

His Dutch team members were spread out up the slope. He summoned what strength he had and followed behind them, taking ten steps, then resting, leaning on the shaft of his ice axe or on his knee in the snow, then starting again. Finally he dropped to his hands and knees and crawled.

And then at last he came over the top onto the summit and he staggered to his feet.

It was wonderful. Gazing around him, he could hardly believe it. Years of frustration had come to an end. Seven-thirty p.m. After seventeen hours of climbing.

"K2!"

Letting go of his backpack, he raised his arms in victory. Then he started to cry.

The whole Dutch team was standing in front of him. They rushed together in a group hug, dancing, a jumble of snowsuits and ski poles, framed by the white churned-up ridge of the summit and the blue dome of the sky. Van Rooijen, Van de Gevel, Gerard McDonnell, Pemba Gyalje.

It was late, but the joy of reaching the summit was on everyone's face. They had joined an elite club, the nearly three hundred mountaineers in the world who had now scaled K2. He and Van de Gevel were only the third and fourth Dutchmen to reach the top. Gerard McDonnell was the first Irishman. Pemba Gyalje and Chhiring Dorje were among the first Sherpas to have done it without the help of extra oxygen.

Cas van de Gevel spoke on the radio to Base Camp to let the rest of the team know the good news. They heard whoops and handclapping.

On the way up, Van Rooijen had kept his satellite phone switched off in the folds of his jacket to keep it warm and to preserve its charge. He knelt down now and took it out, and he called Maarten van Eck at the Dutch team's home base in Utrecht.

"Maarten, we are standing on Kaay Tooo!" he shouted. The news would be immediately relayed to the world via the Dutch team's website.

Van de Gevel filmed his friend and they panned the scenery with their HD camera. Talking to Base Camp, they learned that Dren Mandic had died. It was sad but they didn't let his death dull the mood for long. They couldn't get over how beautiful it was up on the summit.

Gerard McDonnell was especially fired up. He had removed his helmet and was also crying. The air was colder now but he took off his big climbing gloves and pulled an Irish flag from the pocket of his coat. He arched his back and unfurled the flag with two hands above his head.

He tried to call his family in Kilcornan but for some reason the satellite phone wouldn't work and he couldn't get through. But he spoke to his girlfriend, Annie, in Alaska. They talked just for a few moments. "I'm feeling great," he said. He was elated.

While McDonnell was celebrating, Van de Gevel strode across to congratulate Hugues d'Aubarède. "Very good that you did this at your age!" the Dutchman said to d'Aubarède. Despite running out of oxygen, the Frenchman had made it to the top and was taking photographs of the spectacular scenery.

He looked tired but he was happy.

"Yes, but I was using oxygen," said d'Aubarède. "So not so good as you, Cas."

After talking to Van de Gevel, d'Aubarède walked across the little ridge to greet Pemba Gyalje from the Dutch team. The two men had

met at Base Camp when Gyalje helped him arrange some prayer flags around his tent. They had talked about Buddhism, and the political situations in Nepal and Tibet.

The Sherpa was well-traveled and knew the world; he had spent time in France, the Netherlands, Britain.

Before they had set off from Base Camp for the main summit ascent, Gyalje had warned d'Aubarède to take four oxygen bottles with him. But d'Aubarède had insisted two would be enough. The Sherpa didn't say anything now about the oxygen though he could see that d'Aubarède's tanks were empty.

Instead, the Frenchman handed the Sherpa his video camera. "Will you take a picture of me talking to my family?" he said.

While Gyalje filmed him, d'Aubarède took out his satellite phone and called his partner, Mine Dumas, in Lyon.

D'Aubarède had come to climbing relatively late in life. His infatuation had begun in 1972 when he glimpsed the summit of beautiful Kilimanjaro from an airplane window as he returned from Madagascar on military service. He had never forgotten it. Back in Lyon, he had gotten on with his life, marriage, two lovely daughters, and his job at the Audiens insurance company. His wife didn't really approve of climbing, so he rarely went to the mountains, even though Mont Blanc loomed just over the horizon. But in 1993, they divorced; a year later, at the age of forty-seven, he had traveled with Mine back to Kilimanjaro.

"The summit is so beautiful," he said now, shaking his head at the beauty of it all. "The scenery. I am so happy."

D'Aubarède had discovered he had an exceptional ability for high-altitude climbing. On May 17, 2004, he became only the fifty-sixth Frenchman to climb Everest. But his family didn't climb with him in the really tall mountains of the world, and Mine and his daughters worried about him during the time he spent away. One day, he might not return.

With the satellite phone pressed to his lips, he promised Mine

this would be his last climb. "Next time, I will be near the sea with the family!"

He said he kissed her over the phone but she told him to save his breath and to return home to France quickly. His daughter, Constance, was getting married in September in Chamonix.

"I will call you when I get down," he said.

The sun's light was fading and the temperature was dropping. They spoke for a couple more minutes and then d'Aubarède telephoned the director of Audiens in Lyon, Patrick Bezier. In recent years, d'Aubarède's work had become a sideline, compared to his climbing, but he was featured in the company newsletter and his adventures were a favorite talking point among the clients. The company gave him time off from work for his mountaineering and helped sponsor his expeditions.

He reached an answering machine. "This is Hugues d'Aubarède," he said, speaking quietly into his phone. "It's minus twenty. I am at eight thousand, six hundred and eleven meters. I am very cold. I am very happy. Thank you."

When he had finished talking, he offered the phone to Gyalje, who was still standing beside him.

"Did you contact your wife from up here?" d'Aubarède said. "You have to do this, Pemba. Please. You can use my satphone."

But the Sherpa was serious and said they were already late. "It's time we climb down," he said.

"Yes, I agree, but we have reached the summit!"

When Gyalje still refused, d'Aubarède took back the camera and spent a few more minutes snapping more photographs.

One of the Sherpas did call home, however. Jumik Bhote, the lead Sherpa in the South Korean team, had left his cell phone with his partner in Kathmandu. He borrowed the Koreans' satellite phone to call her. When he got through, Dawa Sangmu told him she had had the baby, a boy.

Bhote closed his eyes and thanked her. *I love you! Say hello to everyone. I will be back soon.*

He was so happy. He was going to name his son after his own late father, Jen Jen.

After the celebrations, the expeditions packed up their gear for the descent—cameras, telephones, water bottles, flags. The radios and the satellite phones each weighed about a pound. Gerard McDonnell handed his phone to Pemba Gyalje to lighten his load.

Some of the teams had arrived later than the rest and some chose to spend longer than the others on the summit. By now there was a haze in the air, and it was clear evening was coming on. The sky was a deeper blue. In the valleys, some of the distant craggy peaks stuck up through mist like sharks' fins. Cumulus clouds lined up like trains on the horizon.

The teams gazed down toward Camp Four. It was a distant, alluring pinpoint, beyond the summit plateau, beyond the serac and the Bottleneck.

The two Norwegian climbers were the first to descend. Skog knew that Bae was waiting for her somewhere on the snowfield. She was impatient to share the good news with him. He had insisted on setting a deadline of being back at the Traverse and clipped onto the fixed ropes before nightfall. Once they were on the ropes, they would be fine. It was easy—they could just follow the lines back to Camp Four.

Since leaving the Traverse, Skog had been climbing without the aid of extra oxygen but she felt she needed some now. Nessa was carrying their only remaining cylinder, and he pulled the two pipes from his nose and passed them back over his shoulder to her. In that fashion, one closely following behind the other, they climbed down over the eastern side of the summit ridge.

Directly in front of them, the late afternoon sun cast the shadow of the mountain over hundreds of miles of land. The shadow was stark

and huge, a perfect triangle, and so long that it rose above the horizon.

The sight made them suddenly realize the size of the mountain. *The second-tallest mountain on earth.* And they were at its very pinnacle. They waited for a moment and Nessa took a picture.

───────────

At nearly 8 p.m., the Dutch team quit the summit. Everyone else had already left and it was empty.

They began what everyone knew would be one of the most dangerous parts of the climb—the descent. This was true on any mountain—the climbers were exhausted and the light was failing. On K2, this fact was illustrated by a telling statistic: of the sixty-six people killed on K2 in the past seven decades, twenty-four died on the way down after having successfully reached the summit.

Now, it was late and the sun was already sinking fast below the horizon. Just as the Dutch team was leaving, however, they met Marco Confortola, the Italian, who was still on his way up. Confortola said he needed someone to take a few photographs of him on the top and he asked Cas van de Gevel to wait.

"You take my camera?" he said.

Urging Confortola to be quick, the Dutchman agreed to stay behind. Confortola removed his hat and goggles and knelt in the twilight in his black and green suit. He held his ski pole aloft above his head with two flags tied to it, the Italian and Pakistani. The evening was so dark that Van de Gevel had to use a flash to take the picture.

They took five photographs, and then Confortola switched on his satellite phone to call his main sponsor, Miro Fiordi, the president of Credito Valtellinese, a local Italian bank.

"I am at the top," he said. He couldn't say much more. "I have to go," he said. "It's late."

Putting the phone away inside his jacket, he followed Van de Gevel down onto the dark summit snowfield.

Part II

DESCENT

Friday, August 1–Saturday, August 2

"There's no time for mourning."
—Lars Flato Nessa, K2, 2008

"No ropes! No rope left on the Bottleneck. Big problem.
Many danger."
—Chhiring Dorje, K2, 2008

CHAPTER EIGHT

There are several types of major snow avalanches but two are probably the most common—the loose snow avalanche and the slab avalanche.

Both are caused by weaknesses in the layers of snow in the snowpack. Both are triggered by an energy disturbance such as heat, or movement.

In the loose snow avalanche, the fault point lies close below or at the surface. Loose, powdery snow sloughs away in an inverted V shape down the slope, like grains of salt cascading down a huge salt mound.

The slab avalanche is more dangerous for mountaineers. The weakness is deeper in the snowpack; a large, cohesive snow plate sometimes hundreds of yards wide and several yards deep fractures with a distinctive whumph and shears away.

If an avalanche accelerates over an abrupt change in slope, it becomes a powder snow avalanche. This type of avalanche has a small mass but can travel at 150 miles per hour, moving far along a valley bottom and even up the base of an opposite mountainside. Some of these avalanches are followed by an air blast that sucks up snow and has been known to blow people to their deaths.

Then there is another type of avalanche altogether, which can be more lethal still. Involving not snow but glacial ice, it can be caused when the leading edge of a glacier breaks off, and blocks shear away

like children's bricks toppling from a tower. The technical term is "calving," a term that does not do justice to the violence of the event.

Some of the blocks can be as big as footballs, some as big as refrigerators or cars or houses. The blocks drop fast, bouncing, grinding, colliding down the cliff or slope like rocks in a rockfall. (Glacial ice is a type of metamorphic rock.)

The icefall is pursued by a turbulent dust cloud hundreds of feet high. The cloud can have a runout miles past where the icefall stops.

The most prominent hanging glacier on K2 is the one that sits brooding over the Bottleneck. It is a serac—defined, in the dictionary, as an irregular-shaped pinnacle of ice on a glacier, formed by the intersection of crevasses, or deep-running fissures. The name derives from the nineteenth-century French word for a compact, crumbly white cheese.

Through the years the serac above the Bottleneck had come to be called the Balcony Glacier or Balcony Serac. It was always an ominous sight. In 1993 a Canadian disappeared below the Bottleneck; his fellow climbers turned around and he was gone, and they believed he could have been hit by falling ice.

No one knows when a serac will collapse. It could depend on the heat, snowfall, or earthquakes but mostly on the speed of movement of the glacier, which can vary between many inches each year to yards.

In recent years, the Balcony Serac on K2 had been stable.

"Rolf! Rolf!"

As she had climbed down from the summit behind Lars Flato Nessa, Cecilie Skog had called out for her husband. *Where was he?* The snowfields were quiet and still. Her voice carried a long way over the waves of crusted snow.

After less than an hour, Skog saw him at last. He was sitting on

one of the small hills of snow, and she sped up to reach him. They hugged and then she gazed into his face, feeling proud. His decision to stop after the Traverse proved he was more interested in the climbing, the teamwork, the *just being there* in this wilderness, than in reaching the summit. Not many mountaineers would have turned back after getting so close.

Some of the other climbers in Base Camp had felt slightly in awe of Bae before he had arrived on the mountain. He had an impressive track record. They knew about his reputation as a proficient rock climber, and they feared he would be aloof. But he had joined in and encouraged the others, which climbers like the Americans appreciated. He told them they just had to try their best. Be safe, but enjoy yourself.

Now, Bae congratulated his wife warmly. "Nice that it was a success," he said. His voice became more serious. "But now we have to get down safely."

Bae said he felt better than he had a couple of hours earlier. But his oxygen cylinder was nearly empty again. Skog had been breathing Lars Nessa's supply of oxygen since the summit, and she passed the tank to Bae. He was a cautious expedition leader; he did everything he could to reduce the risks his team faced, insisting they use oxygen even when the other teams criticized it as cheating.

Now, as always, the Norwegians marched in single file, watching for crevasses and drifts of snow.

Skog knew she was lucky in having the life she had always yearned for. On an expedition with Bae, she could be outside under the open sky with the simple goal of reaching camp and getting warm, and when she was warm, she was happy. That was all she wanted. All she needed. She and Bae had none of the tensions other climbers experienced with spouses who resented the months apart and the risks they took with their lives. When they were in the mountains or other wild places, they were home.

During the weeks on K2, when Bae had been away climbing Great

Trango Tower, Skog had missed her husband. She had worked the slopes beside the other teams, but despite the crowds the mountain still felt empty. After Trango, Bae had first returned to Norway for a guiding course in the north of the country, which meant they were apart for even longer.

Occasionally, around Base Camp, Marco Confortola blew her a kiss and greeted her across the rock fields. "Cecilie! The most beautiful woman in Base Camp!" Other times, the three Serbs called to her, though she didn't care to remember what they said to her.

She was lonely.

Then one evening in July, she had come down from one of the higher camps, sweaty and tired, and someone across Base Camp had called out, "Cecilie, there is someone here for you!" It was Rolf, and she had run to him.

They had gone into their big Bergen tent, amid the bags and mats on the floor, and he had told her about Trango. He and his friends had climbed a route called the Norwegian Pillar to the top, and had become the first people to return alive. It was an infamous route in Norway; two Norwegians died on it in 1984.

When they had spoken on the phone while he was in Norway, Skog had joked that he might want to bring some furniture from Stavanger to brighten the tent at Base Camp. Now, she saw, he had kept his promise. He had brought a plastic inflatable Ikea couch, sky blue with pink spots. She hugged him. It was a lovely gesture and so typical of Bae.

In the warmth from a fifteen-pound gas heater, they had sat on the couch and over the next weeks, when the rest of Base Camp turned in after nightfall they entertained friends from other expeditions. McDonnell came over. Eric Meyer, too. They sat watching cheap DVDs on Bae's Mac, movies like *Basic Instinct* and *Legally Blonde*, which Skog had bought in Kathmandu. The whole team was happier once Bae had arrived.

After walking for another hour down the summit snowfields, the three Norwegian climbers approached a stump of ice where on the way up Skog and Nessa had stashed a spare 120-foot coil of rope. Nessa had been given it by one of the Sherpas when they were cutting the lines at the base of the Bottleneck in the morning. After the Traverse, they had calculated they wouldn't need it on the summit snowfields.

Skog had to remind Nessa that it was behind the stump of ice. "Sure we'll need it?" he said, skeptically.

"Who knows if an ice screw will fail or something," Skog said, and they walked over to retrieve it.

Then they went on quickly, aware that Bae's oxygen was gradually running out and that the air around them was getting darker.

At 8 p.m., they came to the start of the fixed ropes that led down into the Traverse. They had made Bae's deadline of arriving at the ropes before dark, but only by a few minutes. The western sky over the Karakorum was blooming pink.

The three climbers had to clip on and rappel diagonally down about one 120-foot rope length to the first belay stance before they could duck along the Traverse under the serac. Soon, they thought, they would be back in Base Camp.

Nessa dropped down the rope first, followed by Skog and then Bae. Skog couldn't help thinking how well they were working together as a team.

They paused for a moment on a ledge where they could stand quite comfortably. The air around them was growing dark and shadowy. The two men switched on their lamps, which were secured around their helmets with elastic headbands and clips. Skog and Nessa waited for Bae to tell them what to do next.

Skog wanted to make sure her headlamp was functioning at full strength, so she unscrewed the back of the lamp to change its batteries.

Nessa asked Bae whether he wanted him to go first.

Bae's reply came from the dark. "No, I'll lead, and I want Cecilie to be between us," he said.

Skog watched her husband shift his clip across the rope and he shuffled quickly down into the darkening well of the Traverse, disappearing from sight.

Soon Skog had finished screwing on the back of her headlamp. She rappelled down another rope length but had to stop again when the rope became badly twisted by the force of her descent just before the next ice screw and she spent a minute getting past it. Then she continued her climb down, staring forward into the darkness with the cone of her lamp. It was another ten or fifteen minutes before she saw Bae's light. He was probably about eighty feet ahead of her.

They kept that distance between them for close to an hour. Lars Nessa followed somewhere behind Skog. Then Bae reached a spot, Skog calculated, that was somewhere in the middle of the Traverse.

Until that moment, there had been no movement or sound above them. But at that point, the mountain began to shake. There was a precise crack and roar. Cecilie lurched off balance against the ice wall. She felt the rope pull taut, then it snapped back again. In the convulsion, her headlamp went out and she blindly gripped the ice in terror until the shaking stopped.

She stared ahead of her along the Traverse but Bae's light had disappeared, too.

"Rolf?"

She called out, tentatively at first but more loudly as her alarm grew.

Lars Flato Nessa was climbing carefully down the Traverse, checking the rope as he pulled himself along, when he heard the rushing sound of ice falling.

He stopped, wondering what it could be. He had no sense for how

far away the sound was. It could have been miles below him, lower down the mountain, or just a few feet away.

An instant later he heard Cecilie yelling for Rolf. Then he knew that whatever had happened was close by. From the sound in her voice it was serious.

He rappelled down and found Skog leaning in the darkness against the ice wall.

"Cecilie, are you all right?"

"Where is he?" Skog said. "Where is he, Lars? Where did he go? What just happened? I want to see him. Where is he?"

"Wait here," he said.

Nessa had no idea what he would find as he climbed out fearfully into the darkness. He followed the rope for ninety feet until he reached the ice screw where the South Koreans had abandoned their cluster of empty oxygen bottles on the way up. But there the rope ended abruptly, as if cut off by a knife.

"You there, Rolf?" he said, peering forward with his lamp.

He could see clearly that there had been a big ice fall on this part of the Traverse. The violence of it was obvious, as if there had been a battle. The snow had been packed down afresh; ice had battered down from above, obliterating any trace of bootprints from earlier in the day.

Nessa knew that his friend Bae was dead. He looked over the precipice and knew that his body was down there somewhere. They could try to find him but they would probably die trying.

When he got back to Skog, she looked at him imploringly.

"Tror du det er haap?" she said. *Do you think there's hope?*

No, Cecile, no hope, he thought. They were on the side of a mountain at more than 26,000 feet, surrounded by a cone of unforgiving darkness. Bae had been their leader, but he wasn't there for them now. Nessa wanted to make sure Skog realized there was no chance they would get her husband back.

"Nei," he said. *No hope.*

"We have to find him, Lars."

Nessa was not a full-time climber like Skog and Bae. The twenty-eight-year-old nurse was the junior member of the expedition. The two stars, Skog and Bae, had offered him a place on the team at the last minute. He had agreed to come to Pakistan almost on a whim to see how high he could climb, to see what this great marvel, K2, was like. He had never thought he would get so far. But he had done better than he had anticipated and now he surprised himself again. He expected to feel overwhelmed and instead he felt calm and rational. He looked at Skog, who was still clinging to the side of ice, and knew she needed his help if she was going to get down alive.

He told her they couldn't afford to mourn for Bae. "Something terrible has happened," he said. "We have to stay focused. There's no time for mourning."

But what were they going to do? They could wait for daylight. But in the Death Zone? On the other hand, they had no rope. Any fumble or misstep meant death.

Nessa reminded himself that it was not unusual to be on an expedition in Norway and discover they had forgotten some of the ropes or belays or screws. They just had to be creative and find some other way out of this problem. And then he remembered the coil of rope that they had stashed and collected again on the summit snowfield and which was in his backpack.

He brought it out and ran it through his hands. In fact, it was two lengths knotted together, one white length and one colored. He also realized he had a reliable ice screw to attach it to—the one that was still screwed into the ice of the Traverse. It had been tested by an avalanche and had held.

He climbed down again and tied the rope and when he came back he told Skog he was going to rappel down to look for a way out. She was in shock, but she nodded and seemed to understand what he told her.

Skog's headlamp was still not working. After she had changed the batteries, she had not fitted it together again properly and the batteries had fallen out when the avalanche hit. Letting himself down on the rope, Nessa watched as Skog was swallowed by the darkness.

He rappelled down diagonally to the right over broken rocks, bracing his legs to avoid swinging back vertically like a pendulum, and watching carefully for the end of the rope. In the darkness, he was unsure where he was heading but after about forty yards he recognized the rocks around him and realized he had reached the Bottleneck.

He yelled back up to Skog and soon he felt her weight moving down the line. He held the end of the rope tightly. Five minutes later, Skog's legs appeared out of the darkness and within a moment she stood beside him, only slightly out of breath.

The first thing she said to Nessa was "Have you found him?"

He shook his head.

"When will we find him?" she said.

"Cecilie, he is gone."

"How can you be sure?"

"Look, we can search tomorrow when it's light. You won't see anything now anyway."

Nessa remembered Bae's three iron rules. He knew he had to get Skog and himself home. They could not take the risk of looking for Bae. Now they saw that in addition to cutting the rope in the Traverse, the avalanche had also swept away or buried the lines fixed in the Bottleneck. The gully was littered with large chunks of ice. There was nothing to do but to turn their faces to the slope and descend without rope.

"We must go," Nessa said.

Skog nodded.

Nessa went first, punching grips with his ice axe and the teeth of his crampons. Every few feet he stopped and pointed his headlamp upward, trying to give Skog as much light as he could. He waited

until she made it down to him, and then he climbed another few feet lower.

It was a slow, laborious way of descending the mountain; they were tired and their nerves were raw from Bae's death. Nessa called out encouragement to Skog and tried to guide her and she tried to concentrate and be patient, though the broken chunks of ice around them made the way perilous.

Skog doubted whether she could make it to the bottom. She climbed automatically, moving one axe down and then her boot. Axe and boot.

Half an hour later, the ice gully flattened out a little, and Skog and Nessa were able to turn and stand up straighter and walk down slowly in single file. They bent forward tentatively because the ice was still slippery, and held the blades of their ice axes in their hands and thrust the handles before them into the crust of the snow.

They were still walking amid the blocks of ice that had crumbled from the serac when Skog's boot caught on a brick of ice and she fell.

The surface was hard and slick and Skog slid fast, tumbling and rolling over and crying out for Nessa to help her. She was on a slope and she couldn't see where she was going. After sixty feet, she flung out her axe and slammed the point into the ice, which brought her to a jolting stop.

She gasped for breath. Her ski pants were ripped down her leg. But she was alive.

Nessa scrambled down to her.

"I thought I was gone," she said, still breathing heavily, as he helped her up.

"So did I," he said.

She was bruised and shaken and feeling more weak and exhausted than ever, but they continued making their way down. The wind was picking up.

After another hour, the line of fixed rope appeared suddenly and

they clipped on to it. Ahead, a small, strong light was flashing on and off from the direction of Camp Four. Someone had put out a beacon. They fixed their compass to it.

As they approached the camp, Skog grew convinced that Bae would be in the tent waiting for her. Of course he was in Camp Four, she thought. Her husband was the one who constantly worried about safety. He never took risks. *Safe and sure. Get back home.* Nothing could have happened to him. She was late and he would be worried about her by now, she thought. *Cecilie, where have you been?* Skog told herself she must hurry. She had to get back.

At Camp Four, Skog and Nessa went straight to the tent of Oystein Stangeland, the fourth member of the Norwegian team. Stangeland had turned back after the Traverse. As Skog opened the tent flap, she looked immediately to see if anyone was sitting with him, but he was alone.

Inside, Stangeland asked where Bae was and Nessa shook his head.

"Rolf got lost," Nessa said.

That was all he had to say. It was short and brutal and all three climbers knew what it meant.

The night before, Skog and Bae had slept together in one of the tents at Camp Four, while Nessa and Stangeland had shared the second tent. Now Skog walked to her tent and went inside. Bae was not there either.

Nessa brought in a bottle of water that Oystein had melted for them. Skog felt thirsty but she was not hungry. She was cold and tired and sad. Nessa helped her remove her crampons. She left her boots, her thick climbing suit, and everything else on.

The two climbers lay down on the mat under the sleeping bag and Nessa held her.

CHAPTER NINE

The violent, shape-shifting nature of K2 was dramatically revealed during an expedition to the mountain in 1953.

A year before Desio, Lacedelli, Bonatti, and Compagnoni made their pilgrimage from Italy, a team of seven Americans and one Briton arrived on the slopes. They were led by a thirty-nine-year-old doctor from New York named Charles Houston, a Harvard graduate and a legendary figure of American mountaineering, although this would be his last climb. His team included a twenty-seven-year-old climber, Art Gilkey, who was a graduate student in geology at Columbia University in New York, and twenty-six-year-old Pete Schoening from Seattle.

For six weeks the team climbed steadily, defeating the most difficult landmarks of K2, including House's Chimney and the Black Pyramid, and discovering the empty tents of Wiessner's expedition. K2's notorious weather had already begun to blow in: In a violent storm, Houston's team was trapped in the tents at the expedition's Camp Eight at 25,500 feet, three thousand feet from the summit. They could not light the stoves easily, so the climbers struggled to melt water to drink, and to cook. They passed the time reading aloud to each other, painting, or writing diaries. Four days later, after one of their three tents had been pummeled by the storm, the wind dropped slightly and they staggered outside. Art Gilkey, however, had developed swelling in his left leg. He collapsed and passed out.

When Gilkey came around, he insisted he was only suffering from

a cramp. "I'm all right, fellows; it's just my leg, that's all," he said. "I've had this Charley horse for a couple of days."

But he had developed thrombophlebitis, or blood clots, in the veins of his left calf. He could certainly climb no higher and was unable to descend alone.

Another storm swept in, confining the team once again to their tents, and the clots spread to Gilkey's right leg and eventually his lungs. Gilkey apologized for being a burden but his six teammates gave him a shot of morphine and then quickly composed a makeshift stretcher from his sleeping bag, a tent, a rucksack, and a cradle of rope.

The route they had followed on the ascent had become a major avalanche risk, so in the howling wind they tacked to the west, down a steep rock rib, dragging a now blue-faced Gilkey through deep snow. When the slope steepened, they lowered him down it with a rope tied to the stretcher and anchored from above by Pete Schoening. This involved Schoening's securing his ice axe in the snow behind a boulder, using the rock to support the axe, and looping the end of the rope once around the axe handle and around his waist.

Delicately, they lowered Gilkey until they reached a place where they began to cross the rocks to Camp Seven. But at this point, one of them lost his footing and slipped. He was roped to a teammate who in the force of the fall was also wrenched off his feet. The pair then crashed into the rope between Houston and another climber. Within a moment all four were hurtling down the slope toward the precipice. They snagged a fifth climber, who was attached by a rope to Gilkey's stretcher, and he too began to slide. Entangled, they were going to fall thousands of feet, it seemed, and they were going to die.

But Schoening was still supporting Gilkey from above and the incredible happened. Even as the weight of six mountaineers jolted onto his rope, Schoening's strength held the falls.

As he strained, the train of falling men stopped, hanging above the

drop. Slowly, one by one, the mountaineers righted themselves. One had lost his gloves and his hands were frozen; another had a cracked rib and a large gash in his leg; a third had a nosebleed. Houston was unconscious and had to be revived by the reminder that if he didn't climb up now he would never see his wife and daughter again.

The climbers anchored Gilkey on the slope with two ice axes and explained that they would return to fetch him soon.

"Yes, I'll be fine," Gilkey said. "I'm okay."

The mountaineers crawled across to the small ledge where one member of the group was already erecting two tents. As they did so, they heard Gilkey calling out to them from his stretcher 150 feet away. Ten minutes later they returned to collect him, but he was gone.

At first they assumed an avalanche had taken him, but in the following years some wondered whether Gilkey had cut himself free so that his teammates would not have to carry him down. Had he sacrificed himself so that they could live? As they continued the descent over the next few days, they found no sign of Gilkey except for a tangle of ropes, a torn sleeping bag, the shaft of an ice axe, and blood-streaked rocks. They all studied the remains but none admitted until later that they had seen them.

K2 had its close Italian connection, thanks to the Duke of Abruzzi and the triumph of Compagnoni and Lacedelli. But down the years, after an American expedition in 1938, Wiessner's ill-fated attempt in 1939, and Houston and his colleagues' expedition in 1953, it also became known as "America's Mountain."

In 1953, the day after the Americans' safe return to Base Camp, their Hunza porters erected a ten-foot-high memorial cairn to Art Gilkey, a pile of boulders thrown aloft on a spur of rock at the confluence of the Savoia and Godwin-Austen glaciers looking across the southern face of K2 and down the glacier to Concordia.

It was a monument to teamwork and brotherhood. It was also a monument to mortality, and to the deadliness of the mountain. Over

the years, names were added to the memorial, names punched into simple tin mess plates, or lives paid tribute to in pictures, elaborate stone carvings, or metalwork. If the remains of fallen climbers were discovered on the glacier, they were often carried up and interred in the crevices between the rocks.

Over the decades, it became a matter of duty for mountaineers coming to K2 to scale the cliff outside Base Camp and visit Gilkey's memorial. The glacier receded and each year the promontory reached higher into the sky.

There were plaques placed there to commemorate later disasters. The 1995 accidents that claimed seven lives, including Alison Hargreaves, a British mother of two young children who was blown off the mountain just below the summit by sudden, hurricane-force winds. And the 1986 deaths, when thirteen climbers perished over the course of the climbing season. One of them, an Italian, Renato Casarotto, climbed on the Magic Line, an especially difficult and renowned route also known as the Southwest Pillar, although he turned back before the summit. Near Base Camp, he fell into a crevasse. He telephoned his wife, who was waiting for him in a tent at Base Camp, to tell her that he was dying and needed urgent help. When rescuers reached him that night, they managed to lift him out, but he died soon afterward and at dawn Casarotto was lowered back into the crevasse.

During the summer, Gerard McDonnell and the Dutch team had climbed up to pay their respects. Marco Confortola visited and so did Alberto Zerain. Eric Meyer and three others from the American team made the pilgrimage, and in the silence linked arms and bowed their heads in prayer, ignoring the stench of rotting flesh on the breeze. Hugues d'Aubarède climbed up and studied the nameplates carefully.

They all brooded on heroism and eternity, accepting that death was a possibility, a risk—yet not fully believing that the Gilkey Memorial and what it stood for could lie in their own futures.

CHAPTER TEN

11 p.m.

In their tent on the Shoulder, where they lay in sleeping bags, waiting for people to climb down from the summit, Eric Meyer and Fredrik Strang didn't hear Cecilie Skog and Lars Flato Nessa return to Camp Four.

They monitored the radio for any transmissions, drank as much water as they could, and tried to stay warm and alert in case their help was needed. They had boiled noodles but it was hard to force any food down.

Earlier, as people had summited, the voices on the radio had been ecstatic. Chhiring Dorje was the only member of their own expedition who had continued to the top.

"Big Namaste," he had said when he called in. "Very happy to be on the summit, brother!" He and Meyer called each other brother.

"Congratulations," said Meyer.

Meyer was a Christian, Dorje a Buddhist. Spiritually, they found they had a lot in common. Dorje and his wife had visited Meyer in Colorado and Meyer had taught him to ski. On K2, Dorje had built a seven-foot rock chorten a few yards from the tents in Base Camp and encouraged the American team members to toss offerings of rice to the mountain; every evening he chanted his prayers.

Meyer and Strang were proud that one of their team had made it to the top. It was also a relief to hear good news in the wake of the

deaths of Dren Mandic and Jahan Baig. They punched the air and gave each other high-fives. *Way to go!*

But then the radio had fallen quiet.

Toward 10 p.m., Meyer had noticed headlamps coming down from the summit. He walked outside to study them, the sight making him feel queasy. The climbers were already having to use lights even though they had far to go to reach Camp Four.

"Fuck, they are late!" Strang said, when Meyer returned to the tent. "Where is Chhiring?"

Camp Four was quiet. The Serbs had already gone down to one of the lower camps. About ten yards from the tents, the American team had planted a strobe light in the snow, taping it to the top of three bamboo wands. One of the other members of the American team, Chris Klinke, a climber from Michigan, had bought it at an outdoor adventure show in Salt Lake City. It was round and only about four inches long but it sent out a powerful flashing white beam that split the night and would help guide people down safely; Camp Four was surrounded by couloirs, or gullies, and you could easily stray into them if you didn't know the way back to camp.

Meyer and Strang waited for news on the radio. The American team had Icom five-watt radios. Some of the sets, which were about six inches high, had remote handheld microphones so the team members could keep the radio inside a coat pocket and the batteries would stay warm. Good communication was essential, the teams had agreed, and so they had established a common frequency for all of the radios that were being used by the expeditions on the climb, which the Americans had nicknamed the United Nations frequency. But the Dutch group's radios didn't always work on that part of the dial for some reason, and the South Koreans had gradually taken it over anyway, and no one in the other teams could understand what they were saying. As a result, the Americans tended to use their own frequency and so did the Italians. Meyer now checked the U.N. channel, but he

also continued to turn the knob listening for anyone else who might be trying to call in.

Not everyone had taken a radio up anyway. Some had left them behind because they didn't want the weight. Others had simply forgotten them in their tents, and other teams had divided up, one person carrying the team's radio and another taking the satellite phone for the obligatory call to the family and friends from the summit. It all made perfect sense in the bright light of day but it seemed to Meyer and Strang a little stupid now that everyone was late and it was getting toward midnight. Why wasn't anyone talking?

The two climbers lay back on their sleeping bags and waited. At 10:30 p.m. the radio finally crackled. It was Chhiring Dorje. He said he had reached the Traverse but he had bad news.

"No ropes!" he said. His voice was anxious and excited. "No rope left on the Bottleneck. Big problem. Many danger."

Meyer held the radio and let the news sink in.

"That is a very difficult spot to be in, Chhiring," he said. He knew he didn't have to tell Dorje what he should do but he said it anyway. "I think you have to keep moving. Keep descending, no matter the danger. But be careful."

Dorje said he was alone, although he had been following two other Sherpas, who were somewhere ahead of him. He made Meyer understand that everyone else was still behind him and so they were also before the break in the ropes. Their umbilical cord down had been cut. Were they good enough to get down without it in the dark—or had they left their descent too late? Meyer and Strang began to realize they could have a full-blown catastrophe on their hands.

———————————

Chhiring Dorje was a stocky, wide-shouldered man with red cheeks and jet-black hair cut in a bowl shape. His friend Eric Meyer said he looked like Oddjob, the James Bond villain.

Dorje had descended from the summit with a large group of climbers. All knew they had left their descent late and were running out of time. They were also worried about falling on these slopes in the poor light, so the South Korean team fixed a rope down a steep section of the snowfields, beginning about one hundred yards below the top. This slowed the teams once again.

Dorje had helped the Koreans' chief Sherpa, Jumik Bhote, carry the rope lower and fix it. The time was past 9 p.m. and in the dusk the mountaineers clipped onto the line and backed down carefully and slowly in single file, the snow in places reaching up to their thighs.

The rope helped. Descending would have been faster if the climbers had divided into two lines. Then the speedier mountaineers could have forged ahead. But there was only one rope, and anyway creating two tracks would have doubled the avalanche risk.

Dorje believed this was the correct course of action. Everyone was staying together as a group. But after about four rope lengths, the climbers suddenly began unclipping and they wandered off independently into the darkness.

Dorje was a strong climber and he went on first with the two Sherpas, Pemba Gyalje and Little Pasang Lama. Up behind him, the slow procession of mountaineers backed down the slopes, seeming hardly to be moving. He could see the vague figures of the Koreans—Kim Jaesoo and Go Mi-sun—and Wilco van Rooijen and Hugues d'Aubarède. They were struggling, and Dorje felt that if he did not wait to help them they might lose their way. Securing his ice axe, he sat in the snow.

When Dorje turned around, Gyalje and Lama had disappeared from sight. There was no trace of their headlamps and he was seized by a fear that they had been taken by an avalanche. The snowfields were a terrifying blank. Suddenly, the Sherpa was worried about whether any of the expeditions were going to survive. He was concerned about himself, too; he was cold, and he wondered whether this time he was really going to be able to return home to Nepal.

"Oy!" he shouted up to the people behind him. There were a few shouts in response. "Come on quickly!" he called.

Dorje set off alone, but he had climbed only a few yards when he slipped and fell fast, bumping and sliding. Shoving his axe handle in behind him, he came to a stop after about seventy feet. He stood up, thinking how lucky he was, and still wondering where the two Sherpas were and whether they really were dead. Then he climbed down alone onto the Traverse, eventually arriving at the section where the rope dangled limply from the ice screw. This was different from the way up.

Testing the rope, he found it tight, probably from the weight of climbers below. His hope rose. Was it the two Sherpas? He climbed down backward, and staring over his shoulder into the darkness, he realized there was a point of light below him. It was a headlamp.

"Pemba, wait for me!" he called out. Someone called up to him and he recognized Pemba Gyalje's voice.

"Here is an avalanche!" Gyalje shouted. "Here is no rope!"

"Still, wait for me," Dorje called back in Nepalese, his high-pitched voice ringing across the slope. He said he was climbing down. "Ma tala jhardai chu!" he added. "I am coming!"

He clutched the rope and rappelled down over the rocks, making for the light, which was about 150 feet below him. He looked up at the looming shadow of the serac, which he thought looked like a god's brow. Dorje considered the mountain to be divine, one of the holiest of mountains; too many western climbers in Base Camp had showed disrespect. As Dorje got closer to the light, Gyalje shouted out that he was not alone. "Little Pasang is also here," he said.

The two men, Gyalje and Little Pasang, were clinging to a shelf of rock and ice. Little Pasang looked awkward. Both stared at Dorje questioningly. What were they waiting for? Dorje scowled. "We must go," he said. "We climb down. There is no other choice."

Gyalje gestured to Little Pasang to explain why they had not gone down. "Little Pasang has lost his ice axe," he said.

Dorje looked more closely at the young Sherpa. He could see he was afraid. His eyes were red from crying.

Dorje stared down with the help of his headlamp at the hard slope, littered now with blocks of ice. You might *just* be able to descend without an ice axe. But it was dark and they had been climbing non-stop for twenty hours and were tired. At least he and Pemba had their axes. The odds on falling without one were pretty high.

Gyalje said he was climbing down to look for the rope, but after he had gone about a hundred yards Dorje could see his headlamp was still dropping lower.

"What are you doing?" Dorje called. "Have you found the rope?"

"No! But I am going down."

"Pasang has no ice axe," Dorje shouted back.

Gyalje said the Koreans were following. They would help Pasang.

Dorje felt sorry for Little Pasang. He didn't know him well. They had called out greetings to each other occasionally when they passed on the route and from time to time they shared tea in Base Camp at the end of a working day, when he, Pemba, Pasang, and Jumik Bhote played cards and gambled for small change. He had met him first in the South Koreans' camp when Dorje walked over to sweet-talk the Koreans' Nepalese cook into giving him a jar of spicy kimchi, or Korean pickled cabbage, for Eric Meyer.

Dorje thought that if Pasang waited where he was he would freeze to death within an hour.

"Okay, Little Pasang," he said. "You clip on to my harness. I have an ice axe. We will go together."

Little Pasang looked shocked. "No!" he said. "Dangerous. Maybe we will die."

Could he hold the two of them? Dorje wondered to himself. If he slipped, they would both plunge to their deaths. If Little Pasang caught a boot or mistimed his step, he would drag Dorje down with him. The Sherpa pictured himself toppling from the Bottleneck.

His wife, Dawa Futi, had told him over and over back in Kathmandu not to go to K2 because it was too dangerous. She had cried, and she had never cried when he had left on expeditions before. He thought of his two daughters, Tshering Namdu and Tenzing Futi. They attended the expensive English-language school just outside Kathmandu, Little Angels' School. What would they do without him? And his brother, Ngawang, and his sister who had moved in to live with his family and depended on Dorje? How would they survive?

Dorje also had his own dreams. Not that long ago, it seemed, although it was ten or more years now, when he was about Little Pasang's age, he had started in the business as a mere porter, fresh from the Rolwaling valley. Gradually he had built a reputation and started his own company; he had climbed Everest ten times; his life had changed. He didn't want to throw everything away. One day, maybe, he and his family might move, to be near Meyer in the United States. His girls might go to an American school.

Now on the Traverse, Dorje felt his voice shake as he spoke to the young Sherpa who was looking at him so expectantly.

"We will go together," Dorje said again to Pasang. "We have two choices. Maybe we arrive together, or we die together. Don't worry. I will not leave you."

Each had a six-foot-long rope connected to his harness and they clipped the two ropes together. Dorje turned to face the slope, and Little Pasang climbed down a few feet below him, balancing with his hands and kicking into the ice with the crampons on his boots. Dorje felt the extra weight and then followed the other man down. He attempted to keep a short space between them and coordinated the placement of his ice axe and his crampons with Pasang's own steps just below. He concentrated hard, snapping out short commands and listening for Little Pasang's answer. He could hear Pasang's heavy breathing.

"Comfortable?"

"Fine! You?" said Pasang.

"You keep balanced, otherwise if you slip, we go!"

"You just hold on to that axe!"

There were further loud icefalls as they descended, and small pieces of ice from the serac pattered around them. Each time, the two men froze and gazed up nervously to see which way they should go to avoid the ice, until the air was quiet before going on.

"I am all right," Little Pasang said.

After one icefall, Little Pasang slipped and pulled Dorje down.

Dorje held the tip of his axe in the ice with both hands, trying desperately to control their fall.

"We are going!" he cried through gritted teeth. "Now we are finished!"

Pasang screamed. They slipped for ninety feet. But the axe blade struck a crack and held them.

"Little Pasang, I thought that was it!" Dorje said.

When the slope eased, they found Pemba Gyalje waiting for them. The relief of surviving made Dorje feel lightheaded. For the past hour he had forced himself to block out thoughts of his family, and only now did he allow himself to think of them again. He felt hot from the climb, and happy and lucky that the mountain had allowed him to survive.

Little Pasang stood quietly beside Dorje. "Thank you," the younger man said.

Dorje nodded and called on the radio to Eric Meyer and Fred Strang. He told them where he was.

"We are down through the Bottleneck," he said. "Everyone is okay. We are in a safe place."

He and little Pasang remained clipped together by their harnesses. As they approached Camp Four, Dorje saw the strobe light flashing from near the Americans' tent. He turned back to look at the summit.

The mountain was big and dark. He saw little groups of head-lamps sparkling high up and still descending from the summit. Some

were in the Traverse, others in the diagonal on the western edge of the serac, and others were still up on the summit snowfield. He thought about the exhausted climbers who had been making their way down laboriously behind him. By now those in the Traverse were probably reaching the place where the ropes were cut.

Dorje hoped they too would have good fortune in finding a way down.

Then he saw Fredrik Strang come out of the tent and Strang rushed to embrace him. "Chhiring, you are back safely!"

When Dorje stepped into the light of Meyer and Strang's tent at 1:30 a.m., Meyer was talking on his satellite phone to his mother, Joyce, in Billings, Montana. He was telling her that she would probably be hearing some bad stuff on the news about the ropes being cut and people still stuck above 26,000 feet. But just so she was reassured, he said, he and his team were all safe now.

He cut short the call to greet Dorje. The Sherpa's face was almost hidden inside the hood of his red jacket. Meyer and Strang helped him unzip his suit and gave him some of the hot tea they had brewed for him. The tea would help rehydrate and warm him. Meyer examined him for injuries. After a few moments to collect himself, he told them what had happened. They were surprised by how coherent he sounded and the fact that he had no frostbite. They helped him into Meyer's sleeping bag beside Meyer. He told them how glad he was to be alive and said that in the morning he would call his brother in Nepal. A few minutes later, he took out his video camera and began to study the images of his successful summit of K2.

Chhiring Bhote and Big Pasang Bhote left their tent in Camp Four at midnight. They were carrying food, water, sleeping bags, and six oxygen cylinders.

The Sherpas for the Flying Jump team had planned to set off for a summit bid with the second group of South Korean climbers that night. But after 9 p.m., when the seven climbers from the first group still hadn't come in, the second summit attempt was postponed.

The Koreans' tents were just a few dozen feet away from the Americans' on the Shoulder. The alarm among the eight mountaineers waiting inside the tents had grown steadily until the two Sherpas were sent out to search for the missing Koreans and Chhiring's brother, and Pasang's cousin, Jumik.

Chhiring was anxious about his brother. Before Jumik had left Kathmandu, he had admitted he was nervous about coming to K2. They had grown up in a family of ten children in a poor village called Hatiya, in Sankhuwasabha district, which was east of Everest, just under Makalu. Their father was a farmer who had grown mostly potatoes and millet. Jumik had more experience as a climber. Chhiring had won his school leaving certificate at Pashupati Multiple Campus, and then studied education for a year before joining Jumik, who was already climbing regularly with the South Koreans. He remembered how Jumik had reassured and helped him on his first big climb on Lhotse.

As the two Sherpas walked out onto the Shoulder, three figures emerged from the darkness. It was Chhiring Dorje, Little Pasang, and Pemba Gyalje.

Greetings!

Why are you late? What went wrong?

"We pushed for the summit too late," said Dorje.

The three climbers were shaken and tired and they told the two Sherpas about the missing ropes and their difficult experience climbing down the Bottleneck.

The two Sherpas were pleased to see them. They handed the three men flasks of water, and waited for them to get their breath back before asking about the location of the other expeditions. Pointing, the three men said they were somewhere behind them but it was un-

clear where. There were a number of climbers following them down. Chhiring Dorje looked concerned and said it was going to be hard for some of the others to make their way in the darkness.

Where is Jumik?

Jumik had stayed with the slower Koreans. They were somewhere behind.

There were no ropes. Will you go up to rescue them?

We will search for them.

The other three were not strong enough to go back up with Chhiring and Big Pasang. They said they had to climb down to Camp Four as quickly as possible to get some rest.

The figures of the three climbers disappeared into the darkness. Chhiring Bhote and Big Pasang Bhote turned back toward the Bottleneck.

Chhiring Bhote and his brother had first started out in the Sherpa business in Hatiya when their older brother had gone out to trade for cooking oil and kerosene and instead had gotten caught up in the portering trade at Namche, a town near Everest. He had fallen into a crevasse and promised the gods he would never disturb them again if he got out. When he returned, he took Jumik with him to Kathmandu, bringing along their sister Bhutik to cook, swearing he was done with the mountains. A few years later, however, Jumik had joined the Korean team.

Half an hour after leaving the other Sherpas, the two men were still on the Shoulder when they saw another headlamp. They called out and Kim Jae-soo, the Korean leader, limped down toward them. He was alone.

Greeting him, they told him he was not far from the camp. Kim was tired and he knelt down in the snow. He asked for water and juice.

What happened? Big Pasang was polite. *Why are you so late?*

Kim wiped the frozen ice from around his eyes. *Everybody went crazy.*

Kim climbed because he loved the potential for danger in nature and possessing the ability to thwart it. The exhilaration of forcing himself to the limit and surviving. When people complained that mountaineering was dangerous, he waved them away. *You could have an accident driving a car, couldn't you?*

For a year he had prepared and trained his team for K2. When the Americans first met him at Base Camp, he was sitting outside the South Koreans' tents, his legs crossed, and he refused to meet their eyes or discuss strategy, claiming he spoke no English. A few weeks later, however, he had opened up, especially after Eric Meyer treated a Korean climber who was suffering from heartburn, and he joined in the cooperation meetings. It turned out Kim spoke English pretty well after all.

Everyone was so tired, Kim told the two Sherpas, as he drank deeply. The other teams had taken much time descending from the summit.

In addition, on the way up to the summit, the ropes fixed in the Bottleneck had swerved too far to the right, Kim thought—someone in the lead group had tried to lay them out of the direct line of the serac, which had added extra distance, delaying everyone. Yet still, despite everything, his team had beaten the Dutch expedition to the top. Then, on the way down, some climbers from the other teams had used the rope that Kim had told Jumik Bhote to lay at the top of the summit snowfields, again delaying his own climbers.

When they had reached the Traverse, he and Go Mi-sun had left the three slower Korean climbers behind with Jumik Bhote. Afraid his feet were getting frostbitten, Kim had climbed down more quickly and had lost Go somewhere along the way.

"Didi is not here," he said, meaning "sister," which was what the Sherpas called Go.

Mr. Kim, we look for her? The two Sherpas watched him restlessly.

Kim looked back up the great swerving track of the Shoulder. She couldn't be far behind, he said.

"She is following," he said, turning back to them. "You must meet her."

Chhiring Bhote and Big Pasang left Kim and climbed for a few more minutes, peering into the gloom of the rocks and snow around them with the light of their headlamps and up at the steep chute of the Bottleneck, when at last they caught a glimpse of something. It wasn't what they had expected. They saw an object plunging down in the darkness on the left-hand side of the route.

The two men scrambled forward.

You see?

Then they saw a second object dropping down the same area and heard the rustling scratching of a body falling.

Was it Jumik?

Bhote's stomach turned at the sight of the falling bodies.

The objects had disappeared so quickly. Maybe they were mistaken. Was it only ice falling from the serac?

But he knew inside that they were climbers, for sure.

They climbed up toward the Bottleneck until they saw a light, and slowly a climber approached them, a tall, thin man in an orange suit.

CHAPTER ELEVEN

Saturday, August 2, 1 a.m.

One moment everyone had been together in a line coming down from the summit, Cas van de Gevel remembered; then darkness had fallen like a blanket on the snowfields. Each climber was focused inwardly on his or her own breathing and exhaustion and aches. Then there were the difficult thoughts of just how many miles remained in the cold. They had drifted apart.

When he had arrived at the descent into the Traverse, Cas van de Gevel felt relief when his boots hit the ledge before the serac.

He was surprised to see the glare of a headlamp not far ahead of him. When he climbed along the ice face, he recognized a hunched figure in a dark yellow suit clipped onto the rope.

"Hugues!"

Van de Gevel wondered how d'Aubarède was feeling. The old guy had made good time since the summit. From the way he was resting against the slope, he looked tired. He was no longer with his HAP, Karim Meherban.

The two men put their faces close together so they could talk. D'Aubarède spoke first and motioned with his hand. "You go first, Cas," he said.

"Aren't you coming?" said Van de Gevel.

"Yes, yes," said d'Aubarède. "But you are faster than me. I will follow."

The rope stretched away down the rocky ice wall. Van de Gevel thought it was a good idea not to have too much weight on the rope. There had been too much of that today already.

Below the Traverse, several hundred yards away, down past the Bottleneck on the Shoulder, he could see a signal light flashing from Camp Four.

"No more talking," said d'Aubarède, prompting him.

Van de Gevel nodded and climbed out along the Traverse, leaving the Frenchman behind.

When he reached the point where the rope was severed, he saw that a new length of rope was dangling down loosely across the rocks. The Dutch climber had no clue of what had happened to Rolf Bae and Cecilie Skog and Lars Nessa, or to Chhiring Dorje or any of the Flying Jump team. He could only imagine that the other end of the rope had worked loose from the screw at the far side of the Traverse and the rope had simply fallen down. Or that it was some climber's idea for a new route. That had to be it.

The prospect of a new route didn't worry Van de Gevel. He had climbed many times in the dark in the Alps, though a person had to be ultra-careful. Sometimes you came upon frayed ropes left over from earlier expeditions, and they led only into the void.

Seeing no alternative, Van de Gevel grabbed the line, jumped over onto the rocks, and dropped backward, rappelling. He glanced below him as far as a turn of the head would allow, and concentrated on the grip of his strong fingers on the rope. When he felt a knot and the second length of line played through his gloves, he noticed that it was thinner than normal rope, and white. It was the rope that Gerard McDonnell had bought in Alaska for the Dutch team. The rush of familiarity buoyed him.

The Bottleneck fell away somewhere below him toward the Shoulder. After a few more feet, he saw the end of the line was approaching. *Steady!* He slowed and then let the rope fall back. It would be picked

up by d'Aubarède behind him. The Frenchman had to be following by now.

He felt good to have reached the Bottleneck but felt trepidation to be without the protection of the fixed rope. The slope was still steep. Van de Gevel turned back to face the ice. He stuck his axe in and began the tough climb down.

A few feet to the right of the narrow channel something caught his eye. When he reached it, he discovered Wilco van Rooijen's backpack, which his colleague had dropped on the way up in the heat and crowds of the morning, a time that now seemed an age ago. It was about at this point that the American Chris Klinke had turned back.

The backpack offered Van de Gevel an indication of where he was on the Bottleneck. It was also a sign that Van Rooijen had not come this way yet. Cas left it for his friend to collect on his way down.

As he turned back toward the lower part of the Bottleneck, Van de Gevel's legs felt heavy. He told himself it was not far back to Camp Four.

Just then he heard a noise above him in the darkness, a scratching sound of something sliding down fast over the ice. Van de Gevel looked up and saw, twenty to thirty feet to his left, a body plunging headfirst down the Bottleneck.

There was no scream or shout. The climber still had his headlamp switched on. The body fell too fast for Cas to see his face in the light from his own headlamp, but Van de Gevel saw clearly that the climber was dressed in a dark yellow suit. The body disappeared into the night.

Lack of oxygen may trigger a complex physiological reaction inside the human body, one whose severity varies considerably from person to person. As oxygen levels decrease, the tiny arteries that feed the

brain dilate. High-pressure blood floods the network of fragile cerebral capillaries, which begin to leak fluid.

The fluid causes swelling in the surrounding tissue. The brain swells, displacing the cushion of cerebrospinal fluid inside the head until the brain starts to squash up against the inside of the skull. When the compression begins to affect the area of the brain responsible for balance and coordination—the cerebellum—it causes ataxia, or stumbling and severe lack of coordination. As the compression progresses, the optic disk swells, causing blurring of vision.

As well as affecting the brain, lack of oxygen can lead to a surge in blood pressure in the arteries in the lungs, and cause more leakage. Fluid floods into the alveoli, the tiny thin-walled air sacs deep within the lungs where oxygen diffuses into the blood. An X ray of a climber suffering from this sort of high-altitude condition reveals a patchy image of fluid in areas of the lung normally filled with air. Among the first ominous signs are shortness of breath and fatigue, a persistent cough, then a gurgle and a coughing up of pink-tinged fluid. Eventually the climber drowns.

The effects of these fluid shifts can set in rapidly before a climber realizes anything is seriously wrong. Much like a drunk, judgment is impaired well before it is apparent to the climber. To help acclimatization or relieve the symptoms, some high-altitude mountaineers use drugs. For example, Viagra is sometimes used to drain fluid from the lungs. Many climbers circumvent the risk by carrying oxygen with them in tanks, but the effects can be disastrous if the supplementary oxygen runs out. When that happens, the climber abruptly enters a new, colder, and suffocating world of oxygen deprivation. There is no time to adjust. It is a massive, startling shock to the system.

Hugues d'Aubarède's oxygen had run out before the summit. When Cas van de Gevel had passed him on the Traverse, d'Aubarède wasn't sure he could go on. He was exhausted and his mind was filled with questions. Could he climb down? Should he stay where he was until daylight?

He remembered how he had almost missed the summit attempt. The bad weather had swept across K2 in the middle of July, forcing every expedition to push back their expected summit dates. But the contract of d'Aubarède's chief high-altitude porter, Qudrat Ali, expired at the end of the month. Qudrat had worked with d'Aubarède since they climbed Nanga Parbat together in 2005. He had been the Frenchman's guide on K2 in 2006, although he hadn't come to the mountain with him in 2007. Ali was tough and experienced. The second guide, Karim Meherban, twenty-nine, was Qudrat's cousin and a student from the same small town. They were both indispensable to d'Aubarède.

D'Aubarède's flight from Islamabad back to France left on August 8 and the journey to the Pakistani capital could take eight days. Eventually he concluded there was going to be no weather window opening up. He telephoned and brought the date of his flight forward and ordered up five porters from Concordia to fetch his belongings from Base Camp.

Gerard McDonnell and Wilco van Rooijen tried to persuade him to stay. They said their forecast showed the storms relenting around July 29. D'Aubarède called his friend Yan Giezendanner, who worked for the French government's meteorological service in Chamonix, who confirmed the better forecast.

"Is it possible for me, Qudrat?" he said when he found his HAP. "I want to get to the summit with Karim."

"You must try," Ali said. The guide knew how much getting to the top of K2 meant to d'Aubarède. "I hope you reach the top."

D'Aubarède called Mine in Lyon. "I have good news," he said.

"Do what you want," Mine said.

D'Aubarède called the airline to change his ticket back. Qudrat insisted he still had to leave—he had other clients waiting on another peak—so d'Aubarède hired a new high-altitude guide to replace Ali—Jahan Baig—whom Ali knew from Shimshal.

But once d'Aubarède believed he was going for the top, a creeping

doubt had set in. He feared the lack of sleep that would come at the higher altitudes, the difficulty in breathing, the cold.

His friend Philippe Vernay in Lyon had tried to make d'Aubarède believe in God: If K2 was so beautiful it was because of God. But that was not the reason he was crazy about climbing. Yes, d'Aubarède fully appreciated the wonders of nature. But he didn't believe in God. Sorry, Philippe. He did, however, believe in something absolute, and that was probably what he was searching for.

But this year the climbing had been more difficult than ever. It was hard for a sixty-one-year-old. How his back hurt on the slopes, especially the steep slopes below Camp Two. At the end of the day it was hard just to bend to get inside the tent. He found sleeping increasingly tough, even at Base Camp, where he had an inch-thick mattress between his body and the glacier, but especially at the higher camps. He gulped aspirin to ease the blaring altitude headaches that squeezed at his temples.

He knew about the dangers. He knew all about death. In July 2005, he had shared a tent with his friend Bernard Constantine on Nanga Parbat. Three months later, on the slopes of Nepal's Kang Guru, Constantine had disappeared under an avalanche with six other Frenchmen and five Sherpas. Last year on K2, his friend Stefano Zavka, exhausted and alone, walked off the side of the Shoulder on the way down and was never seen again. This year, when d'Aubarède made the pilgrimage to the Gilkey Memorial, he studied the plaques stamped with the names of the dead. He said out loud that he hoped he would not be there one day.

He missed his family. He kept in touch with them almost every day. He had a friend back in Lyon, Raphaele Vernay, Philippe's wife, who kept a blog for him. And he took comfort reading in his sleeping bag the text messages his friends and family sent him on his satellite phone.

Back in July, his younger daughter, Constance, had sent him a

bottle of Chartreuse and a note. She told him the latest plans for her wedding. The wine and champagne were purchased, the church at Houches reserved.

She warned her father not to be late. She said she didn't want to walk to the altar alone.

Now, on the Traverse, as d'Aubarède watched Cas van de Gevel disappear into the distance, he reminded himself that he had to descend from the clouds to share his success with his friends and his family. He had to get back for Constance's wedding.

D'Aubarède turned on his Thuraya and tried his family in France but he could not get through. A moment later, he stood up and followed the Dutchman along the rope.

———

In the Bottleneck, Cas van de Gevel climbed several yards down the steep slope in the direction he had seen the body falling. He knew it was Hugues d'Aubarède.

He gazed ahead with his headlamp but he could see no trace of d'Aubarède.

When he looked back up, two lights were quivering among the rocks a few hundred yards above him. He thought they probably belonged to the Korean climbers who were following behind. He braced himself with his ice axe and cupped his hand to his mouth.

"Someone fell!" he shouted, hoping they would help. "Hugues has fallen!"

Whoever it was that was following him down, there was no answer. They were too far away to hear him.

He couldn't waste any more time searching. A few minutes later, the slope lessened and he could turn around to face down the mountain as he climbed.

Near the bottom of the Bottleneck, he saw two headlamps approaching slowly up the gully. They turned out to belong to two

Sherpas or HAPs, who had come out from Camp Four; they were so bundled up behind balaclavas and goggles that he couldn't tell who they were for sure.

He told them what he had seen and pointed to where the body had fallen.

"You look over there," he said. "Can you help?"

The two men walked away in the direction he had pointed but they seemed to be in no rush.

As he approached Camp Four, Van de Gevel radioed Base Camp and spoke to Roeland van Oss. He told Van Oss he was okay.

Van Oss had been waiting all night for the climbers from the Dutch team to call in. He was pleased to hear from Van de Gevel.

"I am below the Bottleneck," Van de Gevel said. "I am safe."

"Okay, Cas," he said. "Good to hear from you."

Van de Gevel said he had no idea where the others in his team were. Van Rooijen. McDonnell. "We got dispersed," he said. He had seen something troubling, he added. "I think I saw someone falling down," he said. "You need to send someone up to find out what happened."

"You should get down to Camp Four as quickly as you can," Van Oss told him.

As Van de Gevel descended the Shoulder, the big light from Camp Four grew brighter.

He thought about Hugues d'Aubarède. He didn't know why d'Aubarède had fallen. Perhaps he had been concentrating so hard on climbing down the rope that he didn't notice when the line had ended. Or he had come off the rope successfully but then tripped on one of the ice blocks littering the slope.

When Van de Gevel reached Camp Four, it was some time around 2 a.m. He was so exhausted that he went straight to his tent. Van Rooijen had not come in yet, he saw.

He drank water thirstily and sank onto his sleeping bag.

Go Mi-sun's oxygen had finished just after the summit. Then she had had to start breathing the empty frigid air of the high mountain, which provided no energy or warmth at all.

When she reached the end of the Traverse, the line was cut, but she managed to turn down into the Bottleneck. She was surprised at the unusually thin rope playing through her hands but she followed it into the gully. Then, using her two axes, she navigated her way between the icefalls onto the Shoulder.

She was following Kim Jae-soo but by then she could no longer see his light. He was in front somewhere but his headlamp was facing forward.

The forty-one-year-old was a small, stocky, pretty woman, who had grown up in a small town about four hours outside of Seoul. She was single, and she lived in Seoul close to her sister and brother. Bouldering and ice and rock climbing were her main sports—she had been an Asian climbing champion for several years and had competed in the extreme sports championships, the X Games, in San Diego—but when she got older and put on weight (she had gained twenty-two pounds since 2003, she complained) she switched from sport climbing to mountaineering.

Now the night was especially dark and the wind started to pick up, so she decided to search for shelter from the wind, a large rock or something else that would protect her. Gradually, the realization dawned that she had made a huge mistake. She had lost the route across the spine of the Shoulder and had wandered instead down its side—probably the eastern side.

Luckily she hadn't gone too far down, probably a hundred feet or so. She was tough; she knew how to get out of tight situations. Once, on another mountain in the Himalayas, she had fallen 180 feet, shattering a bone in her back; she had been alone but she told herself she was not going to allow herself to die, and over several hours she had managed to crawl down to safety.

Now, laboriously, Go retraced her steps in the dark. But when she got back onto what she thought had to be the main part of the Shoulder, the night was still pitch black and featureless and Go had no idea where she was.

She called out Kim's name in frustration and shouted for help. She walked several yards forward, slowly dropping down the slope. But she was lost again. Rocks reached up on every side of her, black and ugly spikes. She remembered how when she was young and had first gone to the mountains, the leaves were so beautiful. But there was no beauty here, only rocks. The hard stone clunked against her axe. She swung her headlamp around, realizing she had no idea where to go.

After two hours, Chhiring Bhote and Big Pasang Bhote saw a distant light and heard a voice calling for help, and it was then that the two Sherpas saw Go Mi-sun.

She was stuck in rocks some distance from the main route. They shouted to make her understand they had seen her. "Didi!" they called.

"Didi is coming!" she called back.

As they got nearer, however, she pleaded with them to get her down, and they reassured her they were on their way.

When they reached her, one of the Sherpas lifted her shoulders while the other held her legs, and together they carried her out. They tied her safety harness to theirs with a rope and led her down.

When they arrived back at Camp Four after about 4:30 a.m., Kim was lying in his tent, dozing. He woke when the two Sherpas helped Go under the nylon flap. At first, when Kim saw Go's familiar face and realized how late it was, he was angry with his star climber. He cared for her, and she had risked her life. He wanted to know why she had taken so long to climb down. Go, who was still shaken by her experience, bowed her head and apologized, until with relief he comforted her.

Go was surprised when she saw that most of the other tents in the camp were still empty. She was not the last climber from the Flying Jump "A" team to return. Four other climbers were still missing. The battery on the Koreans' radio was not working, so she and Kim could not contact them. The two Sherpas waiting outside might have to continue the search.

Chhiring Bhote and Big Pasang went to their tent to try to rest. They were glad they had found Go, who was a good friend to them. They couldn't sleep, however. They drank water and then stood outside, staring at the mountain.

The night was clear. Headlamps were burning above the Traverse. The serac that had so violently severed the ropes was still active and could yet toss more ice down the Traverse and Bottleneck.

The two Sherpas started packing supplies again. Jumik—their brother and cousin—was out there somewhere.

Part III

SERAC

Saturday, August 2

Tiocfaidh Ar La. Our day will come.
—Gerard McDonnell, K2, 2008

CHAPTER TWELVE

2 a.m.

Jumik Bhote had led the seven-man South Korean Flying Jump "A" team victoriously from the summit at around 7:10 p.m., carrying 230 feet of rope in his backpack.

Where there was a clear track and the snow was compact and safe, he anchored one end of the rope into the ground with a snow stake and the team members and other climbers plunged down it. The fit Sherpa brought up the rear and then climbed lower with the rope and fixed it in the snow again.

Bhote repeated the maneuver with the rope four or five times, bending and fixing and scurrying down, helped in his labors by Chhiring Dorje, the Sherpa from the American expedition. Eventually, the teams unclipped from the rope and climbed on independently, spreading out in the darkness. On the long snowfield, the two South Korean leaders, Kim Jae-soo and Go Mi-sun, rushed on ahead. As they disappeared into the shadows, Bhote was left alone with the last climbers in the Flying Jump team.

The three men had been so joyful on the summit, Bhote remembered. Before they had left for Pakistan, one of them, Park Kyeong-hyo, a twenty-nine-year-old from a mountaineering club in Gimhae, South Gyeongsang province, had written on the online bulletin board of his mountaineering club: "Now, it's not just a dream anymore. In

some 150 days, we'll be climbing this mountain. Just imagine that. Isn't it fabulous?"

He had been good enough to climb Everest a year earlier, but now Park and the other two climbers—Kim Hyo-gyeong and Hwang Dong-jin—looked like they were dying. None of them said a word. Hwang had been part of the lead group that had left early from Camp Four to fix the rope up the Bottleneck. They just stared at one another dumbly from behind their climbing masks.

Bhote coaxed them onward. He was cold, too, and tired. *Keep going! We must be quick! Please.*

At the end of the snowfield, after searching for the way lower for a while, Bhote and the three Koreans dropped down toward the fixed rope that they hoped would lead them into the diagonal around the edge of the serac.

Slowly, they backed down on the ropes toward the Traverse. But after a few yards they stopped.

You have to go! Jumik shouted.

Finally, dangling on the rope, the three men underneath Bhote seemed unable to climb down another inch, no matter how much he urged them on.

He was worried about how long the rope would hold their weight, or whether there was danger of snow or ice crashing down from above.

Please!

Bhote's voice rang out in the cold darkness on the side of the mountain. He tried to focus—on the rope, the ice face, the lamps of the climbers below him—until he felt his own mind drifting away.

In Kathmandu, Jumik Bhote failed his school exit exam and started working on his older brother's fourth-hand family bus on the traffic-clogged streets of the capital, collecting five rupees each from the Nepalese passengers and the tourists traveling to the hotels around

the Kathmandu ring road. After a year or two the bus was so broken down that his brother sold it. Later Bhote signed up as a porter with the South Koreans.

Nawang, the expedition cook, was from the same village as Bhote. He had introduced him to the Flying Jump team, warning him under his breath, "If you work for the Koreans, you have no future." But the unemployment rate in Nepal was more than 40 percent. This was good work for a poor man from the mountains.

In the spring of 2007, Bhote climbed Everest twice, once with the South Koreans, and became a favorite of Go Mi-sun, who gave him a digital camera. He was proud of that camera.

In the fall, the South Koreans asked him to climb with them on Shishapangma. He was worried about avalanches and he hesitated. No matter what blessings he called down, the gods would be unhappy. Yet by now his father back in Hatiya was dead from a gastric ulcer, his younger brother Chhiring Bhote was living with him in Kathmandu, and three more sisters had already left the countryside for the capital during the Maoist insurgency, in which the rebels had been rounding up anyone from the villages to fight the government. Jumik needed the money.

By now, he also had a partner, Dawa Sangmu, to support. He and Chhiring and their sisters all lived in their older brother's small apartment in the Boudhanath district near the stupa. The apartment had only four rooms, a kitchen, a dining room, a storeroom, and a small bathroom with a squat toilet. There were no beds, only mats, which during the day they packed away in the storeroom. He knew of no other route to success for a young man such as himself in Nepal. He didn't want to be like another brother of his, who had stayed behind in the village and was drinking himself to death on cheap rice wine, and died shortly before Jumik came to K2.

Bhote went to Shishapangma with Kim and the Koreans and it was a triumph. When he returned to Kathmandhu he had been pro-

moted to lead Sherpa. To celebrate, Bhote spent $2,000 on a big, black secondhand Yamaha motorbike. Dawa got pregnant. She and Jumik moved into a new apartment, only a single room with a shared kitchen, but it was their own.

He still did not relish climbing in the mountains, but he realized they had been good to him. He took other jobs, guiding a banker from New York on a rapid ascent up Mera Peak in the Hinku valley. He learned a bit of Korean from language cassettes bought from Pilgrim's bookstore in Kathmandu. He took a $250 course in high-altitude climbing at the Khumbu Climbing School outside Namche Bazaar near Everest.

In the spring of 2008, he climbed on Lhotse with his brother Chhiring, and in June, despite last-minute misgivings, they left for K2 with the Flying Jump team.

Now, that all seemed such a long time ago. As he waited in the dark above the three Koreans, Bhote wished he had listened to his instinct. His mind was so distracted by the cold that he wasn't sure what happened next. He didn't know whether there was an avalanche or an icefall or whether the top screw had simply come away from where it was fixed.

The rope dropped suddenly and in a dark, roaring, confusing rush Bhote catapulted past the South Koreans.

He crashed painfully into the ice a little way below them and stopped. He was sprawled against a tiny horizontal ledge, held on the mountain by the rope and his harness.

If it had been an icefall that had caused the rope collapse, it had moved on and the lower screws holding the lines in place had held. Two other climbers were dangling above him.

Bhote was able to sit upright but it was a painful struggle to move: his legs and arms ached from the fall and he was tangled in a welter of rope.

Of the two South Korean climbers hanging above him, the one at the top was suspended headfirst against the ice face. His arms reached out toward Bhote. Bhote wasn't sure who it was, though he could see his bloody face.

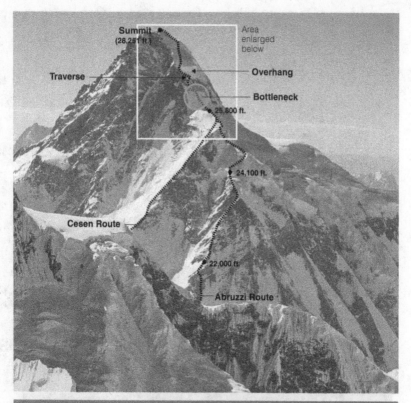

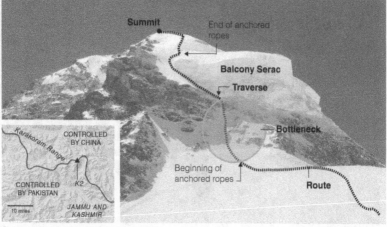

Photographs by Mike Farris (top) and Bruce Normand,
courtesy of SharedSummits.com

The New York Times

The two main approaches to the summit of K2, the Abruzzi and Cesen routes, converge at the Shoulder. From there, climbers must navigate the Bottleneck and the Balcony Serac, an overhanging glacier, before reaching the top. *(The New York Times/Michael Farris/Bruce Normand)*

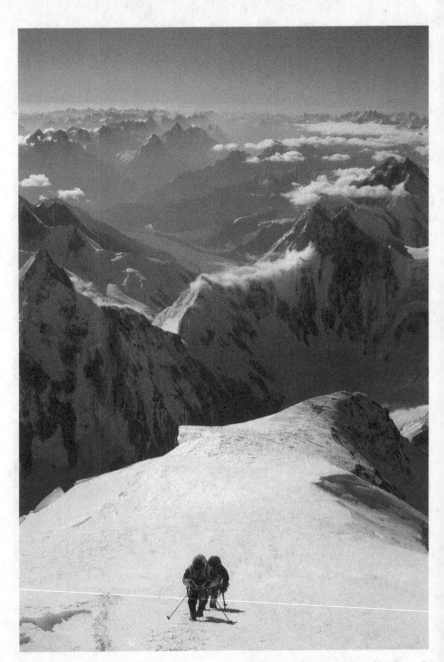

On the morning of August 1, 2008, two mountaineers, Marco Confortola and Gerard McDonnell, climb up the Shoulder toward the Bottleneck. In the background is Camp Four, the last camp before the summit. Within a few hours, the crush of climbers at the top of the Bottleneck would lead to the first death. *(Lars Flato Nessa)*

Climbers grip fixed ropes to ascend the Bottleneck, a steep and dangerous gully, and then rest before crossing over toward the Traverse. At over 26,000 feet, the expeditions enter the so-called Death Zone, where balance, concentration, vision, and other human body functions break down rapidly under the searing effects of altitude. *(Lars Flato Nessa)*

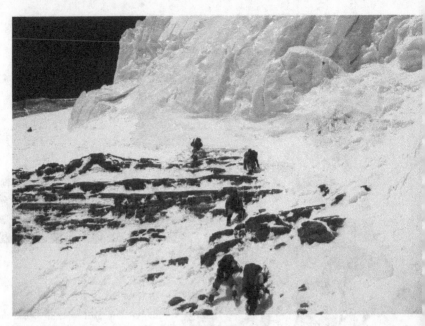

The Bottleneck and the steep ice face of the Traverse lead the climbers beneath the overhanging serac, which glistens ominously in the midday sun. In past years, serac collapses sent huge chunks of ice hurtling onto the Traverse and down the Bottleneck. Climbers did not like to imagine what would happen if they got in the way. *(Lars Flato Nessa)*

Jahan Baig, a Pakistani high-altitude porter. The HAPs, drawn from northern villages in Pakistan, were employed by foreign expeditions as guides and carriers on the mountain. They were often cheaper alternatives to Nepalese Sherpas. *(Hasil Shah)*

The Serbian climber Dren Mandic, shown in foreground at right in one of the mess tents at K2 Base Camp in 2008. Mandic fell to his death among the crowds at the top of the Bottleneck on the morning of August 1. *(Predrag Zagorak)*

After the first two deaths, the line of climbers continues on the diagonal ascent beneath the serac toward the summit snowfields. The Basque mountaineer Alberto Zerain, the first to summit and the only climber to descend in daylight, is visible at top left. *(Chris Klinke)*

Two South Korean climbers struggle to climb the last ice lip from the route beneath the serac onto the summit snowfield. Three members of the South Korean expedition and one of their Nepalese Sherpas would die on the descent; another Sherpa would lose his life trying to rescue them. *(Lars Flato Nessa)*

Climbers arrive at the summit of K2 in the late afternoon of August 1. After fifteen hours or more of continuous climbing, the descent is one of the most dangerous parts of any attempt on K2—of the nearly 70 men and women killed on K2 over the course of its history before 2008, more than a third died on the way down after having successfully reached the summit. *(Lars Flato Nessa)*

Frenchman Hugues d'Aubarède pictured at K2 Base Camp with Qudrat Ali (left), the American climber Nick Rice (right), and Karim Meherban. Most climbers work as members of a larger expedition. D'Aubarède traveled to K2 as an independent climber, though he employed three Pakistani high-altitude porters and joined forces with Rice at Base Camp. *(Raphaele Vernay)*

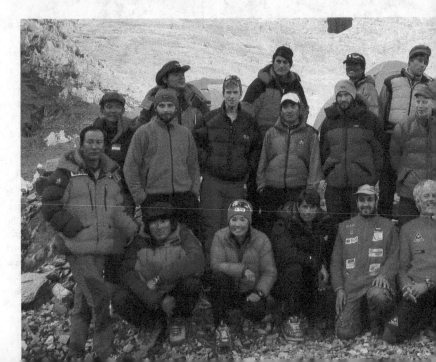

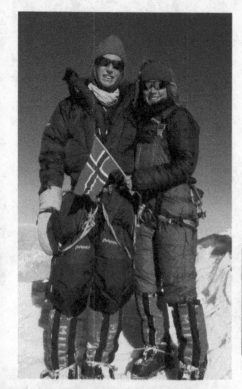

Cecilie Skog and her teammate Lars Flato Nessa stand together on the summit of K2. Skog was the first woman to summit the tallest peaks on all seven continents, and reach both the North and South Poles. *(Lars Flato Nessa)*

The Basque climber Alberto Zerain gazes up toward the serac. On his way down from the summit, Zerain passed the line of climbers still ascending. He warned them the ascent was going to be difficult. *(Alberto Zerain)*

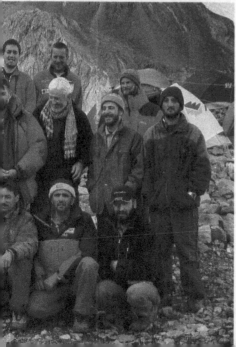

Representatives from different expeditions pose for a team photograph after one of the cooperation meetings at Base Camp. Wilco van Rooijen, the Dutch leader, kneels in the front row, fourth from right. The American Eric Meyer is middle row third from left; Chhiring Dorje stands to his left. Go Mi-sun kneels front row, third from left. Rolf Bae of Norway stands on the back row at far right. After the meeting, Bae commented to Lars Nessa that he had a feeling something was bound to go wrong. *(Lars Flato Nessa)*

ABOVE: At 61, Hugues d'Aubarède was the second oldest person to summit K2. From the top of the mountain, he called home to Lyon: "It's minus 20. I am at 8,611 meters. I am very cold. I am very happy." *(Raphaele Vernay)*

LEFT: The Italian climber Marco Confortola. Italy had a long association with K2: in 1954, two Italian climbers were the first to reach the summit. *(Marco Confortola)*

TOP: Gerard McDonnell holds an Irish flag aloft on the summit. In 2006, during an earlier attempt on K2, he was caught in a rock fall and had to be airlifted from the mountain. *(The family of Gerard McDonnell)*

ABOVE: Cecilie Skog and Rolf Bae had been married for little more than a year when they came to K2. Unlike other mountaineers who left spouses or partners behind for months on end during expeditions, the couple saw exploring and traveling as a way to be together. *(Cecilie Skog / cecilieskog.com)*

RIGHT: Norwegian climber Lars Nessa came to the Karakoram curious to see K2, but with no fixed plan of making it to the summit. In the end, he made it to the top of the second tallest mountain on earth. *(Lars Flato Nessa)*

Kim Jae-soo, the leader of the South Korean Flying Jump expedition. The Korean team, the largest on the mountain, included fifteen members. *(Karrar Haidri / saltorosummits.com)*

BELOW: Kim Jae-soo and the star climber from the South Korean team, Go Mi-sun. Go would die a year later on Nanga Parbat, another mountain in northern Pakistan. *(Karrar Haidri / saltorosummits.com)*

ABOVE: Jumik Bhote, pictured here in Kathmandu, had recently been promoted to chief Sherpa of the South Korean Flying Jump team. His son would be born while Jumik was climbing on K2. *(Virginia O'Leary)*

Jumik with his brother, Chhiring. Chhiring and other family members from their village in Nepal also worked as Sherpas for the South Korean team. *(Virginia O'Leary)*

TOP: Members of different expeditions at Base Camp carry Wilco van Rooijen on a stretcher to the helicopter emergency landing pad on August 4. *(Chris Klinke)*

LEFT PAGE, BOTTOM LEFT: Dutch mountaineer Cas van de Gevel waits for helicopter evacuation from K2 Base Camp. Helping rescue his friend Wilco van Rooijen, he spent the night bivouacking at 24,000 feet. *(Chris Klinke)*

LEFT PAGE, BOTTOM RIGHT: Marco Confortola is helped by military officials from a helicopter in Skardu, northern Pakistan. Badly frostbitten, all his toes would later be amputated. *(The Associated Press)*

RIGHT PAGE, BOTTOM LEFT: The leader of the Dutch Norit K2 team, Wilco van Rooijen, survived two nights without shelter on the mountain and called his wife in the Netherlands to help him find his way down. He lost nearly all his toes from frostbite. *(Wilco van Rooijen)*

RIGHT PAGE, BOTTOM RIGHT: Sherpa Pemba Gyalje. A commercial mountain guide from Nepal, he joined the Dutch team as an independent climber in his own right. He wanted to become one of the first Nepalese Sherpas to reach the summit of K2 without the aid of supplementary oxygen. *(Wilco van Rooijen)*

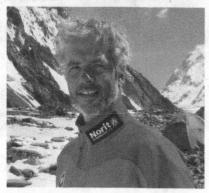

The gregarious Gerard McDonnell called his girlfriend in Alaska from the summit. He was the first Irishman to reach the top of K2. *(Wilco van Rooijen)*

Fredrik Strang at Concordia on the trek toward K2. The Swedish climber turned back from his own attempt on the summit when he saw the delay on the Bottleneck. Later, he helped bring down Dren Mandic's body. *(Chris Klinke)*

The American Eric Meyer poses with Chhiring Dorje, a Sherpa from Nepal who was a member of the American team. Meyer, an anesthesiologist from Colorado, almost died when his rope snapped on his descent. Dorje helped another Sherpa climb down the Bottleneck in darkness. *(Chris Klinke)*

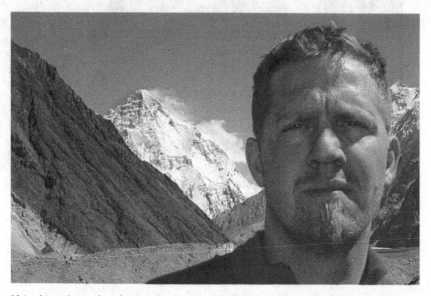

Using binoculars and a telescope, the American climber Chris Klinke sighted Wilco Van Rooijen wandering on the southern face of K2 on the afternoon of August 2, leading eventually to van Rooijen's rescue. *(Chris Klinke)*

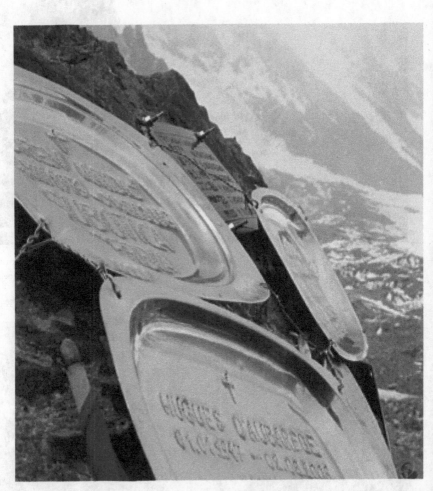

A close-up of metal plates at the Gilkey Memorial, located a few hundred yards above K2 Base Camp. The memorial is named for an American climber, Art Gilkey, who died on the mountain during an expedition in 1953. Most climbers visit it but few imagine they will end up immortalized there themselves. *(Graham Bowley)*

The second one also lay head-down against the ice but at a less steep angle. Both of the climbers, he saw, were still clipped onto the rope and hanging in their harnesses, which were supporting them.

Bhote felt that if he struggled he could perhaps have gone on. But he wasn't sure if he could stand, and these men were his clients; he had a duty to stay with them. He was, however, confused. He could not see the third Korean climber. Perhaps he had escaped the rope collapse and had gone on; or perhaps the fall had knocked him completely off the mountain; or perhaps Bhote was mistaken and he was never on the rope and was now somewhere up behind above the serac.

Bhote knew he and the other two men couldn't stay where they were for long. He shouted out, calling for help at first, and then out of sheer panic, but he grew tired. The two trapped Koreans also occasionally shouted for help and moaned. Bhote wanted to reassure them, but the cold crept over him and soon he found he had no strength to speak.

He started to cry. He couldn't feel his hands, and that scared him most, since they were his livelihood. He thought of Dawa Sangmu and Jen Jen in Kathmandu. If he died, he thought, there would be insurance money, wouldn't there? More than $5,000.

But Bhote didn't want to die. He didn't want his family to be mourners, walking to the puja at the Boudha stupa, carrying corn nuts for the monkeys and birds as offerings in his honor.

He imagined them stopping on the way to give one-rupee notes to the beggars at Pashupatinath, most of them grateful but some complaining when the notes were old and wrinkled. He imagined his family bringing fruit for the monks in the stupa circle, jingling money into the monks' pockets and lighting candles, before his brother fell prostrate, wailing Jumik's name. His mother screaming in anguish because she believed his death could have been avoided if only she had been a better mother.

Bhote's mind was wandering. His only hope was that rescuers would climb up from Camp Four—or that other teams were still making their way down from the summit and would find them.

CHAPTER THIRTEEN

3 a.m.

Marco Confortola had waded alone along the sloping snowfield from the top of K2. After more than an hour, he had seen headlamps in a line a few dozen yards below him and had followed behind them. He thought they belonged to the Korean team but their faces were obscured by the bright spotlights of their headlamps, which cast hazy penumbrae in the dark twilight.

Near the steep slope before the lip of the glacier, Confortola drew closer to the other mountaineers. He saw they were from the Korean team, though there was another climber with them who turned out to be the Irishman Gerard McDonnell.

Where are the ropes?

McDonnell shrugged.

The group of climbers searched for the route that would lead them around the crusted edge of the giant serac onto the Traverse but to their mounting frustration they could not find any sign of the ropes.

The end of the snowfield curved down abruptly in front of them, a slope of 30 or 40 degrees. Confortola dragged his tired body to the left and then back to the right on the top of the steep slope, willing himself to find the ropes. The fixed lines had to be down there somewhere, though neither he nor McDonnell felt sure that they were on the same path they had followed on the way up onto the snowfield.

And then, when the Flying Jump team lurched ahead toward the

lip of the glacier and one after the other went over the top, Confortola held McDonnell back. There was something about the look of the snow that made him uneasy.

Both men knew the risks of staying out overnight. It was ten o'clock. They were exhausted. The night was big and black around them. There was no moon and it was fiercely cold, minus 20, easy. Confortola's altimeter wristwatch said they were at 27,500 feet. They had no tent or sleeping bags, no extra food or oxygen. They knew their lives probably depended on descending quickly through the cold to Camp Four.

But they were on a steep slope and they had no idea where they were or where they were going. The lamp at Camp Four winked about half a mile below them, clearly but beyond their reach. Confortola's instinct told him it was no use looking for a way down anymore. They were better off waiting for daylight, when they could see where they were climbing.

"Let's stay here," he said.

He wanted to be certain that what lay beneath their boots was firm snow and not a crevasse. In addition, there were constant avalanches from these heavy snowfields, big, powerful falls that would crush them if they got caught up in one. Sure enough, minutes later Confortola heard a roll of thunder coming from the serac in front of them, then distant cries and shouts from beneath it. Then silence.

What was that?

I don't know.

Confortola wasn't entirely sure that what he had heard was an avalanche or ice collapsing from the serac but now he felt convinced they were right to stay where they were. They were going to have to bivouac, the term for staying outside without proper shelter under the night sky.

The two climbers sprawled on the steep balcony of snow. McDonnell was wearing his red climbing suit, gray balaclava, and climb-

ing goggles. He was tired, Confortola could see. Confortola wanted to make sure he was making the right decision for them both. He wanted a second opinion, so he took out his satellite phone and called Agostino da Polenza, the president of the Italian Everest-K2 committee, and a friend and mentor. Da Polenza was in Courmayeur, Italy. Confortola explained that he felt uncomfortable about the direction they were taking and that they could not find the ropes. He said he had heard what was probably part of the serac falling.

Confortola didn't expect anyone to climb up to rescue them. He knew what he was doing. Back in Italy he had trained in high-mountain safety and rescue and earned extra euros helping stranded climbers stupid enough to venture onto the steep slopes above his house. He brought them in with curses, sometimes snapping their poles over his knee for good measure.

Da Polenza agreed with him. *Be patient.* "Stay there. Wait for the morning."

Confortola switched off his phone and slid it back into his jacket. "Jesus, let's wait," he said to McDonnell, using the nickname—Jesus—he had given the Irishman, and McDonnell agreed.

Da Polenza had warned him to keep warm; there was a danger of frostbite, which was feared by all mountaineers but common in these cold regions of high altitude. As a person's body cools, it directs blood away from the extremities to preserve its inner heat; even when skin temperature falls to 10 degrees, tissues numb, cells rupture. Hands, feet, nose, cheeks are most vulnerable. In 1996, Beck Weathers, an Everest mountaineer, lost his nose and most of his hands to frostbite.

Confortola felt better after talking to da Polenza. To keep themselves warm and to have a perch on the side of the mountain, the two climbers scooped seats out of the snow with a pole and the picks of their ice axes. Confortola made McDonnell's seat slightly larger so he could lie back down. They also made room for their boots.

Even though McDonnell looked exhausted, Confortola knew that

on such a steep slope they couldn't allow themselves to fall asleep. The slope was 30 to 40 degrees and it would be easy to roll down.

"If you want to rest, I'll take care of the situation," he said.

McDonnell lay back, his blue water bottle hanging from his belt and his black and yellow boots planted in the hole they had cut in the snow.

Confortola turned off his headlamp. It was strange to be up there alone. It was dark and cold. The entire world was stretched out below in shadow. He watched the distant lights of Camp Four, and the single powerful light flashing near the tents. The camp seemed so close. They just could not get down to it. He was convinced they would be able to find the ropes easily in the morning.

At Base Camp, Confortola had gotten to know McDonnell during the final weeks of bad weather. When the storms roared in, the Italian was usually doing nothing much but sitting around in the two-man tent, listening to disco music on his iPod, chewing gum to help with the altitude, or taking long walks across the glacier to keep fit. He started calling in at the Dutch tent to discuss strategy, sometimes bringing bresaola to share, while Wilco van Rooijen or Cas van de Gevel prepared the basic cappuccinos.

He liked them all but he got along best with McDonnell, the handsome Irishman with the wonderful smile. McDonnell had let his hair grow long and had grown a beard, so Confortola had given him the nickname Jesus. McDonnell invited Confortola into his tent and showed him some of his photographs on his laptop—of the waxing moon over K2 or of his girlfriend, Annie, in Alaska or of Ireland. McDonnell took his photography seriously. Neither spoke much of the other's language but they understood climbing.

Outside his tent, above a string of Tibetan prayer flags, McDonnell hung a big Irish flag. He had had it hand-stitched by a tailor in Skardu. Confortola liked to joke with him: "It's just the Italian flag, all mixed up," he said, poking his friend in the ribs.

Now, as the night deepened on the mountain, Confortola forced himself to shiver to stay warm, gently shaking his arms and legs and clapping. Confortola's body bore the history of his mountaineering life. Tattooed around his right wrist was a Tibetan prayer from his 2004 Everest ascent. Another tattoo across the back of his neck spelled out *Salvadek,* or wild animal, which was how he liked to think of himself. He always wore a ring in his left ear. A self-styled "pirate of the mountains," at home he was known as a risk taker and headstrong. He liked fast bikes and speed skiing. In the mountaineering community, he was known as a wily survivor, a man with a big heart and good intentions, if also a little vain. Back in Italy, some other climbers called him, half in mocking jest, "Santa Caterina Iron Man." Around his right bicep he had a ring of six star tattoos celebrating the six peaks above 26,000 feet he had climbed so far in his life—soon now, there would be a seventh for K2.

Away to his left stretched the undulating top of the Great Serac. To his right the slope curved around to a huge gray buttress of rocks and the northern side of K2. In front of him hung the great emptiness beyond the serac.

Somewhere below was the way down into the Traverse. He could still see the light flashing at Camp Four. Everyone else who had made it to the summit must have climbed down onto the ropes and were probably back at their tents by now, he thought. The climbers down there had no idea where they were and if they were alive or dead. He and McDonnell were alone. He didn't know if anyone was still behind them on the summit snowfield.

Confortola was not worried. They were not going to die. They would escape their aerie in the morning. It was uncomfortable, that was all. Cold. To keep his blood circulating, Confortola stood up a few times and walked around the two holes he and McDonnell had dug in the snow.

Then the time passed slowly. The two men were both so cold and

exhausted that Confortola was afraid they were in danger of falling asleep. To keep them awake, Confortola began to hum one of his favorite songs, a song from Italy, from the mountains. "La Montanara."

Lassu' per le montagne (Up there in the mountains)
fra boschi e valli d'or (among woods and valleys of gold)
fra l'aspre rupi echeggia (among the rugged cliffs there echoes)
un cantico d'amor (a canticle of love).

Beside him, McDonnell seemed to respond to the singing and moved his body.

"Don't give up, Jesus," Confortola said, and he was saying it to himself as well.

McDonnell was a singer, too. During the bad weather in Base Camp, when many of the climbers feared they would have to cancel their climbs, the Dutch team's camp manager, Sajjad Shan, an impish twenty-nine-year-old Islamabad taxi driver, organized a party to lift the depressed mood. He pushed together three large mess tents and paid an assistant cook to sing, although the cook knew only two songs, one in Urdu and one in Balti. The porters started drumming on the food barrels. Some of the climbers began to dance. An expedition had arrived in camp with seven cases of beer and whisky. The Serbs paid a runner to fetch twenty-four half-liter cans of beer from Askole. Stepping forward into the silence, McDonnell sang a Gaelic ballad that moved some of the fifty climbers packed into the warm tent to tears.

They said the song had to be about the love of a boy for his lass. But McDonnell said, "No, it's about the yearning of a shepherd for his goat."

McDonnell liked Confortola but then he liked most people at Base Camp. He loved the beauty and isolation of the mountain, but the camaraderie of expedition life also appealed to him. The Dutch team's bulbous tents were perched on the rocks close to the camps of Hugues d'Aubarède and Cecilie Skog. Around Base Camp, McDonnell often carried his video camera, with its small microphone boom, and he filmed the teams' strategy meetings.

On free afternoons, he regularly walked over for a chat with Rolf Bae or with Deedar, the cook for the American expedition. Deedar had cared for McDonnell when he suffered the devastating rock blow to his head on K2 in 2006. Among the Dutch team, he was especially close to Pemba Gyalje and had helped the Sherpa to build a small rock altar for a puja ceremony when they arrived on K2; they played chants from an MP3 player.

On a small computer, he tapped out text messages to his family in Ireland and to Annie, who for a few weeks during this time was climbing Mount McKinley, North America's highest peak. He posted thoughts to his blog. Alone at night, he lay in his tent, listening to the cracks and groans of the Godwin-Austen glacier—shifting more than usual this year, he thought.

"Night now," he wrote in one dispatch, "and one hears the glacier ache beneath and settle with sound of distant gun shots at times. Stars galore and silhouettes surround. Best of luck on Denali, Annie."

Annie sent piles of letters to him in Base Camp, which were carried up from Islamabad by the company that had arranged their expedition, Jasmine Tours. He called hi mother every Sunday. She sent him holy water.

McDonnell was feeling hungry and thirsty and tired now. Under stress, at these altitudes the body did not function normally in a number of ways, and he hadn't been able to eat properly for days. When he had tried, he had not been able to keep anything down.

For Wilco van Rooijen, the joy of the summit had soon evaporated in the pain of the heavy summit snowfield. He was so tired he had fallen behind the other climbers and lost sight of their headlamps.

He laid his exhausted body down and fell asleep in the snow. When he woke up, he climbed lower for several long minutes, but he couldn't shake the vague sense that he had taken a wrong turn. The snows looked unfamiliar and he wasn't coming to the abrupt drop down to the fixed ropes. So he veered back to the right for several hundred yards across the top of the serac. It was then that he heard the sound of someone whistling shrilly.

About one hundred yards away he noticed a headlamp. When he got closer he saw in the light of his own headlamp Marco Confortola, who was standing up and shouting at the top of his voice. Beside him sat the hunched figure of Gerard McDonnell.

He realized they were trying to attract the attention of people down at Camp Four. He wondered where everyone else was and why Confortola and McDonnell were just sitting there. Why weren't they searching for the ropes down? But then Van Rooijen saw that they were in trouble. Confortola was massaging McDonnell's knees.

"Gerard is cold," the Italian said in his halting English. "We can't find the way down." Confortola had hoped Van Rooijen was someone who could show them the way down and he was disappointed that the Dutchman was lost, too. "Not safe out there," he added.

Confortola said that he thought they were in the wrong area. He described the crashing sound he had heard. Looking back toward the part of the snowfield where Van Rooijen had come from, he asked whether they should try in that direction. Van Rooijen shook his head and said it wasn't the right way, either.

"I am lost," he said above the wind, which was picking up. "We must be able to see something we recognize."

The three men began to explore the snows again. The balcony of ice thrust out and down for a few hundred yards before dropping

away. Feeling their way out a little distance, Van Rooijen went to the right, Confortola to the left, both men zig-zagging down the snow. McDonnell stayed where he was in the center.

With the help of his headlamp, Van Rooijen looked over the edge of a steep drop. Seeing the thick black air above a chasm, he realized that Confortola was talking sense after all. There was no way down here. Where were the fixed lines?

Far below, headlamps bobbed lower toward Camp Four. They tempted him. He turned and started to climb down but he had gone only a few feet when he heard Confortola behind him calling out loudly that he thought the snow was unsafe. Van Rooijen stopped himself and climbed back up. Confortola was right; it wasn't worth it.

When he reached the other two climbers, his headlamp lighting up the reflectors on their suits, he said, "Let's stay." But now it was Gerard McDonnell's turn to be seized by panic, warning that they couldn't stay there overnight. They had to try one last time to attract the attention of the people at Camp Four, he said. They would signal the way they had to go to get down. After a minute or two of yelling, however, they realized it was no use. There was no alternative but to bivouac for the night.

It was risky—some would say stupid—to stay on a mountain like K2 above 26,000 feet. Since they were proficient mountaineers, they should have been able to climb down the Traverse and the Bottleneck even without fixed ropes. They should never have been in this position in the first place. But having made up their minds, they settled back in the snow.

McDonnell sat in the middle; Confortola sat on his left-hand side; and Van Rooijen perched on the right. They turned their backs to the wind. It was not snowing. But as they hunched over, their coats were soon plastered with snow blown by the gusts.

Van Rooijen had bivouacked countless times before in the Alps, and often on the more perilous north face of high peaks, when the

interminably falling snow filled the space behind your back until you felt you were going to be pushed off the edge. In comparison, he felt, this was easy. He was also in good company. He looked at the other two men. The emergency mountain rescue expert. And McDonnell, whom he could trust with his life.

Van Rooijen didn't even bother to take his satellite phone out of his jacket to call anyone. When the sun rose, they would act fast, descend quickly. In a few hours he would be down in Camp Four. Then they could tell everyone about their adventure in person.

———————

Marco Confortola watched as the sky started to brighten at about 4 or 5 a.m.

"Let's go," he said, shaking himself.

Wilco van Rooijen was already on his feet, wading through the snow to the left-hand side of the ridge. McDonnell crossed to the right-hand edge while Confortola walked ahead to look directly over the head of the serac.

They were impatient. They wanted to lose altitude and relieve their bodies, which had existed above 26,000 feet for thirty-six hours. They wanted to get warm again.

They spent about half an hour looking for the ropes or a way down over the tip of the serac, until one by one they gave up and returned to the middle.

When he came back to the other two men, Van Rooijen muttered something but Confortola and McDonnell couldn't understand what he was saying.

Then to their surprise Van Rooijen turned away, strode forward, and began to back over the edge of the ridge.

CHAPTER FOURTEEN

6 a.m.

Wilco van Rooijen took a direct line down from the top of the glacier, backing slowly lower, securing his ice axe and feeling for each step with the points of his crampons.

While he had been searching for the fixed ropes to the left of the bivouac, Van Rooijen had realized something was wrong with his eyes. The eye is especially vulnerable at high altitude, where ultraviolet light is more intense than at sea level. Without protection, the ultraviolet radiation inflames the outer covering of the eyeball, resulting in excruciatingly painful snow blindness.

Van Rooijen recognized the symptoms because he had suffered the same problem at the North and South Poles. Dehydration, he was convinced, made it worse, and he was desperately thirsty. It had been a hot summit day and, foolishly, he had dropped his flask in the Traverse on the way up, so he hadn't had a drink since then.

Now he knew he had to get down immediately. If he didn't, and his eyes got slowly worse, he would be trapped.

Van Rooijen struggled to keep himself from panicking. On K2, the altitude was going to kill anyone in the end. And it was finally killing him. *Shit.* It only took a small mistake to slip and fall. He couldn't expect Confortola and McDonnell to carry him down, and no helicopter could get up to this height to rescue him. It was imperative that he descend quickly. He wasn't going to wait for Confortola

and McDonnell. They hadn't reacted when he told them. They were too tired and too absorbed in searching for the ropes. He had to save himself.

Now he climbed down, not knowing where he was or where he was going. The slope was so steep that the other two climbers disappeared from view within a few yards.

Van Rooijen knew that somewhere behind him were K2's vast lower gullies and the distant glaciers at the valley floor, all opening out beneath the dark morning sky. He had a suspicion that by getting lost on the snowfield he, Confortola, and McDonnell had wandered onto a completely different side of K2. He didn't think he was near the Traverse and the lines that the teams had fixed on the way up.

However, three hundred feet into the climb down, he saw a rope a few yards away. He didn't recognize it; some other expedition must have fixed it on an alternative route, he thought. Nevertheless, he clipped on to it and it gave him some encouragement.

Then, facing the mountain, he glanced to his right and saw, only two yards away across the ice face, a dreadful scene.

Three climbers were hanging from ropes against the smooth ice wall leading down from the glacier. They were tangled in two ropes, one of which was still attached to their harnesses. It was keeping them from falling to their deaths.

At first Van Rooijen thought he must have simply lost his mind. It took him a few moments to accept they were real. *Who were they? How did they get here?* He didn't know which part of the upper mountain he was on, so as far as he knew, these strangers belonged to a completely different expedition than the ones he had climbed up with the day before. They could have climbed onto K2 from the Chinese side.

He focused on the trapped climbers. They were beaten up and bloody and unrecognizable.

The first one was dangling upside down, his harness wrapped around his feet. He was moaning from the pain and cold. His face

was so badly smashed that Van Rooijen couldn't tell who he was. A large camera swung from his chest.

About thirty feet below him, the second climber was also hanging upside down but at a less steep angle. He seemed to be supporting himself with one hand on a ledge, and was almost lying down, but he was staring ahead listlessly, as if he had given up. Just a few feet below him, the third climber sat upright, awake and looking terrified.

It was a horrific sight. The three men had suffered a brutal fall and then must have been hanging there for hours in the subzero temperatures. They had been slowly freezing to death. Van Rooijen especially pitied the man at the top, the blood running to his head, barely able to breathe.

But even though they looked desperate, Van Rooijen, who himself was clinging to the side of the mountain, wondered what he could do. If he tried to untangle the ropes or cut them, the climbers would fall. Even if he were successful in freeing them from the ropes, the climbers could not walk for themselves, he thought. He had no strength left to lift them. And every extra minute he stayed with them, his eyesight was getting worse and he was becoming ever more befuddled by the altitude.

When the Dutchman climbed down to the third climber, the man asked him for help. He had lost his gloves. Van Rooijen handed him a spare pair.

"I have to go," Van Rooijen said. "Okay? I am going snow blind."

"I radio already," the climber said. Van Rooijen didn't recognize the accent. The climber added that people were coming up to rescue him.

His words made Van Rooijen feel better about going on. Still, he hesitated. It was against every instinct in his body to leave the climbers. If he left them, and the rescuers didn't come, he would be abandoning them to die. But Van Rooijen had to save himself. He had his own struggle for survival ahead of him. He couldn't help these men.

Still he hesitated. He stayed with the climbers for just a few minutes. Then he left them and continued to drop down the side of the mountain.

Van Rooijen's thirst was so desperate and he was so concerned about his eyesight that he had no time to worry about whether following an untested route down the side of K2 was a wise idea and whether it would lead him to safer ground or to a dead end.

The ice and rocks were steep and he held on with his wet gloves. He felt for each next step with the teeth of his right crampon.

On a stretch of icy rocks, he couldn't find a place to put his boot. Switching the way he was standing, he reached down with his left boot, but he fumbled, his boot slipping out from under him, scratching against the rock, and he managed to save himself only by gripping on to the mountain face with his fingers.

A few hundred feet later, the rope ended, and he climbed down without its support. The climbing became steeper, until finally, a few more yards on, he stood at the top of a stretch of sheer brown rocks and realized there was no way past them. He tried desperately to keep his balance as the world swirled thousands of feet below him. He laid his forehead against the rock. Every instinct told him to get lower in order to breathe oxygen and, when he reached camp, to drink water. The idea of climbing back up again was hateful but there was no other choice. He realized he had to do it.

Ascending through the ice and snow was far tougher than climbing down because he was so exhausted, and for every three painful steps up, Van Rooijen slid two back. He counted the steps and then stopped to refill his lungs.

The sun was higher now and he was hot. He forced himself to breathe through his nose, not his mouth, to keep the moisture in.

Once when he stopped, he slumped forward on his ice axe and, without meaning to, fell asleep. When he woke up, he blinked into the sun.

He saw he was getting closer to the place where the three trapped climbers had been hanging. Squinting, he thought he could make

out two other figures with them now. Marco Confortola and Gerard McDonnell must have descended and were trying to help them, he thought. They were still a few hundred yards away from him.

Above him to the left were huge fists of black rocks, and to the right was a possible route beneath a serac. The serac looked as frightening and dangerous as the one he had passed under on the way up to the summit. He wasn't going to be able to make it all the way back to where he had started, so he could either follow the rocks around the western edge of the mountain, though he had no idea where that path would take him, or he could go under the serac.

He called out to McDonnell and Confortola, hoping they could see which direction he should take.

"Marco! Gerard!" His voice was hoarse. "Which way? Can you see? Left or right?"

He gripped the rocks and repeated the question but his voice was weak and they couldn't hear him. Then he went right, moving out under the serac.

Below him was a drop of thousands of feet and he still didn't know where he was heading. Yet, after about a hundred feet, he saw another rope fixed to a screw. That was good news. Traversing toward it, he clipped on to the rope and followed it.

It was taking him on some sort of route, although it looked unfamiliar. When he saw four oxygen bottles hanging from the next screw, he began to recognize where he was. He thought it had to be the Traverse. This was the same route he had followed on the way up. But it looked completely different. The snow was blasted away in sections on the slopes and there had been icefalls.

He reached a place where the rope hung diagonally over a huge rump of rocks. He rappelled down and after a few minutes he recognized Gerard McDonnell's 5mm Spectra line. Then Van Rooijen saw the Bottleneck and was elated.

He let go of the end of the rope and descended carefully until the ground started to level out. By now, however, clouds had started to blow around him.

At the lower altitude, Van Rooijen's eyesight was improving, at least temporarily. His next goal was to reach Camp Four. He was soon disappointed. The clouds had grown thicker around him and he couldn't make out the way along the Shoulder.

He climbed down several yards farther but the whiteout forced him to stop. He could see nothing. Below him somewhere was the Shoulder and the safety of Camp Four, but there also lurked crevasses and the steep drops on both sides of the long ridge. It was too much of a risk. He couldn't go on.

Faced by a cold wall of fog, Van Rooijen sat down. He fumed with frustration and with disappointment in himself. He had studied the history of K2. He knew how tough it was to find the high camp on the descent; that's why he had brought a lightweight GPS and a strobe light to the mountain. But when he had set out the day before, the weather had seemed so perfect, and the other teams had promised to put up flags and bamboo sticks and fish lines to guide climbers on the Shoulder. That was all part of the cooperation agreement. So he had left his GPS and the light behind in the tent. He thought now how reassuring it would be to hold the GPS or to have the fish line leading him down.

What a mess! Despite Van Rooijen's pains to assemble a team worthy of taking on K2, he thought, the Dutch expedition had become entangled with lesser climbers. They had forgotten equipment they had promised; they had underestimated the sheer difficulties of this climb. He was not saying the other climbers were incompetent. Most of them were good enough. But there was the beginning of the trend on K2 that had afflicted Everest decades ago. Unqualified climbers paying big money to come to a mountain they had no business attempting. With just a click on the Internet you got a place on a trip.

Van Rooijen remembered his satellite telephone tucked away in-

side his coat, and a new hope began to form in his mind. He pulled the phone out, nearly dropping it, then cradled it carefully. But when he held the Thuraya's glowing screen a few inches from his face to read the numbers stored in the electronic address book, he could not see them.

His thumb flicked desperately through the list. He wanted to call the Dutch team's main point man in the Netherlands, Maarten van Eck. Van Eck, he thought, would know what to do.

Van Rooijen tried to type in his friend's number but he couldn't remember it and the call failed to connect. Eventually he realized that the only number he knew by heart was his own in Utrecht, where his wife would be waiting. Though she might be out at the day-care center where she worked.

Van Rooijen dialed the number, and Heleen picked up. She was sitting on the sofa with their son, Teun. Heleen had not heard anything from her husband in three days and she had begun to give up hope that he was alive.

"Where are you?" she asked.

Relieved to hear her voice, Van Rooijen spoke quickly, telling Heleen about the bivouac and about leaving Confortola and McDonnell.

"I am alive," he told her. "But I can't see and I am lost. I don't know where I am."

Van Rooijen described his thirst but he tried to reassure her and said he thought he could see Base Camp so he knew he would get a drink soon. Even as he spoke, though, he realized in another part of his mind that he was babbling and making no sense. Base Camp was in reality still nearly 10,000 feet below him.

Then, as he was talking to Heleen, he saw shadows moving in the distance, which he thought were climbers in the fog. He told Heleen, and she shouted into the phone that he had to go toward them. But within a moment the shadows were gone. Van Rooijen realized he couldn't trust his own senses.

"Listen, write this down," he said, trying to stay as matter-of-fact as he could. He estimated his altitude as being about 600 feet above Camp Four. "I am at seventy-eight hundred meters on the south side. Below the Bottleneck. Call Maarten and ask him to call Base Camp."

He told Heleen he would call her back within the next twenty-four hours. "Don't worry," he assured her. "I am safe."

After she had hung up, Van Rooijen realized how alone he was. She had seemed so close, and now she was gone.

Maarten van Eck, a fifty-one-year-old businessman with silver-tinged black hair and square platinum-colored glasses, was sitting in the kitchen of his two-story houseboat, the *Archimedes*, on the Merwede Canal in Utrecht when Heleen called to tell him about Van Rooijen.

It was here on the boat that Van Eck had set up what he liked to call K2 Base Camp Netherlands—essentially a kitchen table with three computers and a bank of phones. He had spent the previous few nights sleeping on his couch to be ready to take calls and updates from Wilco and the gang on K2. They had an agreement that on the descent Van Rooijen would call in at specified points—the start of the fixed lines, the Bottleneck, Camp Four—but he had heard nothing from him since the summit.

After reassuring Heleen, Van Eck called the Dutch climbers in the tents at the real K2 Base Camp in Pakistan and they radioed up the mountain to Pemba Gyalje, who was waiting at Camp Four.

In the whiteout above the high camp, Van Rooijen's Thuraya rang and he greeted Gyalje.

The Sherpa asked him to describe his location.

"I really don't know where I am exactly," Van Rooijen said. He squinted into the mist. There was snow and great hulks of rocks but nothing that struck him as familiar.

"I think I am near Camp Four."

Gyalje said he and Cas van de Gevel were coming up to find him. He told Van Rooijen to climb down toward them.

"Come down but keep left," Gyalje said. "Don't go right because that's the south face. We are coming up. We will shout."

Van Rooijen climbed down through the snow, excited now. Surely they couldn't miss each other. He didn't know what he would do if this plan failed. He called their names.

"Cas! Cas! Pemba! Pemba!"

He could already imagine their reunion.

A dark figure appeared in the distance in the swirling fog but it turned out to be a rock. Van Rooijen saw another shape and climbed down toward it. "Cas!" Again it was the mountain playing tricks on him.

After descending a few more feet, he abruptly stopped, feeling uneasy.

As the fog shifted, he saw he was standing above a steep drop. He turned slowly, then retreated quickly back up the slope. He had been close to falling. He saw a way to the right and climbed down in that direction, though it took him among huge rocks.

He began to get the disturbing feeling that he had missed Van de Gevel and Gyalje. He stopped and realized it was true. The world around him was cold and empty; he was lost and alone again.

The feeling was devastating. And now Van Rooijen was afraid that in trying to reach his rescuers he had strayed onto the big southern face, far down the wrong side of the Shoulder. Continuing in this direction meant getting even more lost, or at some point slipping unnoticed into the thousand-foot gullies beneath him. But it would take too much effort to climb back the way he had come. He couldn't face it. So he went on.

As he climbed down, he called Heleen again. He was worried the call wouldn't go through on the satellite because there was often a difficult connection, but she picked up on the first ring.

"Where are you?" he heard her say. "Can you see any other mountains? Can you see Broad Peak?"

"I am sure I am at Camp Four," he said abruptly. "Just tell Maarten. I am at Camp Four," he insisted. Hanging up, he regretted his blunt tone.

He continued down. He wanted to breathe the air of the lower altitudes and he wanted water. He looked longingly at the snow. He knew the snow had no calories; you lost energy melting it inside your body, and once he started eating it, it would taste so good he wouldn't be able to stop. Still, he hacked out a chunk with his ice axe, rubbed it against his lips, and swallowed a few flakes. They burned his mouth, yet for a few glorious moments they quenched his thirst. To avoid blisters and numb his throat, the next time he dropped the snow directly down into his throat.

Wherever he saw a safe stretch of ice or rock in front of him, Van Rooijen put his boot there and stepped another few inches lower. *Down, down,* he told himself, despite the exhaustion he was feeling. He fell asleep, then woke up angrily and forced himself on. Then he came to a point where the mountain face sank beneath him in the fog and there was no place to put his boot. Not to the right or to the left or straight ahead.

Folding his legs, he sat down. He grabbed his knees closer, trying to keep in the warmth. He had, he thought, reached the end.

Sitting on the precipice, he rested his head on the stone behind him and he reflected that K2 was such a beautiful peak, but that now amid the dark rocks and clouds it had turned ugly. He was trapped in a nightmarish otherworld of shifting fogs and bottomless voids. This was a place no man or woman was ever meant to be.

He tried to call again on the Thuraya but the batteries were either too cold or dead. He saw a group of climbers nearby and called out to them for help, but they disappeared.

CHAPTER FIFTEEN

7 a.m.

Up at the end of the summit snowfield, Marco Confortola and Gerard McDonnell followed the route Van Rooijen had taken lower around the edge of the serac. As they lowered themselves down, the two men could barely believe that the Dutchman had abandoned them. The altitude, the lack of oxygen, and the exhaustion must have finally driven Van Rooijen out of his mind.

Backing down several yards, Confortola saw three climbers off to the right. They were trapped in ropes and hanging several yards apart from one another against the rough ice on the side of the mountain. Some other lengths of old rope also hung down between the rocks. Confortola remembered the cries he had heard in the darkness the night before.

McDonnell was about eighteen feet above him, and Confortola called up to tell him to come and look at what he had discovered.

"Come here, Gerard!" he cried, his voice growing louder. "Come here!"

He couldn't tell who the climber at the top was. He was dangling headfirst down the slope. But Confortola recognized the big camera hanging around his neck. It was a German Rollei; one of the South Koreans in the Flying Jump team had owned a similar camera.

Confortola could recognize the climber at the bottom—he was a Sherpa. He had lost a boot; the man's left foot, exposed to the air, was covered only by a sock.

All three climbers seemed to be alive, though it looked to Confortola as if they were barely hanging on. He wondered why Van Rooijen had not stopped to help them. Maybe the Dutchman hadn't even noticed the climbers, although he must have passed close by. Van Rooijen had perhaps concluded that he couldn't do anything.

When Confortola looked down, he could see Van Rooijen about four hundred feet below them. He had descended rapidly but had now stopped and appeared to be peering tentatively over a stretch of steep rocks. McDonnell had come down closer to Confortola, and the two men whistled to Van Rooijen to tell him to change route, but it seemed he couldn't hear them.

Confortola, too, was doubtful about what he could do to help the trapped men. These guys had been hanging all night. Confortola and McDonnell had to think of themselves. But at the same time, Confortola thought, if the three men were going to die, it was better they died respectably, and not hanging upside down like carcasses.

McDonnell was already lifting up the head of the climber at the top, trying to make him more comfortable. He had a history of aiding mountaineers in distress—he had been awarded a Denali pin in 1998 for bravery on Mount McKinley and in 2003 he had helped an older Irish climber descend from near the top of Everest after his oxygen failed.

It took only a moment for Confortola to decide to help his friend. He knew that he could never have left these men.

Their first task had to be to relieve the suffering of the top Korean with the camera by turning him the right way up. They also had to untangle his harness, which was wrapped around his legs. Then they could lower him down to the other two climbers, where the slope was less steep.

The three climbers were hanging on a steep face of ice and snow. Confortola and McDonnell were a few yards away on a marginally less

steep incline, about 30 to 40 degrees. If they could untangle or cut the rope, they could lift the climbers across and make them more secure.

"Give me a hand so I can help these people," said Confortola. "If you hold the head of the first guy up, I can try to get his harness off."

They had to be careful because the climbers were dangerously intertwined. When they tried to pull one of the men closer, another swung out, threatening to take all three down with them. They also had to think of themselves because they were not protected by ropes. It was going to be a terrifying balancing act.

McDonnell braced himself and held up the head of the first climber. Confortola descended a few yards to test the state of the ropes and to see whether he could untangle them or whether it was safe to try to cut them. He realized, though, that the ropes were too tight to untangle, and they were supporting the climbers; severing them would cause the men to tumble down the mountain. He searched for an extra loose bit of rope he might use, and for some spare oxygen cylinders.

He saw that the two climbers at the bottom had oxygen cylinders. They were next to their backpacks among the ropes. But the men were missing oxygen masks, which must have been lost in the fall.

The second climber was unconscious, he discovered. When Confortola reached him, he initially thought it was a Sherpa. But he realized later that it was Park Kyeong-hyo, one of the South Korean climbers. From his harness, Confortola retrieved a yellow and gray knife. A few yards away a yellow Grivel axe lay on the ice. Confortola thought he might be able to use the knife and axe to do something with the ropes. Holding both like weapons, he climbed back up to a position a few yards above McDonnell and the uppermost Korean. There he cut ten yards of old rope from one of the spare lengths.

Dropping a few yards, he rammed the Grivel axe into a crack in the ice and secured the rope around it. He tied the other end of the rope around the Korean's waist, and then he opened the man's har-

ness. He took the weight of the Korean from McDonnell and began to lower him down.

All this took a long time, more than an hour, it seemed, although Confortola wasn't sure how long. He and McDonnell had been exchanging only a few words as they worked, and Confortola now realized that McDonnell had gone quiet.

When he looked up, he saw that McDonnell was climbing back up the ice face toward the top of the glacier.

"Where are you going?" he called.

At first he thought his friend was climbing higher to take a photograph for evidence. But when the Irishman continued to climb past the ropes, Confortola became alarmed. He didn't know where his friend was going.

"Jesus! Come back! Jesuuus!"

There was no answer. Without turning around, McDonnell scaled the slope and disappeared around the edge of the serac.

Confortola was mortified. The altitude must finally have gotten to McDonnell's brain. No wonder, after everything he had been through. The bivouac. No oxygen. No water. The horror of the trapped climbers. His mind had been plunged into delirium and perhaps he thought he still had to reach the summit.

Confortola paused to consider what he could do now that he was left alone. He stared up at the top of the serac but McDonnell had really gone. He couldn't climb up after his friend. Should he descend now? Was he going to lose his mind like McDonnell?

The sun was bright but he was freezing, hungry, and so tired. Anger, however, gave him new energy. He climbed down to the first climber. He was on a less steep slope and Confortola secured him and propped him upright with a ski pole so that he could breathe more easily. He also lifted the second climber to a sitting position. He hadn't freed them from the ropes entirely because it was the ropes that were keeping them on the mountain.

He climbed down the final few yards to the Sherpa, who was awake. Confortola didn't know his name. The man was confused but of the three he was the least injured. His foot had been exposed for the entire night, and in a weak voice he begged the Italian to help him.

Confortola urged him to stay calm. The Italian took his own outer high-altitude glove from his right hand and pulled it over the man's left sock.

"I call for rescue with the radio," he said to the Sherpa.

He had seen a radio microphone coiling from one of the climbers' jackets and he thought he could see the radio set down the slope, where it must have fallen on the ice. Confortola climbed down slowly, careful not to slip, and retrieved it.

When he held it in his hand, he shouted into the mouthpiece, and heard the voices of two Sherpas answering him. *Emergency!* he shouted. Confortola explained where he was and what had happened. *But I'm exhausted. It's impossible for me to help anymore. Come quickly.*

About this time, a strong avalanche roar sounded somewhere across the mountain, and Confortola realized he had to be quick. The serac was unstable.

He had spent three hours with the trapped climbers. It was going to take another four to get down to Camp Four. Now he climbed above the three men and shoved his own axe in the ice to give further support for the ropes. Then he left them and crossed down toward the Traverse, which yawned without fixed lines. He thought of the roar he had heard earlier and guessed that ice may have fallen from the serac and swept the lines away.

Confortola went vertical, scrambling out onto the slope beneath the serac on his crampon tips. He only had one outer glove. His feet felt heavy and numb. Because he had left his axe in the ropes with the three trapped climbers, he had to use the point of his ski pole as an axe to support him, thrusting it like a dagger into the ice. In that way, he pulled himself across, staring straight at the face, feeling the

frightening overhang of ice above him and not daring to look at the drop below.

He was relieved when the end of the Traverse came close. He wanted to get out from under the serac.

Here he found a length of what seemed like old rope that he followed down into the Bottleneck. It was still hard climbing, and he was exhausted, but it was easier than it had been in the Traverse. He felt some relief.

When he came off the rope, he paused, hot and thirsty. He wished he could rip off his heavy suit to get some air. Several yards down in the gully he noticed an ice axe lying in the snow. It had probably been dropped by another climber. It would be invaluable to him, but to get to it he would have to climb down and across the ice for twenty yards. As he climbed out to reach it, his boot caught on a piece of ice and he tripped.

Confortola rolled fast straight down the gully, bumping hard against the ice, screaming and thrusting his arms out and kicking his legs, desperate to stop himself. This was it. He knew he was going to die.

He rolled for about ten yards before he stopped himself. He lay back on the snow, breathing hard. He was alive.

Standing up slowly, he found his legs and arms were stiff but he was uninjured. He had lost his other glove, however.

He climbed down several more feet, though he wasn't sure exactly how far he went. He was not sure of distances anymore. He was close to the Shoulder, but still within range of any avalanche from the serac, when he heard an explosion.

Several hundred yards away, up at the top of the big glacier, a huge avalanche cloud burst from the head of the serac. The ice and snow poured down across the Traverse and pummeled into the rocks at the side of the Bottleneck.

There were big chunks of ice, tumbling and bouncing down over

the rocks, followed by hovering clouds of snow, rolling in a channel beside the Bottleneck but also beginning to spread out across the gully.

Confortola watched, transfixed, his ears filled with the great rushing groan of the avalanche. The ice river bounced and poured toward him: within a few seconds, surely, he would be engulfed. But the avalanche's momentum slowed, the snow cloud died away, and only a few tributaries passed close by, stopping about thirty feet away from him.

As the avalanche had poured down from the Traverse, he had noticed something yellow caught up in the ice. He thought he had recognized something. Gerard McDonnell had been wearing yellow and black climbing boots.

Now, a few yards away, there was a dark spot in the snow. When Confortola crossed down to it he saw blood streaked across the ice and human remains. He saw bits of brain and a human eye, a blue eye. He picked the eye up and held it for a moment in his hand, staring at it, and then he placed it back down again.

Confortola knelt in the snow. He felt hopeless. He thought about McDonnell, about the good times they had had in Base Camp. *Gerard. Jesus.* He couldn't be sure, and his mind was struggling to function properly in the altitude. But he thought that McDonnell had probably climbed up onto the top of the glacier after he had left the three trapped climbers and he had been hit by the avalanche.

After a few minutes, Confortola forced himself to stand and he climbed down.

He hated the mountain now and wanted to go home. But he was so tired that several minutes later, he stopped and lay down on his back in the snow.

He told himself he could not fall asleep. He had to fight the feeling that the mountain had finally gotten him. But it felt good to rest at last, to lay his head against the slope and close his eyes, forgetting what he had witnessed.

His hands burned with the cold, and he put them behind his head, tucking them inside his hood.

Clouds crept over the slope and slowly snow started to fall. Confortola didn't move.

What must have been minutes later, he shook himself awake.

"Marco! Marco!"

Someone was standing over him, calling his name, and trying to thrust an oxygen mask over his face.

CHAPTER SIXTEEN

8 a.m.

Eric Meyer and Fred Strang were surprised by Pemba Gyalje's appearance when he came to the door of their tent. The usually stoic man was nearly hysterical.

They unzipped the nylon tent door and helped him inside and onto the mats.

"Come on in," Meyer said in a soft voice, seeing that the Sherpa needed comforting. "What's wrong? Sit down."

The two men were resting on their sleeping bags. They helped Gyalje sit against some gear, made him tea, and told him he had to calm down. The tea would help him rehydrate.

Gyalje looked exhausted and was barely able to lift his head.

He had been up for most of the night since he had come down from the Bottleneck. He was zipped up in his dark blue Feathered Friends climbing suit. His breath billowed out in the cold air.

He started to cry as he told Meyer his account of how he had found the ropes cut in the Traverse and how he had made it down. Gyalje was a survivor, Meyer could see, but he had had to draw on deep reserves to descend and it had cost him.

It seemed to Meyer and Strang that Gyalje was also feeling guilty because though he was safe, his friends Wilco van Rooijen and Gerard McDonnell had still not made it down. Yet he was terrified about returning to the Bottleneck.

"What can I do?" he said, rubbing his eyes with the heels of his hands. "I am feeling bad."

Earlier, before dawn, he had confronted Big Pasang Bhote and Chhiring Bhote before they left Camp Four, urging them not to go back up into the Bottleneck to search for survivors. It was too dangerous. He suspected that Kim, the South Korean leader, was pushing them to go up there because the three Koreans were missing—Park Kyeong-hyo, Kim Hyo-gyeong, and Hwang Dong-jin. But the two Sherpas had told him they were going of their own free will. They wanted to go because Jumik Bhote had still failed to return.

Talking now to Meyer and Strang, Gyalje was adamant that they all should descend from Camp Four soon. None of them should stay at that altitude for many more hours, he said.

"We must go down," Gyalje said. "Before we lose more energy. The weather is also getting worse."

Meyer realized Gyalje could use some of his doctor's help. He shook some pills into Gyalje's hand, dexamethasone, dextroamphetamine, and 200 milligrams of Provigil. The capsules seemed to help; Gyalje soon seemed more alert. He said he was going back to his tent to rest.

The sun rose and Meyer and Strang went outside. At this altitude, the dawn was quick and already the sun's rays shone on the Bottleneck and the hanging glacier. The air temperature, which had dropped sharply during the night, had risen again and was a few degrees above freezing. They could see the slopes. A dozen or so climbers were standing around the tents—including Go and Kim and the six or seven members of the Korean B team, and the group of the other mountaineers who had been expecting to make a summit attempt today but had now called it off.

Everyone was staring up at the mountain. Meyer could see the day was going to be stunning again; the air was so clear. The sky arched over the summit. Crystals of snow seemed to jump across the waves

of the Shoulder, where the wands and red flags Marco Confortola had set the day before fluttered in the breeze.

At about 7 a.m., Cecilie Skog and Lars Nessa walked over to the Americans' tent. Skog borrowed Strang's satellite phone to call their manager in Norway who was going to let Rolf Bae's parents know about his death.

She spoke of walking out a short way onto the Shoulder for a small ceremony to say good-bye to her husband properly. But at around 8 a.m., she, Nessa, and Stangeland set out for Base Camp, leaving their two tents standing.

Those who remained behind looked to see whether they could locate anyone beyond the Shoulder. The Bottleneck and the serac were a beautiful blue-gray. Up to the left of the serac, on its western edge, where the climbers had seen headlamps the previous night, the onlookers at Camp Four could now see black specks in the snow. They pointed, able to make out the specks with the naked eye but also staring through binoculars. The specks, they realized, could be bodies but they were not moving, except one. A single figure was standing alone in the snowfields above the serac. As they watched, the figure moved slowly through the snows to the right, zig-zagging higher and then descending again toward the lip of the serac. His mind must have gone, or he was panicking, for he was heading in the wrong direction if he was going to descend to the Traverse and come down the Bottleneck. After a short while, when clouds started to drift in, the mountaineers at Camp Four lost sight of the figure.

A few of the climbers took photographs. Strang shot some film. It had been so dark and cold during the night that forming a clear picture of what happened had been impossible. But now they counted who was missing: Van Rooijen, McDonnell, Confortola, Jumik Bhote, Hwang, Kim, Park. There was still some uncertainty about Hugues d'Aubarède. His HAP, Karim Meherban, was also not accounted for.

Standing outside his tent, Meyer took out one of the Americans' radios and tried to make contact with anyone who was still up on the mountain and alive. He went up and down the frequencies, turning the knob on top of the radio, even though he still did not know for sure who among those missing possessed a radio and who didn't. They believed that Gerard McDonnell wasn't carrying a radio or a satellite phone because they thought he had given his satphone to Pemba Gyalje at the summit. Wilco van Rooijen had only his Thuraya.

"This is Camp Four," Meyer said. "Do you hear us?"

He spun the dial around and listened to the static. Some of the others still had binoculars trained on the specks.

What if someone was alive but couldn't talk? What if they were frozen or in such a state of hypoxia that they couldn't speak?

"Press the talk button if you hear us," Meyer said, hoping.

Still, nothing.

Strang had lit three burners and was melting snow just outside the tent to prepare water for anyone who came in. Survivors would need liquids quickly.

They were ready to go up to rescue people if there were signs of life, but so far they had none. They could not bring down a person unable to move on his own.

Among the climbers gathered around the tents, the sense grew that they were in the middle of something serious, an escalating tragedy beyond their power to cope. Cas van de Gevel stalked out of his tent. He looked exhausted. His eyes were bloodshot. He said he was going to search for Wilco van Rooijen and Gerard McDonnell, but Strang pointed out that he couldn't just run up into the Bottleneck without any idea of where they were likely to be.

"This is not a guided tour," added Meyer. "If there were one person, we could go get him. But there are nine missing."

Down in Base Camp, the Dutchman Roeland van Oss and the American Chris Klinke, who together were now leading the informa-

tion gathering and setting up the emergency operations, made plans for people still in Camp Four to organize and send a rescue party into the Bottleneck. At the high camp, however, there was an overwhelming reluctance to go up. As far as Meyer and Strang could tell, they had no ropes, save those that were pinning down the tents. And they had only a single bottle of oxygen, which was the six-kilo bottle Chhiring Dorje had taken all the way to the summit and back again without using.

By 10 a.m., the serac and the Bottleneck were cut off from view as the weather turned. Gray clouds rolled over the summit and billowed around the great face of K2, closing around it like a curtain. The temperature plummeted again to minus twenty degrees or lower.

By noon, most of the climbers decided they had had enough and they couldn't wait any longer. Who knew what was going to happen to the weather next? Not to mention the fact that they had been above 26,000 feet for nearly forty-eight hours.

"We're going down," said Meyer. He knew it would be dark before they reached the base of the mountain.

The American team packed up their belongings but left their tent. A second American expedition had arrived at Base Camp and they had an agreement they would use Meyer's tent for their summit push.

Van de Gevel was still lying inside his tent. He was going to wait at Camp Four. Pemba Gyalje said that he would stay awhile as well, in case there were any survivors, but he wasn't going to wait for long.

"I stay for a few more hours but I come down today," he said.

The Koreans were also staying.

A group of five climbers led by Meyer and Strang came together on the slope outside Camp Four to begin their descent. Some of those who had come up a day late to try for a second night's summit attempt were disappointed that they had never gotten the chance because people had not turned back when they should have. They were not going to go for the summit while climbers were still missing.

The mountaineers had a big descent ahead and Meyer handed out a few more drugs—Provigil, dextroamphetamine—to give a kick to their systems. They left Chhiring Dorje's oxygen bottle with Gyalje along with a bag of resuscitation pills. One by one, they climbed down the last hundred yards of the Shoulder and over the brow onto the Abruzzi ridge.

Up on the great hump of the Shoulder, the two Sherpas Chhiring Bhote and Pasang Bhote scoured the area below the Bottleneck for the missing Korean climbers.

Just after noon, through the mist, they noticed something in the distance. Thirty or forty yards away, a climber was crawling on his hands and knees.

When they reached him, he wasn't making much sense. Pasang, who was carrying the radio, called Pemba Gyalje farther down the mountain. *We have found someone! He is collapsed.*

They said the climber was wearing a green and black suit, and hearing this description, Gyalje realized the climber had to be the Italian, Marco Confortola.

He told the two Sherpas to get out of the Bottleneck area quickly and bring him down. But Pasang said the climber was out of the most dangerous area and they still planned to go higher to search for Jumik Bhote and the Koreans.

You climb up to bring this one down?

Gyalje thought about the Bottleneck, and the hell he had survived the previous night.

Pemba?

Big Pasang and Chhiring said they were setting off.

Pemba relented. His teammates in the Dutch expedition were still missing. He wanted to find them. *Okay. I come. I will bring the oxygen.*

Pemba Gyalje and Cas van de Gevel packed up and climbed out tentatively onto the wasteland of the Shoulder. They were following the same route over the snow they had climbed a day earlier. This time, Van de Gevel thought, he was without Wilco van Rooijen and Gerard McDonnell. He looked from side to side but he could not see his colleagues anywhere in the snows.

Occasionally, the mists above them parted, revealing the great summit slopes. At one point they saw two black figures moving several hundred feet above them. It was the two Sherpas from the South Korean expedition who had gone out to search the slopes.

Then the clouds came down again and Gyalje and Van de Gevel could see nothing.

Van de Gevel felt his body giving in. It had been a long few days. He stopped and said to Gyalje, "If I go onto the Bottleneck, I will never come back." Even for Wilco, he couldn't go on.

"We should not split up," said Gyalje.

"It will be safer," said Van de Gevel. "I am sorry."

The clouds were thick now, and the two men agreed that Van de Gevel would sit where he was and mark the way back to Camp Four for Gyalje. They each had a radio and could communicate if they got into any trouble. The Sherpa turned and climbed up into the mist.

The man in the black and luminous green climbing suit lay unconscious in the snow. His hands were folded behind his head. He wasn't wearing any big climbing gloves and his harness was half off. Pemba Gyalje saw that the snow was cut and churned up around him.

Gyalje took a photograph to record the state of the climber and then he took out the oxygen tank he had carried up and tried to rouse Confortola. As the gas began to flow into his body, Confortola

struggled and pushed the mask away. Confortola had reached the summit of K2 without using supplementary oxygen, and even now he didn't want to diminish his accomplishment.

Gyalje forced the mask back over Confortola's mouth. Confortola stopped struggling. After a few minutes, taking gasps of air, he was able to stand.

Gyalje's top priority was to get the exhausted man down to Camp Four as quickly as possible. It was hard going—Confortola's feet were frozen, and Gyalje had to watch every step he took. Gyalje knew they had to keep him moving at a steady pace to be really sure they were out of the reach of the serac; he urged Confortola on.

As the two climbers struggled down the top of the Shoulder in the mist, Gyalje received another crackling radio call from Big Pasang Bhote, who was still about six hundred feet above them. Pasang had more news.

He had climbed to the top of the Bottleneck, Pasang told Gyalje, and there he had met up with the Sherpa Jumik Bhote and the two South Korean mountaineers who had been trapped on the ropes. They were injured but they had been able to make their way slowly across the Traverse. Incredibly, they were still alive. Big Pasang was now helping them to descend.

"We met at the top section of the couloir and we come down now together," Pasang told him. "There are three. Two Koreans. One Sherpa."

Gyalje listened to the report and could hardly believe it. It was the best news in the world. Jumik and the Koreans had survived!

"We come down, though we have no ropes," Bhote said on the radio.

Gyalje looked up in the direction of the mountain but the mist was so dense that he could see nothing beyond ten yards away. Somewhere up there Big Pasang was now helping the injured climbers down the Bottleneck.

The radio continued to crackle. Awkwardly, Gyalje paused with Confortola on the Shoulder and held the set close against his ear. Big Pasang had something else to tell his friend.

Bhote said he had seen, on the lower sections of the Traverse, a fourth climber following about ten yards behind the two Koreans and Jumik Bhote. But he said another part of the serac had collapsed and had killed him.

"Okay, Pemba, there is one member falling down from the Traverse, the lower section of the Traverse, because hit by serac," Pasang said on the radio.

Pasang said he had watched as the climber had fallen to his death.

Gyalje wanted to know who it was.

"Can you identify him?" said Gyalje.

"He had a red and black down suit."

Gyalje heard this description and his heart fell. He knew immediately who it was.

It could have been Karim Meherban, Hugues d'Aubarède's HAP, but in Gyalje's memory Meherban was wearing a pure red suit, like many of the other climbers on the mountain. Alberto Zerain had a red suit, but he had already descended. So did the Koreans but he didn't think the description fit them. Only one person had a red suit with black patches, and that was Gerard McDonnell.

"A red and black down suit. Definitely Gerard."

Gyalje's friend was dead. Gyalje was devastated. It was too much. The mountain was taking a heavy toll.

Holding Confortola securely on the slope, Gyalje put the radio up to his mouth and told Big Pasang to get out of the Bottleneck and bring Jumik Bhote and the two Koreans down as quickly as he could. It was too dangerous for anyone to be up there any longer.

We are below you. Come down.

It was going to be a hard task for the Sherpa to get them down safely with minimal equipment and he hoped they were going to be okay.

Five minutes after the radio call from Pasang, Marco Confortola was concentrating hard on climbing down the slope below the bottom of the Bottleneck when he felt Pemba Gyalje's hand on his arm pushing him harder.

Up close beside him, Gyalje shouted that something terrible was about to happen.

"Run, run!" Gyalje screamed. "Go fast!"

Confortola moved his clumsy legs more quickly. He was exhausted but he tried to hurry. Gyalje, he realized, knew something that he did not.

Then, the world exploded. The serac was collapsing again.

Because the slopes were hidden in cloud, the two men could see nothing at first. But the roar grew louder and they realized an avalanche was spilling onto the Bottleneck. There was a second blast and another and they understood there were repeated icefalls. The avalanches punched down through the fog toward the two climbers, spitting out a great shower of ice and snow that was funneled and multiplied by the Bottleneck.

Struggling down the steep slope Confortola felt something slap hard into the back of his head and throw him forward. An oxygen bottle had been caught up in the avalanche and had been tossed down with the rest of the mess of ice and snow. Reeling from the blow, Confortola was convinced he was going to fall to his death, but as he toppled forward, Gyalje, who was still beside him, pulled Confortola back and pinned him against the snow, covering him with his own body until the rumbling stopped and the avalanche had passed. It had missed them by just a couple of yards.

They had survived. Confortola owed his life to Gyalje's quick and brave action. But several yards below them, visible through the cold fog, four bodies were lying scattered on the top of the ice that had been swept down the mountain.

It was another scene of death. Gyalje and Confortola climbed lower

toward the bodies, Gyalje helping Confortola navigate the big chunks of ice that littered the slope. When they came within a few yards, Confortola sat in the snow while Gyalje stepped across the slope to the bodies.

Watching him walk closer, Confortola could see that it was the climbers who had been trapped up at the other end of the Traverse. The climbers he and Gerard McDonnell had tried to save. They were tangled in ropes and lying on the ice, lifeless bundles in big jackets and climbing gear, the crampons on their boots sticking up in the air.

Big Pasang was also among them. He was dead. Gyalje had spoken to the Sherpa just a few minutes before the serac collapsed and now he was gone.

Gyalje took out his camera and shot some photographs of the dead. Then he returned to Confortola and helped him up and the two men started to climb down the Shoulder through the fog.

They had gone several yards when Confortola heard a voice calling from up above them on the Bottleneck. A person climbed down toward them, waving his arms to attract their attention.

They waited until Chhiring Bhote climbed down. He had accompanied Big Pasang on the rescue bid but he and the other Sherpa had become separated; while Big Pasang had climbed ahead up the Bottleneck, Chhiring had stopped to pick up some of the fixed lines off the lower slopes in case they needed them later. He was about eighty feet below Big Pasang when the avalanche occurred. When he heard the roar, he had screamed and unclipped his safety harness from the rope as the ice swept by. In that way, he had saved himself. He was close to a rump of large rocks, which had protected him.

The young Sherpa was crying as he stepped gingerly past the avalanche debris and joined Gyalje and Confortola.

They went down together, and farther down the slope two Korean climbers and Little Pasang came out to meet them. Near Camp Four, they met Cas van de Gevel.

"Come with me," the Dutchman said to Confortola, taking his arm.

Van de Gevel was disappointed that his friend Wilco van Rooijen, had not been located, but he was glad nevertheless to see Confortola.

As he was helped down, Confortola couldn't shake the sense that the mountain could have killed him three or four times by this point. It could still claim him, he knew, and he just wanted to get off its slopes.

The snow was falling more heavily, the clouds wrapping even more tightly around the peak. K2 seemed to be closing in on itself.

At Camp Four, he went directly to the Flying Jump tents to talk to the Korean leaders. Confortola told Go Mi-sun and Kim Jae-soo about his attempts to free the Korean climbers and Jumik Bhote from the ropes. He related what they knew about the deaths of the Korean climbers at the base of the Bottleneck. But Confortola couldn't speak much. He was in tears, and as they heard the news Kim and Go cried, too.

Chhiring Bhote had calmed down, but he still seemed in shock about losing his brother. He would return now to Kathmandu without him. He feared the moment when he would have to tell his mother and his older brother about Jumik's death. He wondered how they would support Dawa Sangmu and Jen Jen. Big Pasang also was dead. He had children, too, back in Kathmandu.

Van de Gevel then led Confortola to his tent but the Italian refused to go inside. He was in a terrible condition after thirty-six hours on the upper mountain, and he was badly shaken by all the suffering and violence he had witnessed. He was talking fast, incoherently, wanting to tell his story about what he had seen.

Van de Gevel, however, insisted that Confortola should sleep. He was forced to push Confortola into his tent and help him into a sleeping bag. Then Confortola wanted to call his brother Luigi. He had to tell Luigi he was alive. He searched desperately among his gear for a battery for his satellite phone, but he couldn't find one. At last he gave in and asked to be left alone to sleep.

Part IV

RESCUE

"Yes, yes," she whispered.
You can do it, Cecile. Just keep going.
"Yes, I can."
—Cecilie Skog, K2, 2008

"There! I see something. I see someone moving
on the south face."
—Chris Klinke, K2, 2008

CHAPTER SEVENTEEN

3 p.m.

In the huddle of tents on the Godwin-Austen glacier at 16,400 feet, Chris Klinke and Roeland van Oss were busy coordinating information-gathering and emergency operations. The night before, after the early reports came in of the delays and the first serac collapse, Van Oss had worked from the South Koreans' communications tent. But this morning they moved to the Dutch mess tent, which was closer to the middle of the camp and had a better sight line of the routes.

They tried to work out who knew what, who was still missing, and where climbers had last been spotted. They set up a table with a row of four radios, one for each of the frequencies being used on the mountain. They also had a satellite phone, spare batteries, and paper and pen for emergency note taking. There were photographs of the routes pinned to the tent wall. The solar panels for the satellite phone were set up outside on the stones, though Van Oss was anxious about what they would do for power when night fell.

Van Oss was a lanky twenty-nine-year-old with curly brown hair. Through June and July, he had worked hard to get used to life so high up, climbing steadily to the higher camps, but one day he was traversing slowly at altitude when something snapped inside and he realized he would never be able to reach a summit as high as K2. He was relieved to be free of the pressure and expectations, and instead

had become the main point man at Base Camp for the final summit attempt.

Whenever he got any news, he called it through to Maarten van Eck in the Netherlands, who posted updates on the website. Some of the other climbers were keeping blogs—Nick Rice was also posting updates to his site—but it was mainly through the Dutch team's website that information about the escalating tragedy was spreading to the families of the climbers and the rest of the outside world.

Chris Klinke had climbed up to the Bottleneck with everyone else the previous morning but he had gotten a furious headache, a result of being hit in the head by a baseball-sized chunk of ice a couple of days before, and had turned back. As he had climbed down, he had become dehydrated and then he had started to pee blood, like tomato juice, and that worried him. Now he was maintaining a list of the people who were confirmed killed. It was a balled-up sheet of paper he kept in his pocket. Rolf Bae was on it, and Dren Mandic and Jahan Baig. Klinke called it the "death list," even though it also included the names of everyone who had so far come down safely.

Alberto Zerain had walked into Base Camp. The Spaniard had slept at Camp Three on Friday night, and then descended the Abruzzi, collecting litter at the camps he passed through—an empty gas tank, cans of ham and tuna.

He was oblivious to the problems unfolding above him. When he got down to Base Camp, however, he witnessed a grim scene on the Godwin-Austen glacier. Crowds of people stood about on the gray rocks speaking into their telephones. The place looked like a cemetery. He headed for the little clump of tents sheltering beneath the slopes of Broad Peak a mile away, where he could rest.

Farther up the mountain, Cecilie Skog and her two Norwegian teammates were still climbing down the Abruzzi ridge. They were met on the way by the Singaporean expedition and a climber from the American team, Mike Farris, who had interrupted his ascent be-

cause of ear trouble. They were offered consoling cups of hot tea and coffee.

When they prepared to move on, Skog said she didn't want to go down.

"I want to stay with Rolf," she said. She was tired and her hips ached from her fall and she couldn't stop thinking of Bae up there on the mountain.

Lars Nessa was beside her. He said she had to go on.

Skog emptied her mind and tried to avoid thinking about her husband. It was then that she heard a voice speaking inside her head. Quiet at first, and then more insistent. *Cecilie*. She realized it had been there all along. It was Bae talking to her. He was with her, she was convinced.

Come on, he said. *Get down*.

"Yes, yes," she whispered.

You can do it, Cecilie. Just keep going.

"Yes, I can."

At Camp Two, where they had left tents to sleep in on the way down, including one for Rolf Bae, and where they had stashed their satellite phone, Skog summoned up the courage to call Bae's parents in Norway. Bae's father was a retired pilot and his mother was a nurse. Rolf was their only child, and now they would have no grandchildren.

"Jacob," Skog said. "I am sorry."

"It's okay," Bae's father reassured her. "We only have you now. You must get down safely."

They rolled up their tents and tossed them down a long slope below House's Chimney. They collected them when they got down to Advance Base Camp at about 17,500 feet, where they planned to spend the night before they walked the three miles farther to Base Camp on Sunday.

Another climber, Nick Rice, the young American who had been a close friend of Hugues d'Aubarède, came into Base Camp. Like

Zerain, Rice had gone to sleep at Camp Three on Friday evening unaware of the troubles up above him. He woke on Saturday morning to a 6:43 a.m. text message from his mother in Hermosa Beach, California: The disaster on K2 was all over the news, she said.

"A big chunk of ice has fallen below the summit, taking a large part of the fixed lines with it," she reported. "Twelve members are stranded high on the route. Sta—"

The last sentence was cut off but Rice was sure she had signed off, "Stay safe."

When Rice finally climbed down onto the rocks at Base Camp, another mountaineer from a different expedition rushed at him and declared excitedly that everyone who was still up on the mountain was dead, but Rice refused to believe it.

He felt the world was going crazy. Later, in one of the tents he passed, someone was speaking on a telephone, negotiating to sell a photograph of an icefall on the serac. *Let's make some money,* he heard the climber say. *This is a money shot!* Rice was overcome with exhaustion and emotion.

In the early afternoon, Eric Meyer radioed in from Camp Four to inform Klinke and Van Oss that he was starting his descent.

A few hours later, Klinke got an update that Cas van de Gevel had probably seen Hugues d'Aubarède falling the night before. Klinke sadly moved the Frenchman's name from the "presumed missing" column on his list to "presumed dead." Pemba Gyalje radioed in from Camp Four to relate what he had witnessed in the Bottleneck. Klinke learned that the three missing Koreans and two of their Sherpas were probably dead but Marco Confortola was back safe.

He had nine climbers who were presumed dead—d'Aubarède, Dren Mandic, Jahan Baig, Rolf Bae, Jumik Bhote, Kim Hyo-gyeong, Park Kyeong-hyo, Hwang Dong-jin, Big Pasang Bhote.

There were still three people missing—Gerard McDonnell, Wilco van Rooijen, and d'Aubarède's HAP, Karim Meherban. Klinke did not yet know of Pemba Gyalje's conviction that McDonnell was the climber in red and black who had fallen from the Traverse; or Confortola's belief that McDonnell's were the remains he had discovered in the icefall.

At Base Camp, they had received the reports that Wilco van Rooijen had telephoned his wife in Utrecht to tell her he was lost. When Klinke heard that news, he thought, *Shit*, since he knew the story of climber Rob Hall on the South Summit of Everest in 1996 who had made a final call to his pregnant wife in New Zealand just before he died of hypothermia. Van Rooijen had a baby son at home.

Things also looked bad for Gerard McDonnell, in truth. It was getting late and the chance of anyone else coming off the mountain was slim. But no one knew absolutely for certain what had happened to him, and his family in Ireland still held out the hope that he had survived. In Kilcornan, when his mother and sisters had gone to bed on Friday night, they had known that he had reached the summit. But on Saturday morning they heard nothing from him and there was no fresh sighting. The local newspaper, the *Limerick Leader*, reported McDonnell's triumph on its website, but telephone calls to his satellite phone were not going through. McDonnell's brothers-in-law sent text messages to friends around Kilcornan to announce that he had reached the top. They cautioned that descending was the hard part. Then the news had come through of the icefall and Rolf Bae's death; they had heard that the fixed ropes had been swept away.

As Saturday wore on, his family gathered in his mother Gertie's farmhouse in Kilcornan. They swapped reminiscences of McDonnell to keep up their spirits and reinforce their belief that somewhere, four thousand miles away, he was alive. They laughed and made cups of tea.

Behind them on the sideboard, McDonnell's hurling stick had

pride of place in a case beside a picture of him on Everest. McDonnell had sold it at a charity auction but his family had bought it for him. Ger's older brother J.J. was on vacation in Lanzarote and was due to return to Ireland the next morning.

After a while, they moved to Gerard's sister's house and waited. They had their laptops open and constantly checked for email updates and refreshed the Dutch team's website for news.

———

At about 4 p.m. on K2, Eric Meyer and the four climbers who were descending together to Base Camp from Camp Four arrived at the top of a steep, 60-degree ice slope above Camp One.

Two ropes had already been fixed in parallel down the slope. The Australian climber, Mark Sheen, rappelled down first and waited at the anchor 150 feet below. Then it was Meyer's turn.

The two ropes appeared somewhat worn to him. There were other ropes partially buried in the snow but these two were probably as good as any the climbers would find; they looked as though they had probably been fixed by one of this year's expeditions. He selected what appeared to be the newest, and clipped it into the special descending carabiner on his safety harness. As he descended, he watched the rope spool quickly through the carabiner near his waist.

He was about one hundred and twenty feet down when he saw the three distinct strands of the rope passing through the mouth of the carabiner unravel, and a second later, disintegrate as the rope split. Meyer fell backward from the mountain.

He swiveled head over heels; the world suddenly turned in fantastic slow motion around him. He could see Broad Peak and some of the other beautiful Karakoram mountains hanging weirdly upside down.

Meyer thought, *I guess this is how it is going to go down. I am going to die.*

Before he had started to rappel, he had attached a two-foot-long tubular nylon safety sling from his belt to the second fixed rope.

Now, he somersaulted and crashed down onto the ice but stopped ten feet below Mark Sheen as the sling snapped tight. He had fallen forty feet but he could have gone airborne over the 4,000-foot drop if it weren't for the sling.

"I can't believe you didn't keep going!" Sheen called down to him.

Meyer's adrenaline was pumping. "I can't believe I am alive," he said.

His weight—and he wasn't a heavy guy—must have found a weakness in the rope that had caused it to snap; it had probably already been weakened by someone else's ice axe or crampon. In the air, as he fell, he had reached over with his right arm and caught the safety line in the crook of his elbow in an attempt to stop himself. That had left a sharp rope burn on his skin, but otherwise he was okay.

He remembered thinking, as he tumbled, how beautiful a way it would have been to die. The other three climbers still up at the top of the slope—Chhiring Dorje, Paul Walters, and Fredrik Strang—climbed down cautiously after him.

Klinke and Van Oss stood outside the tents at Base Camp peering up thousands of feet at the gullies and ridges on the enormous southern face of K2. To watch the slopes, they had three pairs of binoculars and a telescope. The telescope, which the Serbs had donated to the rescue effort, was mounted on a tripod on the rocks.

Earlier, it had been warm in the sunshine but the temperature was dropping again. Clouds drifted across the sky. The two men were surrounded by other hopeful mountaineers. Wilco van Rooijen was still unaccounted for and everyone prayed that he and the other climbers who were missing would put in an appearance before night fell. They were unlikely to survive another night out in the open.

The climbers gathered at Base Camp had divided up the mountain

into grids in their heads, and each had taken a grid to watch. Gazing carefully through the binoculars, Klinke's eyes roamed up and down his grid, which was to the left of the Cesen route. After a while, he switched to the Serbs' telescope.

At about three o'clock, the clouds parted and Klinke thought he saw an object moving on the southern face but no one else could make anything out—only the mist and black shapes of rocks amid the dull fields of snow. Then the clouds closed together again. The slopes were getting darker. The sun would set in three or four hours.

Back in the Netherlands, in Utrecht, Maarten van Eck had an idea about how to locate Wilco van Rooijen. By now Van Rooijen had called in a handful of times on his Thuraya. So perhaps they could track the GPS coordinates of his satellite calls?

He contacted the company in Colorado that had rented Van Rooijen his phone, and asked for the position of his last five calls. At first the people at Thuraya said the data was personal and refused to give it up. But when the circumstances were explained to them by a furious Van Eck, they relented and Van Eck plotted the coordinates on a 3-D model of K2 on Google Maps he had on his desktop.

The first three calls were all over the place. But Van Rooijen's last two calls showed the same position. Van Eck called Base Camp.

"Where is he?" said Van Oss.

"Seventy-five hundred meters near the Black Pyramid!" Van Eck declared, confident they had found him.

On K2, Klinke was still watching the mountain, and at around 5:30 p.m. the clouds cleared and he saw a small orange dot scaling down the southern face.

He grabbed a pair of binoculars, which had a wider field of view.

"There!" he shouted. "I see something. I see someone moving on the south face."

Everyone stared where Klinke was pointing. Was he sure? No climber was supposed to be in that area of the mountain.

Klinke was also confused. The Black Pyramid and the coordinates from Van Eck were nowhere near that part of the southern face where he had glimpsed the orange figure. Eventually he realized that Van Eck was mistaken and he had confused the real Black Pyramid with another area of black rock where the climber in orange had been seen.

"It's a climber." Klinke was adamant. "I am not sure but I think it's Wilco."

By now, the others had picked out the figure, too. They cheered when they saw him. They thought it was a climber in an orange suit, although it could have been a different color. Whoever he was, he was about 1,500 feet to the left of the Cesen route and 1,800 feet below the Shoulder. And he was on the move.

A dozen mountaineers stood in the middle of Base Camp near the Serbian tent staring up at the south face of the mountain.

Van Oss called through to Van Eck in the Netherlands, who posted a report on the website:

K2 Base Camp (Roeland) can see a person in Orange suit between C3 and C4. That person is slowly moving down.

Who was it?

The Dutch team hoped it was Van Rooijen. As the news spread to Kilcornan, Gerard McDonnell's family prayed it was him.

Soon, however, the clouds closed in again, concealing the climber from view.

To try to make sure of the identity of the climber in orange, Van Eck called the clothing company North Face. It had supplied the gear for many of the climbers on K2. Of the list the company gave him of mountaineers wearing orange suits, only Van Rooijen was unaccounted for.

Klinke was not ruling out McDonnell or Karim Meherban or even Hugues d'Aubarède but gradually a consensus grew. It had to be Wilco.

At around 6:30 p.m., the clouds drifted apart, and in an opening they saw the figure in orange again. He was still there, and this time he seemed to be sitting down. Whoever it was, it was a survivor. The mood at Base Camp was jubilant. Van Oss and Klinke jumped up and down on the rocks.

They still had to bring the climber down alive, they realized. They had to act quickly if they were going to get him to safety before nightfall. If it was Van Rooijen, they had no idea what sort of condition he was in. Clouds filled the gullies again and the sky was growing even darker. Daylight was failing.

Ten thousand feet above Base Camp, Cas van de Gevel and Pemba Gyalje had stayed in their tent at Camp Four, resting and still not willing to go down while Van Rooijen was missing. Klinke and Van Oss decided they had to call them on the radio to tell them the news and ask them to attempt a rescue.

They knew they had to be quick before night came in but it took a while to raise them. Eventually Klinke and Van Oss got through and told them a climber had been spotted somewhere below them between Camp Three and Camp Four. It was probably Wilco van Rooijen.

"Go down the Cesen and signal over," Van Oss said.

It was not going to be easy for the two exhausted climbers to climb down the Cesen. The rocky slope was steep at any time of day; in the dark, it was deadly.

"We go down," said Pemba.

It took the two men about an hour to hastily grab some food, zip on their suits, and gather Chhiring Dorje's extra oxygen bottle. Then Klinke watched two headlamps set out from the tents up on the Shoulder and begin to move lower.

"Cas and Pemba will descend from C4 toward C3 to try to locate the lone climber," Van Eck reported on the website. "More news to follow as soon as we hear something."

CHAPTER EIGHTEEN

7 p.m.

When Wilco van Rooijen woke up on the ledge of rock, he was alive but he was trapped at 25,300 feet.

Although it was still light, he realized some hours had passed. He felt stiff and cold.

He called his wife again, and the battery worked. He left the phone on so that Maarten van Eck could get through to him. This was the first time that Van Eck had managed to speak directly to his friend. Van Rooijen told Van Eck he was stuck at the top of a large ravine. His eyes were in such a bad state that he could see almost nothing now. He was so thirsty he could hardly speak. All he wanted to do, he said, was fall asleep again.

"You must not sleep," said Van Eck. Van Rooijen heard the words leach into his brain over the satellite phone and he knew his friend was right.

By now, since he had the phone coordinates, Van Eck believed he knew where Van Rooijen was. He told him he had to continue climbing to his left.

"That's the only way back to the Cesen." It was imperative, he said.

Once Van Rooijen had gotten off the phone, he sat for a few minutes. Then, when the clouds thinned, he spotted a narrow snow gully a few hundred yards to his left as he faced out from the mountain. If he could reach that gully, he could drop down six hundred feet.

He stood up and climbed around the ledge. Then he slid lower, letting himself go, taking a chance, and he made it. After that, the going was easier.

Soon, however, he saw that there were huge crevasses that split the snow along the bottom of the gully. They were like toothless mouths, and he was terrified he was going to fall into one.

The only other way down was to turn to the east onto a big ridge of brown rocks. But the rocks were steep and Van Rooijen had no idea where they would lead him.

By now, the sun had set. A bright line cut across the horizon. He was desperate to continue but he discovered that his headlamp had slipped from his pocket. He searched his coat but it was gone, as was his camera.

He raised his eyes to the sky and cursed. He couldn't go on. If he stumbled in the dark, he risked falling forever into one of the crevasses.

There was nothing to do, he soon realized, but to stop and bivouac for a second night.

The prospect appalled him. At least on the first night's bivouac, he had Marco Confortola and Gerard McDonnell for company. And that bivouac had started past midnight and lasted for only a few hours. Now it was 7:30 p.m.; he had hours ahead of him alone in the freezing dark.

The bivouac was a terrible thing, he felt, but necessary. Before he stopped, he climbed a few more feet toward the rocks. There in the twilight he made another grim discovery. A few yards away, a dead climber dressed in a yellow jacket lay on a shallow incline. He was tied by rope to a second dead climber, who was sprawled a little farther up. Van Rooijen didn't know who it was, though he thought it was somebody from this year's groups.

He sat down beside the corpse in the yellow jacket. By now Van Rooijen was desensitized to the terrible things he had seen on the

mountain and the corpse didn't register with him. There was also the fact that his mind was no longer functioning properly after the days at high altitude. He didn't focus on the body. Kneeling down beside the corpse, he reached up with his ice axe and climbed onto a higher part of the slope. He climbed on and found a place to spend the night. Sitting down, he crossed his long legs. He stabbed his ice axe into the steep slope behind him so he could attach a rope.

Wind gusted across the face. Now it was really cold. Van Rooijen tried to keep his back to it and, now and then, he stood up and turned around to stretch his limbs and keep the blood circulating, especially in his feet, which were feeling numb. That was how he was going to survive. The numbness of his feet was a bad sign, but Van Rooijen had no energy to rip off his boots and massage his toes.

He closed his eyes, but after a while he opened them again and concentrated on the line of the horizon, the dark shadows of the tops of mountains and the huge blankness of the sky. What with the wind and the cold and the cramps, sleep was impossible. He waited. He took out a tube of energy gel he remembered he had in a pocket and ate it with some snow. That he had only remembered it now was another sign of his deteriorating faculties. He avoided looking at his watch. He didn't want to be disappointed by how slowly the minutes passed.

Once during the dark night, Van Rooijen thought he saw a bright light flash less than nine hundred feet away. He followed its progress with his eyes for a while but it abruptly shut off. He remembered his Thuraya and pulled it out. He tried it twice but either the battery was too cold to work or the charge had seeped away. Hoping his body warmth would revive it, he slipped the phone back in his coat, closer to his skin.

He may have slept after all. He wasn't sure. He wasn't certain of anything anymore. Finally, the sky over K2 grew light. It was Sunday morning, August 3, 2008. He was still alive.

At last, he allowed himself to check his watch. Five a.m. More than two days since he had set out from the tents at Camp Four leading the Dutch expedition gloriously toward the Bottleneck. And it was more than thirty-six hours since his lips had touched any water.

I am going down, he told himself.

He decided he could cut a path down the side of the rocks, thus avoiding both the hump of the ridge and the crevasses that frightened him. He stood up from the bivouac and climbed uncertainly downward.

On Saturday night, when they received the joyful radio call from Klinke and Van Oss at Base Camp, Cas van de Gevel and Pemba Gyalje had set out as quickly as they could from Camp Four.

The idea was to descend rapidly to Camp Three on the Cesen route. Van Oss and Klinke had given them directions about where they should be able to see the climber in orange. They knew they were risking their own lives and they wanted to get off the Cesen route before dark, although it was already nearly black outside.

The Sherpa climbed ahead down the rocky fissures. Van de Gevel was moving more slowly and he watched his friend gradually moving away from him down the steep route.

Snowflakes blew across the Cesen but from time to time Van de Gevel could see a little distance ahead. He hollered out Van Rooijen's name, but his voice was sucked away by the gray emptiness of the snow and rocks. All he could see in the sweep of his headlamp were dark empty slopes freckled with rocks and silent stone ledges.

"Wilco! Wilco!"

Van de Gevel had only climbed down a few hundred yards when his headlamp lost power and flickered out. The batteries were dead. He was carrying a radio, which also had batteries. Crouching on the slope, he radioed down to Gyalje to say that he was switching his

radio batteries to the headlamp and would be off air for a while. He opened the back of the radio, but when he lifted out the batteries they were encased in plastic and he couldn't pull them apart. He picked at them with his axe but fumbled and dropped the batteries. They slid away down the mountain. It was a bad mistake. Alone without communication or light, Van de Gevel realized that he was stuck.

He wasn't going to give in, however. He grabbed one of the ropes that led down the slope, following it for several yards, but it came to a dead end and he stopped himself abruptly. *Not that way.*

The rock and snow beneath him were cold as he slumped down in the snow to wait until dawn. Taking off his gloves, he unfolded a lightweight sleeping bag. He lay back on the snow and spread the sleeping bag over his head like a cover. There was a little warmth at least for his body.

An hour or so later he blinked open his eyes and realized he had fallen asleep without putting his gloves back on. A sharp pain ate into his hands and he realized it was frostbite. Hastily, he grabbed for his gloves, pulling them over his stiff fingers, but it felt like he was too late. It was still dark, and all he could do was sit tight and wait.

He had set out to rescue his friend but he himself was lost in the night. Below him, Pemba had probably made it down to Camp Three by this time. Van de Gevel wondered how many hours were left until the sun came up, what had happened to Wilco van Rooijen, and what now would become of him. He pondered his fate. *No one knows where I am.* It was a terrifying thought.

───────────

When night enveloped the mountain, like a hand closing its grip, the climbers in front of the cluster of tents at Base Camp watched the lone figure in the orange suit being swallowed up by the darkness.

Van de Gevel and Gyalje had not reached him before nightfall.

Then one of the two headlamps shimmering down the Cesen

route from the Shoulder suddenly blinked off. The remaining lamp moved lower for an hour or so before it disappeared into a tent at Camp Three. Shortly afterward, Chris Klinke received an alarmed radio call from Pemba Gyalje, who said Cas van de Gevel had not come in.

"I have lost him," Gyalje said, sounding both frightened and exhausted. "Cas is not here!"

Gyalje hadn't been able to see the climber in the orange suit, either, he said, although he had shouted for more than an hour.

The Sherpa said that while he had been outside, he had heard a satellite phone ringing. He thought it had to be Van Rooijen's. But it had stopped. The ringing was coming from an area that was prone to avalanches and Gyalje was wary of searching further, though he offered to go.

"I don't want you to go out," said Klinke, who was getting worried about the latest turn of events. "We don't know where Wilco is. Cas's light has disappeared. This is getting scary!"

He told Gyalje to stay where he was and sleep.

As the night closed in, the failure to locate the climber in orange depressed the spirits of the climbers in Base Camp. Roeland van Oss, who had only had about three hours of sleep during the last two days, ducked into his tent to get some rest. Wilco van Rooijen was spending a third night on K2 above or close to 26,000 feet. Van Rooijen was tough, Van Oss thought, but few people could survive that.

After Van Oss had gone, Chris Klinke stayed outside to keep vigil, sitting on a big rock and gazing up at the darkened south face. The rock was the size of a dinner table and flat on top. The thirty-eight-year-old Klinke had given up his job as a vice president at the financial advisory firm Ameriprise to follow the mountaineering life. Now he had the sheet of paper, the "death list," folded in his pocket. He looked for the distant dots of headlamps but he saw none. He listened for any voices on the radio but there was an eerie silence. He shivered.

Damn, it was cold. He was wearing a down coat, down booties, and insulated pants. But the rock and the stones beneath his feet seemed to rip the warmth out of him.

Now and then, the American expedition's cook, Deedar Ali, or his assistant brought him warm tea or biscuits and stopped to watch with him. Just after 9 p.m., Klinke received the news on the radio that the remainder of his own American expedition, including Eric Meyer, Fredrik Strang, and Chhiring Dorje, were descending the last few hundred feet of the Abruzzi and were at Advance Base Camp.

At about 1 a.m., Deedar walked up to them with hot tea and more biscuits. They would be glad to get them. Klinke walked out a few hundred yards from Base Camp to meet them and was relieved when at last he saw headlamps, and Meyer and the team walked wearily across the boulders toward the tents. The descent had been a tough one. Meyer's fall down the 60-degree ice slope had been a reminder of how close anyone was to losing their life on this mountain.

Other members of the team, Paul Walters and Mike Farris, joined them and the whole team went inside the mess tent to sit and decompress. They drank whisky from tin cups. The mood was grim because people were still missing. Klinke told them the news that Van Rooijen was alive. If the Dutchman survived to the morning, he was going to need medical treatment.

Klinke went back out onto the rocks. It was past 2 a.m. Now and then he touched the list of the missing and the dead in his pocket. He had made contact with the Pakistani military to arrange for a plane to fly over K2 to locate any survivors. But the plane that would conduct the "low-and-slow" was being kept on the runway at Skardu by the bad weather. The conditions had to be perfect for a low-and-slow.

CHAPTER NINETEEN

Sunday, August 3, 5 a.m.

As the morning light started to brighten the vast white and gray snows above Chris Klinke, clouds were still gusting across K2's massive promontories but most of the mountain was visible. And that is when he saw the orange figure again.

At 5:15 a.m., he woke Roeland van Oss, who was in his warm sleeping bag in his tent.

"Roeland, he is moving!" he shouted urgently. "Wake up! He is moving!"

The climber in orange was now about nine hundred feet to the left of the Cesen route and about three hundred feet above Camp Three, which itself was at about 24,000 feet, and he was traversing to the right.

Several more climbers joined them on the rocks and one of them, an independent Serbian climber, could also see another figure above Camp Three struggling down the fixed lines of the Cesen, and they realized that this had to be Cas van de Gevel. They were relieved he had survived though they didn't know what injuries he had sustained after being outside all night.

They called up on the radio to Pemba Gyalje, who was in one of the tents at Camp Three, but there was no answer. Perhaps he was sleeping or his radio was off. A few minutes later, however, the Sherpa's voice abruptly broke the silence. He sounded flustered.

Here is Pemba, over.

A rock had been dislodged from above, probably by Van de Gevel as he descended, and it had smashed into Gyalje's tent, waking him with a fright. But he had stuck his head outside and he could see his Dutch colleague making his way toward him.

"I see Cas!" he told them. "He is twenty to thirty meters above me."

Within a few minutes, Van de Gevel arrived at the tent and both men spoke on the radio again to Base Camp. Klinke and Van Oss suggested that the two men step outside their tent and begin shouting to attract the attention of the climber in orange.

"He must be two hundred and fifty to three hundred feet away from where you are," Van Oss said.

They wouldn't be able to see him yet because of the large ice fins and promontories that crossed the southern face. Van Rooijen was on the western side of one of these. No one looking from Camp Three could spot him yet, and they were invisible to him.

"You will see him soon," said Van Oss. "He has to cross around the ice corner."

Gyalje put on his down suit and boots. He melted water on the burner. Then he and Van de Gevel went out. As soon as they started calling, the climbers at Base Camp, gazing through the Serbs' telescope and the binoculars, saw the orange figure respond. He stood up and began moving faster.

Klinke and Van Oss saw that Van de Gevel and Gyalje were so close to reaching the climber in orange. They prayed that they weren't going to miss this chance to save him.

———————

Cecilie Skog, Lars Nessa, and Oystein Stangeland were met at Advance Base Camp by their cook, who helped them carry their equipment the final three miles back to the tents at Base Camp, where three or four mountaineers from other expeditions greeted them. Just outside the camp one of the other climbers tried to take

Skog's backpack but she insisted on holding on to it because it was Bae's.

After wanting to stay up on the mountain, Skog was now intent on leaving K2 as soon as possible. It was a place of so much pain and death.

Then at Base Camp she climbed inside her tent, the tent she had shared with Rolf.

Inside, Skog looked around at their belongings, lay down on her sleeping bag, and felt again suddenly that she couldn't leave him behind. It was too hard to think that he was still up there, his body left alone in the snow.

Over the next few days, she would appear outside the tents on the glacial moraine for a few hours but would become inconsolable. At night, the others in the expedition heard her crying.

Skog felt paralyzed. She couldn't go back to Norway, to the little apartment she and Bae had shared in Stavanger, back to their life, back to their friends and their families, back to Fram Expeditions, back to all the questions—not without Rolf.

She sat alone inside the tent, but soon she realized Bae was in truth no longer on K2. He had gone. She had known it all along. Then she wanted to pack up and leave before the Norwegian media descended on her.

Nessa and Stangeland said they would stay for a few more days to get the team's gear together, call porters, and help with the rescue, but Skog started to prepare to leave quickly.

High on the southern face, Wilco van Rooijen picked his way down the rocks at the bottom of the gully. The world stretched out before him in the morning light—hundreds of miles of beautiful, startling peaks, though he cared nothing for that now, only his survival.

Amazingly, he felt better after his rest and it seemed the energy gel had worked.

He passed some of the big crevasses, cutting between them and some of the huge rumps of brown rock that lay farther over to the left.

The sun must have warmed up Van Rooijen's phone in his jacket because it started to ring. He realized he had left it on after trying it during the night. It was Heleen. She had waited for his call but had finally given up waiting and in the darkness in Utrecht at 2:30 a.m. had tried the number. She hadn't expected him to answer.

She screamed, "Wilco!"

He said he was feeling confident. The terrain was easing off. He was nearly down.

"I think I can see Camp One," he said.

"Keep on going!" Heleen was overjoyed by how positive he sounded. "I am here on the couch with Teun," his wife said. "Do it for us," she said, speaking so loudly that she woke her son. "You have to keep on going. Keep on going!"

He told her he would call her again when he reached the camp.

He rounded the corner, and he saw some fixed ropes snaking lower. He had stumbled onto a route, though he didn't know whether it was the Cesen route. A long way below were what looked like two yellow North Face tents.

Van Rooijen realized now that two figures were climbing across toward him, between him and the tents. They appeared to speed up. When he saw them, he was overjoyed. Climbers meant a stove, and that meant melting snow for water. It would be an end to his thirst. Van Rooijen walked on slowly, pausing every few steps and bending down on one knee to lean on his ice axe, catching his breath.

The two men were still about three hundred feet away from Van Rooijen when they came into focus. The one at the rear was wearing a dark blue suit. The one leading was dressed like Van Rooijen in orange. *Shit! It's Cas!*

When Van Rooijen reached Cas van de Gevel, he embraced his friend and Van de Gevel hugged him back. Chest to chest, they

screamed their joy into the other's face. Both men cried, so desperately happy to have found each other and cheated death.

"I didn't think we were ever going to meet again!" Van de Gevel said.

He looked into Van Rooijen's gaunt, sunburned face. Van Rooijen's lips were sore and blistered, and his eyes were bloodshot. The wind and the cold had marked his cheeks with red blood vessels.

Van de Gevel helped Van Rooijen down the Cesen and they crammed into one of the Dutch tents. He was in shock and they helped him get himself together. Gyalje had already melted two liters of water from snow in a pan and Van Rooijen gulped it down. He also breathed some oxygen from the tank Gyalje had carried lower, and forced a Sultana biscuit into his mouth.

Van de Gevel took out his video camera and filmed Van Rooijen speaking into the lens under the low roof of the tent, his silver hair sticking up crazily. Even after his adventure he was well enough to give an interview for posterity. But when they explained he was only at Camp Three, he was disbelieving and then angry.

"What do you mean?" he said. He was convinced he had been climbing so long that he must have bypassed the top three camps. "Not funny."

After all his hard work there was still about 7,000 feet between him and Base Camp.

"It's true!"

Van de Gevel told him about the deaths on the mountain. They had rescued Marco Confortola. But Hugues d'Aubarède was dead. They also thought that Gerard McDonnell was gone. Van de Gevel and Gyalje didn't go into greater detail because they didn't know more. Chris Klinke had the list at Base Camp.

Van Rooijen was devastated and shook his head ruefully, only half comprehending. He said he thought he had been the only one caught in this nightmare.

He said he could not feel his feet and asked Van de Gevel and

Gyalje to take a look. They peeled off the outer part of his boots, then his inner boots. It looked bad. His toes, swollen and hard, had turned gray and light blue. They had severe frostbite.

They radioed Base Camp to report the news that the lost climber had been found. It was a terrific, joyful moment. After all the bad news, there was immense relief. The voices on the radio were full of congratulation.

Van Rooijen thanked them all. "Now you have to focus on finding Gerard and getting Marco down," he said. The Italian, still above them at Camp Four at 26,000 feet, was in a bad way.

They discussed the state of Van Rooijen's injuries. Eric Meyer's gravelly voice came on the line, and he told them they had to lose height as rapidly as possible if they were going to save Van Rooijen's toes. Some of the teams at Base Camp had made a rescue plan and offered to climb up carrying ropes and oxygen tanks to help lift Van Rooijen down. But Gyalje demurred, saying they would manage on their own; the mountain was dangerous and there had been too many deaths already.

Van Rooijen insisted he could walk, and with the oxygen tank on his back the three men descended toward Camp Two. If anything, Cas van de Gevel was more exhausted than Van Rooijen. As they climbed, his colleague passed him the bottle of oxygen, and breathing the extra gas gave him some new energy, though the bottle was empty after a few minutes.

At Camp Two, Gyalje melted more snow for water and Van de Gevel was so tired that he crashed into a deep sleep outside the tent. When he woke up, he told the others he wanted to stay at the camp for the night. It looked like he had some frostbite on his hands; his fingers were turning rigid and painful. "You must get up," said Gyalje, insisting. The other two men forced him to his feet and they began climbing down the route again.

Van de Gevel fell behind. Walking down alone, he forced himself onward. Later, he would think about what K2 had done to him and

to his friend; Van Rooijen had lost twenty-two pounds. Van de Gevel had lost thirty. They had both nearly died. He would think how dreadful it would be to face Gerard McDonnell's family. He had met the Irishman for the first time on this expedition. They had gotten to know each other on the trek in from Askole. Now McDonnell was gone. Ger's mother, his sisters, his brother would hate them all for having allowed this to happen.

The tragedy would no doubt stop some people from coming back. But it would not keep Van de Gevel from returning to the mountains. If he gave up climbing, he knew, he wouldn't be the same person. When he was climbing, he felt at ease, the most comfortable he ever was.

He couldn't stop thinking about the moment on the summit when the guys—d'Aubarède, McDonnell, and Van Rooijen—had embraced under the dome of the perfect blue evening sky.

That is what it was all about. Even this disaster could not rob him of that.

Ahead of Cas, Van Rooijen, for his part, reflected that he had finished with K2. After three attempts, he had conquered its summit. K2 was a mountain you climbed only once in your lifetime. To try again would be stupid. As he hobbled lower, he knew he was not coming back.

———————

Marco Confortola had woken up alone on Sunday morning at Camp Four with only his two Balti HAPs for help. The last of the large South Korean contingent had cleared out without waiting to assist him down.

The sun was high in the sky. Confortola felt dizzy. After his hours outside unprotected on the mountain, and his fall down the Bottleneck, he ached, and pains burned in his left hand and in his feet, but he climbed over the misty ridge onto the rocks of the Abruzzi. He was familiar with it, whereas the Cesen was strange to him.

The two HAPs followed him down, but they stayed a few hundred

feet behind him, as though Confortola were bad luck or too much work. He cursed them. He knew he couldn't rely on them.

The Abruzzi was deserted. He followed the ropes alone. When he climbed down onto the cut-up snows at Camp Three, he found nobody. No one to wave or run to him or bring him in.

The climbers who had waited to help the Norwegians had abandoned the camp, but he found a Sprite in one of the tents and drank it, and found two energy bars in another tent and ate them. He found a battery for his phone and called Luigi at his bank in Valfurva.

"This is Marco!" he said, pressing the phone eagerly to his mouth.

But Confortola's luck wasn't getting any better. Luigi wasn't there. His brother was out.

Confortola nodded. "Okay."

He hung up, and then slept.

As Wilco van Rooijen, Cas van de Gevel, and Pemba Gyalje dropped onto the steep paths near the bottom of the mountain, they were met by climbers from Base Camp. There had been no ropes on the lower thousand feet of the Cesen so the rescue party had fixed new lines to help the injured climbers get down.

Roeland van Oss and others from the Dutch team, including the Base Camp manager, Sajjad Shah, gathered around the men. They had brought water, Pepsi, Coca-Cola and Snickers and Kit Kat bars.

One of Sajjad's jobs in Base Camp had been to keep Van Rooijen in supplies of cookies and peanut butter. It was one of his favorite foods, so much so that halfway through the season Shah had had to send down for another dozen jars from Skardu. Now, when Van Rooijen saw the Pakistani, he bellowed out: "Sajjad!" Then added with a smile: "Where are my peanut butter and cookies!" Shah could see that the ebullient Dutch leader had emerged from his trials with his spirits undiminished.

As they gathered around, Van Rooijen, Van de Gevel, and Pemba

Gyalje asked the climbers from Base Camp whether there had been a sighting of Gerard McDonnell. It became clear as they talked that if there had been any chance that the Irishman was alive, it was now finally gone.

Roeland van Oss got on the radio and satellite phone to report that the rescue party had reached the stricken climbers. "Wilco, Cas, and Pemba are safe," he said somberly. "But we are now fairly sure that Gerard died in the Bottleneck."

In Utrecht, Maarten van Eck had called Heleen as soon as Van Rooijen reached Camp Three. He posted the news of the successful rescue on the Dutch team's website:

WILCO IS ALIVE EXHAUSTED BUT HE SOUNDS GOOD. ONLY PROBLEMS WITH FEET. WE HOPE TO UPDATE SOON!

In Ireland, the hopes of Gerard's family that he was the lone surviving climber were finally extinguished. On Sunday morning, the McDonnells called a news conference at the local school, just a few hundred yards from the farmhouse. It was a gray day. His brother-in-law stood in the parking lot to announce that they accepted he was dead. A few days later the family issued a statement to the press:

We are extremely proud of the many heroic and brave achievements of Gerard, whose death has left a major void in our lives. He brought honour not only to us his family, but the whole country when he became the first Irish man to summit K2.

On K2, the decisive realization that McDonnell was dead seemed to have the most powerful effect on Pemba Gyalje. From that moment, he hung his head and fell silent, the other climbers noticed.

He was convinced now that the climber in the red and black suit that Big Pasang had reported seeing being hit by ice and falling from the Traverse was indeed McDonnell. That meant the Irishman had not abandoned Jumik Bhote and the two injured Korean climbers on the slopes at the end of the Traverse. He had stayed behind after Marco Confortola had left and had helped them to descend, before he had been swept off the Traverse to his death.

Another Sherpa, Little Pasang Lama, had received a radio call in Camp Four from Big Pasang Bhote before the final avalanche; Big Pasang said again that he had reached the Koreans and Jumik Bhote near the Traverse. Jumik had even come on the radio to say his limbs were frozen and the injured Koreans were suffering from snow blindness but he could walk, and when he reached Base Camp he hoped he could be flown by helicopter to Islamabad and home.

Then Big Pasang and Jumik and the Koreans had died when the serac collapsed.

But it was already becoming complicated. Another Sherpa, Chhiring Dorje in the American team, believed that Gerard McDonnell had probably been the lone figure witnessed at 10 a.m. on Saturday, trapped above the serac and walking up and down on the snowfields. He had either fallen over the serac, Dorje felt, or climbed down onto the Traverse where he was hit by the avalanche and had little to do with the rescue of Jumik and the Koreans.

On the Cesen, it took the three injured climbers and their retinue another few hours to reach Base Camp. It was dark, approaching 9 p.m., when Pemba Gyalje walked in first, assisted by one member of the rescue team. It was a while before the other two men followed across the dark rocks of the Godwin-Austen glacier, hobbling away from the maw of K2 and into the blessed safety of Base Camp.

A lot of effort was now directed toward saving the men's frostbitten toes and fingers. The Americans had converted the big Dutch mess tent into a medical emergency room to receive the injured climbers.

It soon became a busy crowded scene inside. The cooks boiled water and put down blue basins for the men's feet. The Norwegians' heater blasted some warmth from the corner. Eric Meyer and Chris Klinke had their headlamps strapped on their foreheads. Their lights illuminated the prone figures of the two stricken Dutch climbers who were laid on bed mats, their backs propped up against the inflatable Ikea sofa that Rolf Bae had originally carried from Norway for Cecilie and that the Norwegians had also donated to the rescue effort.

In their orange North Face fleeces, both Dutch climbers looked years older. Cas van de Gevel, in particular, seemed shrunken and gray, his skin lined and hanging from his cheeks. Klinke and Chhiring Dorje handed out Pepsi in tin cups and with Lars Nessa they scrubbed and warmed Van Rooijen's and Van de Gevel's hands and feet, while Meyer prepared to apply what medicines he had. Roeland van Oss was relieved to let Meyer take charge, to see now whether the descent had been rapid enough to save the climbers' fingers and toes.

Meyer inserted plastic tubes into veins on the back of their hands and injected a cocktail of medicines. First, morphine and Valium to ease the painful thawing of their flesh. He also possessed two bottles of a new drug, tPA, or tissue plasminogen activator. Normally used to treat heart attacks, it had shown in university trials that it could help frostbite, though it had never before been tested at altitude and it had side effects such as internal bleeding. Meyer was worried about what dosage to try, so he called a specialist at the medical school in Denver, who advised against using it. The drug also had to be injected within twenty-four hours of the initial exposure. This applied only to Van de Gevel, but Meyer was growing so concerned about their condition that he injected it into both men. He followed it with another drug, heparin, to stop the blood clotting in the tiny vessels of their fingers and toes.

Fredrik Strang came into the tent and turned on his camera. Wilco van Rooijen looked disoriented as the Americans filled him in on the full extent of the disaster.

"How many victims are there?" he said.

"Eleven," said Meyer. "Eleven people."

"Missing?"

"No, dead. Rolf, Gerard."

Blowing out his cheeks, Van Rooijen gazed emptily around the tent.

They told him Marco Confortola had left Camp Four and that another rescue party was climbing up to meet him on the Abruzzi. Down at Base Camp, Roberto Manni, Confortola's Italian colleague, had been desperate for volunteers to help Confortola and had offered money to any Sherpa who was willing to go up to find him and bring him down. Eventually, after a day's delay caused by the need to get equipment together, another American climber, George Dijmarescu, had set off up the Abruzzi with the two Sherpas in his expedition.

Lying beside Van Rooijen, Van de Gevel sank lower against the mattress. Initially Meyer was most concerned about Van Rooijen's frostbite. He had slept two nights in the open, the first night at about 27,000 feet, the second at somewhere around 25,000 feet. But Van de Gevel's hands looked bad, too. He told Meyer about waking up with his gloves off. The Dutchman was a carpenter, Meyer knew, and his fingers were important to him. But the fingers on his left hand were limp blocks of gray, with purple streaks across the mid portions. Meyer could see hemorrhagic blisters, which meant serious frostbite damage.

They dunked his hands in a tin basin of warm water and soaked his feet in a bowl but repeatedly he dozed off, trying to stretch out, and pulling his hands and feet out of the water. Chris Klinke had to keep lifting them back in.

Looking in a concerned fashion at both men, Meyer said, "I hope they will keep their digits."

After a few hours, the only thing left that Meyer could do was bandage the two men up and prepare them for their departure. It was about 3:30 a.m. There was talk of helicopters flying up from Skardu to airlift them out.

CHAPTER TWENTY

Monday, August 4, 8 a.m.

Helicopter transportation for injured climbers is being organized for tomorrow morning," Maarten van Eck wrote in an update on his website late on Sunday night.

At K2 on Monday morning, Roeland van Oss thought the helicopters would not arrive until late, but at eight o'clock one of the military liaison officers at Base Camp rushed to his tent with the news that they were only forty minutes away. The Pakistani military had established a private company precisely with the aim of plucking injured mountaineers out of the Karakoram, and it had choppers stationed at the military airport at Skardu. Van Oss had spoken by satellite phone with the owner of Jasmine Tours, the Dutch expedition's organizer, and he had made the arrangements.

Suddenly Van Oss had much to do. He scurried to collect Van Rooijen's and Van de Gevel's bags. The Dutch climbing leader sat upright in the mess tent shooting instructions at Van Oss about all the jobs he had to do after Van Rooijen was gone, such as paying the porters and dealing with the remaining food barrels.

Away from the tents, about three-quarters of a mile down the glacier toward the southeastern shanks of the mountain, the Serbian team's liaison officer and a team of helpers shifted rocks to build a landing pad for the helicopters. They marked it with flags and a windsock.

At nine o'clock, two former Pakistani military Eurocopter Ecu-

reuils, or Squirrel helicopters, flew in from the south, casting shadows against the mountainside. They came noiselessly at first but then thudded above the glacier near the tents.

Almost everyone left in Base Camp took turns in the scrum helping to lug Wilco van Rooijen over the rocks on a red stretcher. After they set him down, Chris Klinke shielded the Dutchman's head with his arms as the chopper blades billowed gusts of wind over the rocks. Then they lifted Van Rooijen through the helicopter door and the chopper hovered into the air and flew away.

Roberto Manni persuaded the pilot of the second Squirrel to take a detour up the Abruzzi ridge to attempt a long-line cable and harness rescue of Marco Confortola. The arrangement was that Confortola would climb down onto a flat space below House's Chimney, but when the helicopter got up to 19,000 feet the pilot could not see him. Confortola hadn't managed to descend to that point yet. The weather forced the chopper to wheel away without waiting.

The Squirrel flew back down to the Godwin-Austen glacier for Cas van de Gevel. His hands bandaged, the Dutchman walked from the tent to the landing strip.

The trip was a stunning hour back down the Baltoro glacier, past Masherbrum and Trango Towers, to Skardu. There, Van de Gevel was reunited with Van Rooijen, and the two men were hooked up to monitors in the military hospital, a one-story complex of run-down cream-colored buildings beneath the hot, sandy hills on the outskirts of the town, where military officials strode the grounds and loudspeakers repeatedly called people to prayer.

Back at K2, more porters were arriving to carry away the teams' gear. Mules waited around on the rocks. The big South Korean team climbed down to Base Camp, and Nawang, the cook from Nepal, prepared a special meal in the mess tent. His *bibimbap*—warm rice

mixed with vegetables, chili, and meat, when they had some—had become a favorite of the Flying Jump team. Now he cooked the meal even though he had lost two friends from his own region, Jumik Bhote and Big Pasang. From outside, people heard him crying.

Chhiring Bhote was preparing to return to his village near Makalu to observe two months of mourning for Jumik.

The Korean climbers drank suji, which they had brought to K2 intending to celebrate Go Mi-sun's birthday. Instead they were marking the deaths of their two Sherpas and three of their own climbers. The Koreans were not going to wait around. They were crushed by the deaths. They rolled up their flags and their gear. Then the survivors walked out of Base Camp and left the tents standing for the porters to dismantle. They walked for two hours down to Broad Peak Base Camp, which was at a lower altitude for the bigger helicopters they had ordered up. Then the sky was full of helicopters, which flew them out of the Karakoram toward Islamabad.

Before they left, Lars Nessa spoke to Go Mi-sun. She was distraught at the deaths in the Korean team and she offered her commiserations for Rolf Bae. But she was not going to give up climbing; she was leaving to move on to the next peak in her quest to reach the top of all fourteen 26,000-foot mountains. She would die a year later on Nanga Parbat, another tough mountain in northern Pakistan.

Nessa thought about what he had learned from K2. The human costs of mountaineering. Not just those costs inflicted on a climber caught up in a tragedy like this, but the pain for the families left behind.

The Serbs from Vojvodina were leaving. Without Dren Mandic. Predrag Zagorac and Iso Planic intended to sell the team's spare oxygen cylinders and give the money to Jahan Baig's family.

Cecilie Skog had left earlier on Monday, trekking out alone with a single porter to reach Askole as quickly as possible, planning to barely stop to eat. Sixteen months later she would trek across Antarctica, her love for the wilderness undimmed. Nevertheless, her burden was

heavy. And, Nessa thought, was it fair on his own family, his parents, who were farmers near Stavanger, or his girlfriend? Nessa had decided he would climb again but never on a killer mountain like K2.

After Van Rooijen and Van de Gevel had gone, Roeland van Oss left a lot of what he couldn't take with him for the porters to burn. Wastepaper, his Alistair MacLean and Tom Clancy novels, all the other garbage. He would never return to K2, never again face those weeks of climbing, all that danger, just to stand on a summit. What did it mean? Most of the people who died had been victims of bad luck, he thought. They were in the wrong place at the wrong time.

As the remaining Dutch climbers were packing up the equipment in Gerard McDonnell's tent, they discovered a bottle of beer among his belongings. That night, a group gathered in the Americans' mess tent and toasted the Irishman. They went around the table reminiscing about him.

"He was a gift to the world," said Eric Meyer in his toast. "He was a gentle, kind spirit."

A Serbian climber borrowed two tin plates from the kitchen tent and punched out the names of the dead. It took him five hours. He made a mistake with one plate and had to go back for a third.

Lars Nessa also made a plate for Rolf Bae, using a hammer and chisel.

Before they left K2, the climbers scaled the brown cliffs at the western edge of Base Camp to hang the plates on the Gilkey Memorial.

One of the oval plates was for Dren Mandic. It read:

DREN MANDIC
13.XII.1976–01.VIII. 2008
SUBOTICA
SERBIA

The Serbs sprinkled whisky on the plate and knocked some of it back themselves in honor of Mandic.

Another plaque was for Gerard McDonnell.

GERARD McDONNELL
20.01.1971–02.08.2008
LIMERICK
IRISH

Rolf Bae's plate had a cross hammered above his name:

ROLF BAE
19.01.1975–01.08.2008
NORWAY

On Monday morning, Marco Confortola had woken up alone at Camp Three, anxious because he had to navigate the Black Pyramid on his own. His feet throbbed as if they had nails in them, he feared he had frostbite in his left hand, and his penis was frozen.

He heard the sound of a helicopter and saw it rising from below, but then it went away and its buzzing faded. As he got down the Black Pyramid, clouds and snow blew in, and out of the mist he saw the three figures of the rescue party from Base Camp approaching. It was George Dijmarescu and two Sherpas from the Makalu Valley, Rinjing Sherpa and Mingma Sherpa. They gave him extra oxygen. They helped Confortola down to Camp Two, where he borrowed Dijmarescu's satellite phone so that at last he could call Luigi. He told his brother he was alive.

Confortola limped down to an area below House's Chimney where Dijmarescu and the two Sherpas had cleared a landing space for the helicopter. Confortola was excited that he was finally going to be delivered from his torment. But then Dijmarescu's radio blurted out

the dispiriting news from Base Camp that the helicopter was canceled because of poor weather. Confortola's suffering was not going to end quickly and he realized he had to find yet more energy from he knew not where to keep going down.

The four men climbed down to Camp One, where they spent the night.

The next morning, Tuesday, they climbed down to Advance Base Camp, where a welcoming party hiked out from Base Camp to meet them, Red Bull, Coca-Cola, and salami in hand. The group included Eric Meyer, Chris Klinke, Chhiring Dorje, and the members of another newly arrived American expedition. They were carrying a stretcher but it was too difficult to walk with it on the rocks. They had heard he had been hit by an oxygen bottle, and Dijmarescu had radioed down that Confortola had also been caught in a rockfall. But Confortola was not in as terrible shape as they had feared, and his mood was improving now that he was convinced he was going to survive.

The weather was turning again. It was cold and damp, and a mix of snow and rain was coming down. Confortola sat on the rocks. The others gathered around while Meyer tried to diagnose his frostbite and they attempted to work out how they were going to carry him back to Base Camp. But Confortola soon lost patience and after ten minutes he stood up and started walking, and the others scrambled to catch up.

They walked slowly on the path between the mangled walls of the icefall. Despite his eagerness, he was unsteady on his feet and they coaxed him on for the three miles to Base Camp.

Halfway to Base Camp, he met another Italian climber, Mario Panzeri, who had hiked across from Broad Peak after news of the K2 disaster spread. Seeing someone he knew burst something inside Confortola, it seemed to the others, and he broke down. Sipping Red Bull, he sat for half an hour with Panzeri.

When the group reached Base Camp later on Tuesday, Confortola was surprised by how many of the tents had been taken down. The

long strip of rocks was much barer. He learned about the number of people who had died. He hadn't known.

The Americans helped him inside the large, comfortable domed tent he shared with Roberto Manni, and Meyer treated him there, filling him with pain-relief drugs. He took off his boots and there was a purple line across his toes as if they had been burned. His worst fears were borne out. It was the damage wreaked by frostbite.

Confortola looked up at the doctor. "What a disaster," he said in astonishment.

Meyer shook his head. "I don't know," Meyer said uncertainly.

Confortola was angry at his HAPs, and at the whole country of Pakistan. One of his HAPs came to the tent and spoke to the other climbers. The Americans' Sherpa, Chhiring Dorje, chided him for not doing enough to help Confortola, for showing no respect to the people who employed him. The HAP went away looking embarrassed.

Meyer had no tPA left over since he had used both doses on Wilco van Rooijen and Cas van de Gevel. He would not have given it to Confortola anyway because of the blow the Italian had received to his head at the bottom of the Bottleneck, which increased the risk of internal bleeding. Instead, the only thing he could do was scrub Confortola's skin clean and try to kill the pain as much as possible.

Klinke thawed Confortola's feet in warm water, careful with the ribbons of frozen flesh that were peeling away. The feet didn't look as bad as Van Rooijen's or Van de Gevel's but if the frostbite worsened, Meyer said, it could lay bare tendons and bones. They wrapped iodine-impregnated gauze around his toes.

As they worked on him, Confortola tried to talk about some of the things that had happened up above Camp Four. The story of his terrible experience was boiling inside him, they could see. Starting to cry, he talked about stopping to help the Koreans and he mentioned Jesus. But he was so emotional and exhausted that Meyer and Klinke could not understand much. They felt sorry for him.

"What do you know about Gerard?" Meyer said.

"I am grateful for you helping me," Confortola said.

The next day, Wednesday, August 6, a helicopter came up the valley and took Confortola away. He spent a night at the military hospital in Skardu, where he related the story of his rescue of the Koreans to the Italian embassy staff. Then he caught the Pakistani Airways flight back to Islamabad. From there he flew via London to Milan.

In the next few weeks, he became increasingly upset, and on some days he drove around the roads near his hometown and he didn't know where he was going, sometimes in tears, unable to come to terms with the deaths on the mountain, until he went to a friend for help. His feet were in a bad way by then but he was given emergency medical treatment. About six weeks after he left the mountain, he was treated in a hyperbaric chamber at a hospital in Padua. It was one of the best hospitals in Italy for frostbite and burns. The people around him assured him he was going to be all right but he knew his condition was bad, and in the end all of his toes were amputated.

After packing up at Base Camp, what was left of the Dutch team trekked out in a line down the Baltoro glacier, passing quickly through the camps at Concordia, Goro II, and Paiju, and skirting the big rock at Korophone, until in a few days they reached the muddy campsites at Askole.

From there they sped in dirty blue jeeps on the mountain road, packed tightly, swaying through the dust clouds thrown up by the Toyotas' wheels. Sajjad Shah, the team's bearded Base Camp manager, had traveled to K2 with the team on this same road two and a half months earlier. Now he gazed at the seat left empty by Gerard McDonnell.

The once polite, talkative Pemba Gyalje watched the ravines sullenly. When a fall of rocks blocked the road, Sajjad stayed with the equipment while the climbers switched to jeeps sent up from the western side. They drove four hours to the hotel in Skardu, to its

cold showers and hard beds, delights after the mountain, and to the attentions of the international media. Wilco van Rooijen was already freely airing to the press his conclusions about what had gone wrong. When he returned to Europe, he would lose all the toes on his left foot and almost all the toes on the other. But a year later he would tell people he was considering another return to K2.

To the climbers left behind at Base Camp, the spine of rocks where the tents had stood seemed eerie and silent. The rocks were spotted with muck from the donkeys. Since the emergency helicopter evacuations, the crowds of fifty or more had fallen to less than a dozen people in a few days. Porters were taking down the Koreans' tents and burning the garbage. Eric Meyer and Chris Klinke's team was one of the last to leave, and before he walked out, Klinke left Meyer and Fredrik Strang and climbed a few hundred feet up to the Gilkey Memorial.

From high on the lonely promontory, he gazed down at the foot of K2, the spits of black and brown rock stretching onto the rubble of the bare glacier. The air was cold, still, and loud with the cawing of ravens. On the memorial, the metal plaques to the dead lined the wall, tied together with wire and tinkling slightly in the breeze.

Klinke was preparing to return to America and the real world. Before he came to Pakistan, he had split with his girlfriend, and he wasn't sure where he was going to live when he got back. He would find a job or join another expedition to somewhere else in the world.

Now that he was leaving K2, he thought of the people who were staying behind.

Before he had traveled to Pakistan and to K2 this season, the names on these plaques had been just that, names. But now there were new plates. Some of the names belonged to friends he had come to know. They had chosen to venture toward the ultimate prize, the summit of K2, and they had paid a terrible price. They had become a part of its history.

As he turned away, he saw their faces, heard their voices, remembered their kindnesses.

THE DEAD

Dren Mandic

Jahan Baig

Rolf Bae

Hugues d'Aubarède

Karim Meherban

Gerard McDonnell

Jumik Bhote

Pasang Bhote

Park Kyeong-hyo

Kim Hyo-gyeong

Hwang Dong-jin

EPILOGUE

My own journey to K2 began in Kilcornan in western Ireland. I flew from New York to Limerick and, in a jet-lagged haze, drove one hundred miles to the southern mountains to meet McDonnell's climbing mentor, Pat Falvey, a fast-talking Irishman in his fifties who organized climbing expeditions and had taken Gerard on his first climb of Everest. We sat in front of his computer and he pointed out the Bottleneck and the serac on photographs of K2. Scraps of climbing gear cluttered his house. A helmet. Boots. In the kitchen he tied a rope between two wooden chairs and clung on, demonstrating how the climbers on K2 had progressed up the Bottleneck and how Dren Mandic had unclipped from the fixed line. Falvey's own life had been hurt by his passion for climbing, he explained. His wife had left him; his sons called him names for risking his life. Behind him on the wall he had hung a painting of McDonnell beside one of Ernest Shackleton—"another Irish hero," he said.

Among the burble of drinkers in Kate Kearneys, a nearby pub, Falvey balanced a wallet on top of a beer glass and tipped it, flopping the wallet onto the table to demonstrate the effect of the serac falling. As we drove back in his Land Rover, I asked whether Gerard McDonnell had ever thought he was going to die. I expected Falvey to say, *Of course not.* But he shrugged and with an air of resignation said, "Everyone who ventures into the Death Zone knows they are dicing with death."

The following morning I drove back north to McDonnell's hometown for McDonnell's wake. A big white tent covered a rainy parking lot behind the Kilcornan school. Inside the tent, more than a thousand people dressed in their Sunday best stood at the edges or sat in rows in front of a long, white table. It was the first time many of them had heard the name K2. Behind the table hung a framed picture of McDonnell— a blue shirt, blue tie, a lick of brown hair, his enigmatic smile.

I was struck by how bewildered the people of McDonnell's village seemed to be. What exactly had motivated their son and brother to travel four thousand miles across the earth to risk his life on a mountain? they wondered. Was it worth such a cost?

The priest, Father Joe Noonan, uttered a few words through the microphone.

"We know we are here to honor Gerard, to praise him, and welcome Gerard to his heavenly home. Gerard, who died on the K2. That is his burial place, and in a sense where he wished to die."

McDonnell's mother, Margaret, a small woman dressed in black, was helped from the front row to the table to light a single candle that stood for her son's absent body. As she turned back, her uncomprehending loss seemed to ripple across the faces of the whole community.

"It was on a mountain that Moses communicated with God," Father Noonan went on. "It was on a mountain where Jesus was transfigured. It was on a mountain that Gerard achieved one of his life's ambitions. It was such a spiritual experience that he even referred to it as being an honor to die on a mountain."

A friend of McDonnell's read William Butler Yeats's poem "Aedh Wishes for the Cloths of Heaven."

Had I the heaven's embroidered cloths,
Enwrought with golden and silver light,
The blue and the dim and the dark cloths

Of night and light and the half light,
I would spread the cloths under your feet:
But I, being poor, have only my dreams;
I have spread my dreams under your feet;
Tread softly because you tread on my dreams.

Then, one by one, people who had known McDonnell carried gifts to the table. A drum, a picture of his home in Kilcornan, a Kilcornan flag to illustrate Ger's love of his parish, a passport. An Irish flag, a book for his love of literature, his late father's wristwatch. Annie Starkey, his girlfriend from Alaska, a trim young woman with dark curly hair, carried Tibetan prayer flags.

"Ger was a brave one," said his older brother, J.J., who also stood up to speak. "Ger, we miss you and we will love you. The future will be hard to face without you. Ger, God bless you, and may God have mercy on your brave soul."

Clearly, or at least it seemed to me, few of the people present could comprehend what drove McDonnell to K2. I encountered the same yearning for understanding, the void at the center of things, when I visited Hugues d'Aubarède's family in Lyon, France. In the elegant dining rooms of his friends, I listened to the stories of his love for the mountains and came to grasp the fascinating alter ego he had carefully constructed through his pursuit of distant peaks. But as well as the love, I witnessed the anger—in his partner, Mine, a wondrously robust woman who at first refused to talk to me before spending hours describing Hugues, and in his thirty-one-year-old daughter, Julia. Julia, who remained silent, carefully listening to my questions to others about her father's death only five months earlier, while Hugues's grandchild played at her knees.

I visited the dead, but I also had to confront the living. One morning in late November, I landed in Milan with an agreement to meet Marco Confortola. That evening he was to travel to Rome to receive

a medal from the Association of Olympic Athletes of Italy. I was two hours late flying into Malpensa and by the time I was sprinting across the station platform at Milan's grand main station, the train was leaving with him on it. My phone beeped with a text message from his agent, Barbara Baraldi, explaining that he could not wait around any longer because his feet hurt so much. It had been only a month since his toes had been amputated.

In Rome, later that evening, at the Hotel Torre Rossa, I finally got my chance to meet Confortola. A young man emerged from the crowd, hopping awkwardly on crutches, broad-shouldered, wearing a white top and jeans, with a shaved head and a long sunburned face. An earring shone in his left ear.

"I am Marco," he said.

He immediately swung around and moved awkwardly back into the crowd, greeting well-wishers and pulling off his socks to show off his bandaged feet. Over dinner, he was treated like a rock star. Women flocked to the table. When I finally asked him what it was like on the summit of K2, he glanced up at me with sullen brown eyes as if he had been waiting for my question.

"Did it fill you with joy?"

"No. People died," he replied in his poor English. The conversation was over before it even began.

The next morning at Rome's Olympic stadium he gave a speech in front of five hundred people. He praised Gerard McDonnell. "It is important to say that Gerard, because he stayed too long above eight thousand meters, he went out of his mind. He is no longer with us. He gave his life. I was lucky not to go out of my mind. A part of this medal is also his."

Just as it was getting interesting, he cut the talk short. There was loud applause and then to my surprise I was called to the front to give my own assessment of the 2008 climb and of Confortola's heroics. Even as I spoke, staring at the rows of intent faces eager for

further praise of their national hero, it struck me as implausible that I was speaking at all. Confortola stood at my side, listening, too, as if he were waiting for some sort of judgment about himself and the mountain.

On the journey back to Milan, he was less than keen to talk. Grimacing, he placed his feet on the table and massaged them through his socks. He hid behind his iPod earphones, insisting he wanted to sleep. Barbara looked embarrassed. She said he had been bombarded with media interviews. I felt both that he was wasting my time and that I was intruding on a terrible memory. But just when I felt like giving in, Confortola removed his earphones. He stretched out his legs and for the rest of the way to Milan sketched detailed scenes from the mountain on a napkin and gave me a blow-by-blow account of his fight to save the two Korean climbers and Jumik Bhote. His mood improved. We ended our journey standing in Milan Stazione, eating grilled cheese and ham sandwiches, while he pointed out the tallest stilettos on the women striding by and grinned at me.

He talked for hours, but even then there were questions he would not answer, and parts of his account already felt rehearsed, as if he were not telling the whole story. Two days later, we traveled north to the Alpine village where he grew up, and I saw another side of Confortola. By now it was clear to me he was a wily survivor, a full-time mountaineer who climbed to make money. I met his father, a plain, pleasant man. Marco was liked in his village, even if he was regarded as something of a hothead. We sat on the lawn in front of his house in Via Uzzi. He did not invite me inside. Tibetan prayer flags fluttered from the roof in the breeze. His nephew, who had Down syndrome, played with a dog, Bobby, and Confortola occasionally showed off his strength by tussling with them. He grew taciturn again and shook his head when I asked questions, such as whether his Pakistani high-altitude porters were responsible for forgetting essential equipment at Camp Four, just before the main summit push. Baraldi said he would

not be able to climb for a long while and he needed to find other ways to make money. When we said good-bye, he joked about the amazing strength of his arms. I expected a crushing handshake but his hold was surprisingly weak. He dropped my hand quickly.

I was relieved when I returned to New York to receive an email from a friend of Cecilie Skog, who said that she would talk to me. She had granted no other interviews. I expected to be flying to Norway but instead I was told to meet her in Denver, Colorado. There, two weeks later, a small, beautiful woman dressed in a white blouse with lace cuffs stepped into the Holiday Inn Crowne Plaza.

Only sixteen weeks after the death of her husband on K2, she had traveled to the Rockies to return to the mountains. She had brought her ice axe with her and was planning on going ice climbing near Boulder.

"I will see how I feel," she said, shrugging as she sat opposite me in the booth in the hotel restaurant, explaining that she had just wanted to get away from Norway.

Skog began to cry as she poured forth her memories of how the mountain shook that night in the dark beneath the serac, how she called for Rolf Bae until Lars Nessa finally urged her to go down, and she talked of her guilt about leaving Bae behind.

"We did look for him," she said, wiping her eyes on her red napkin. "For so long, I regretted going on. I still do sometimes. I ask myself sometimes. I don't know how I got down."

Despite her grief, Skog communicated something that I found infectious. It was a powerful joy for the outdoors—she called it a "devotion to the outdoors"—a love of life in the open. I saw this same physical joy in the Spanish climber Alberto Zerain when I visited him at his home in a small village about forty miles outside Bilbao. We talked for hours on the sofa in his living room, watching the

homemade film of his K2 trip—bizarrely set to the soundtrack of the Who's "Baba O'Riley."

Afterward we drove to a nearby highway restaurant for a late lunch. He was a gentle, polite man who had bonded most strongly on the mountain with the Pakistani high-altitude porters and said he wanted to write a book about the region from their perspective. I told him I would send him Greg Mortenson's *Three Cups of Tea*.

Like all of the climbers I met, Zerain was extremely fit, and when I asked him how long it would take him to prepare if he wanted to go back to K2, he pushed back his chair and clenched his fist demonstratively. "I would go back now!" he said, in a surprisingly loud voice, gazing through the window as if the mountain were already calling him.

But while Zerain exuded the same physical passion as Skog, there was something Skog and Bae shared in their love for the outdoors that the others lacked. The mountains were the place where Skog and Bae could be together. It was where and how they expressed their love for one another. In contrast, Zerain's wife, Patricia, a teacher, glanced over uneasily when he talked about his plans to spend months away again on Kanchenjunga; and in the case of Hugues d'Aubarède, frictions with the loved ones he left behind ran through his life. When Skog discussed their life at Base Camp—the conversations with friends, the days side by side on the slope—it made me think how the couple had brought their relationship to the wilderness and imposed it there, a very human urge. Cruel then that K2 had cared nothing for that and wiped it blithely away.

One January morning, I flew to the Netherlands for what I considered would be my most difficult interview, with Wilco van Rooijen. I had talked to him at the wake in Kilcornan, where he had sat erect in a wheelchair, his bandaged feet pushed out in front of him. His

wife, Heleen, sat beside him looking weary of the attention, and a bit resentful. At that time, Van Rooijen had told me he had no time for involved explanations of what went wrong on K2.

"Bullshit," he said. "It's K2. You know it is going to happen," he said, referring to the collapse of the serac. "Some people had bad luck."

His subsequent emails were abrupt, though eventually he offered a time and a date for another meeting. One evening I found myself in the east of the Netherlands near the German border, walking across a plowed field in the dark on the outskirts of a village called Voorst. Even now, I was worried that Van Rooijen would slam the door in my face. How could I presume to pry into the inner experiences of his profession? A white Land Rover, splashed with mud and sponsors' logos, was parked outside the old straw-roofed farmhouse into which he had recently moved.

When he opened the door, wearing slippers and holding back a golden retriever, he looked me up and down and seemed both surprised and impressed that I had managed to find him at all. He switched on the kettle for tea but it went unpoured for four hours as he stood before me and gave a fevered, nonstop recounting of his horrific experiences on K2. He sat on the stone floor, legs crossed, to demonstrate how he had bivouacked, and paced across the room as he waded through the deep snow and the whiteout below the Shoulder. I listened in wonder and gratitude for the time he was giving me.

At 1 a.m., my tea cold, Van Rooijen stopped. My notebook was full as he called a taxi for me.

I heard a faint crying, and when we opened the door to the hallway his young son was screaming.

By now my taxi driver, a young man from Afghanistan, had arrived.

I asked Van Rooijen if his wife was with his son but he said no, it was her night off. He was in charge.

"But she must be in the house."

"No, in Utrecht."

I wondered how long the boy, about a year old, had been crying.

Van Rooijen sold me a book about his expedition to K2 in 2006 and I left.

The taxi driver, a doctor, had been watching all of this. "He is a focused man, if I may say so, egocentric," he said as we drove away toward the highway in the dark. I had to agree.

Still, Van Rooijen had given me insight into mountaineering psychology. Before I left, he had said something unsettling. Leaning back in his chair, he shook his head. "Shame about Marco, though, that he got it all wrong. He was exhausted. His mind was obviously gone. He may have . . . exaggerated."

He was referring to the story that Confortola had recounted on the train from Rome to Milan: the struggle beside Gerard McDonnell to free the two trapped South Koreans and Jumik Bhote; McDonnell subsequently wandering away in a hypoxic haze; his subsequent death in the avalanche. It was one of the most devastating chapters of the entire tragedy. But recently, McDonnell's family had begun to dispute it.

Confortola stuck tenaciously to his story, but McDonnell's family put forth a rival account, the rewriting led by Annie Starkey, McDonnell's partner in Alaska. She could not believe that McDonnell would walk away from the trapped climbers, no matter what pressure his mind and body were under. In fact, she insisted it was McDonnell who had stayed and Marco Confortola who had climbed down. It was not McDonnell whom Confortola saw killed in the avalanche but instead another climber entirely, Karim Meherban, Hugues d'Aubarède's high-altitude porter. She had photographs she believed showed Karim on the top of the serac before he fell. McDonnell had freed the trapped mountaineers and was descending behind them when he was thrown to his death by a separate avalanche.

For evidence, Starkey relied, among other things, on a radio call that Pemba Gyalje said he had received from Pasang Bhote. In the call, according to Gyalje, the Sherpa reported having reached the trapped climbers and that he was guiding them back down toward Camp Four, just minutes before they were swept away in the serac collapse. Pasang also said he had seen a climber in a red and black suit following behind. In Gyalje and Starkey's view, this was Gerard McDonnell, who had just freed the Koreans and Jumik Bhote.

When I sought out the opinion of Chris Klinke, the American climber who had been closely involved in coordinating the rescue attempt from Base Camp, he said, "I don't believe Gerard freed the Koreans; they had been hanging there for twenty-four hours, and you don't just get up and walk down after that, though he may have rescued Jumik Bhote. I believe however it was Gerard that Marco saw killed."

I also called Michael Kodas, a climber and author who writes about mountaineering and who knew some of the people involved in the tragedy. He said he had studied the photographs of the serac and Bottleneck on the morning of August 2, purportedly taken by Pemba Gyalje and published on the website ExplorersWeb, which Starkey claimed showed Gerard working to free the climbers. But Kodas was unconvinced. The narrative Starkey and ExplorersWeb had imposed on them was just "too perfect," he said. In a follow-up email, he said that the "evidence—Pemba's supposition that the man described in a radio call from a now-dead colleague was Gerard, tiny dots in photos that can't be identified for certain as climbers, much less as specific climbers engaged in a rescue, and a faint line in the top of the gla-cier—one of scores of such marks—was inadequate "to contradict the description of the only living eyewitness to the events," Marco Confortola.

It is possible that McDonnell stayed or returned after Marco Con-fortola descended and helped the two Korean climbers and Jumik

Bhote begin their journey down. If it is true, it could be one of the most selfless rescue attempts in the history of high-altitude mountaineering. Confortola would be right in his speech in Rome to say McDonnell deserved at least part of his medal. Even the fact that, in Confortola's account, McDonnell stayed for one and a half hours alongside the Italian to try to free the climbers is unimaginably brave. It sits alongside other acts of heroism over those three days, such as Chhiring Dorje's descent tied to Little Pasang, Fredrik Strang and Eric Meyer's ascent to try to resuscitate Dren Mandic, the decision by Pemba Gyalje to retrieve Marco Confortola. And, perhaps most of all, the willing climb by Big Pasang Bhote, and behind him by Chhiring Bhote, into the terrifying dangers of the Bottleneck to reach their cousin and brother Jumik, only for Big Pasang to lose his life.

It is a terrible sadness that McDonnell died. It is made worse that we will never know for sure about those last minutes of his life, just as we will never know for certain what Big Pasang found at the top of the Bottleneck.

This was the point in the story about which there was sharpest disagreement, but it was not the only one. In piecing together the tragedy, I had expected a clear narrative but I found myself in some postmodern fractured tale. For example, I put it to the Serbs that in the final ascent to the summit, their HAP had turned around and that important equipment he was carrying was left behind below Camp Four. They retorted that this was ridiculous. The lack of equipment for the summit bid was someone else's fault. Chhiring Dorje, the Sherpa in the American expedition, told me how he caught Wilco van Rooijen when the Dutchman slipped on his way up in the Bottleneck, and several others corroborated this version of events; but Van Rooijen reacted with surprise when I asked him about the incident. Many people I have interviewed claimed that it was under the Korean team's influence that the ropes were set low before the Bottleneck and that their climbers were responsible for

the extremely slow progress across the Traverse. But when I caught up with Go Mi-sun and Kim Jae-soo in a guesthouse in Islamabad, they claimed that the ropes on the Bottleneck had been set too far to the right—this had nothing to do with the Korean team and it was this that had caused the delay. And the real reason for the late descent was that exhausted climbers from other expeditions were using their ropes on the way down and holding everybody else up.

There were several more points of disagreement—not surprising given the fact that there were so many strong characters on the mountain with different points of view, and then there is the trick that lack of oxygen can play on memory at 20,000 feet above sea level.

Fortunately, in most cases the differences were a matter of shading. Most people agreed on the significant points, and a clear story emerged.

Ten months after the accidents I flew to Pakistan, intending to travel to K2, still unclear after all my conversations as to why people would risk their lives on such a mountain. The Taliban was intensifying its insurgency and the country seemed in uproar; climbing K2 at this time meant traveling through a nation at war.

One hot night, I crept out of Islamabad in a white Toyota minivan, sitting beside six climbers who were also heading north to the mountains—in their case, to Gasherbrum I and II, two peaks near K2. We followed the Karakoram Highway, skirting the Swat Valley where the Pakistani Army was launching its latest bloody offensive. From Askole, we trekked six days east surrounded by the cold solitude of the Baltoro glacier to K2 Base Camp.

In the frigid morning, my heart beating wildly from the altitude and exhaustion, I gazed up two miles in the sky, trying to make out the serac's cruel, jagged outline. My seven porters, fearful of avalanches, and superstitious about this place, clattered impatiently around me, eager to leave these altitudes. Finally, in the presence of this awesome mountain, I considered its reputation for death, the group of people

who had challenged it, and the questions that had filled my mind ever since I wrote the first story in the *New York Times* about the disaster.

K2 was terrifically beautiful—its beauty exceeding anything I had expected. Yet, still the questions remained. Why had they come? Why had I come? For me, their story possessed an archetypal force, specific to their time and location and the personalities involved, but also basic and timeless.

They had broken out of comfortable lives to venture to a place few of us dare go in our lives. They had confronted their mortality, immediately and up close. Some had even come back to K2 after serious injury in earlier years, attracted like flies to the light to some deeper meaning about themselves, human experience, and human achievement.

In return, K2 had required from them heroism and selflessness and responsibility. It had also laid bare fatal flaws and staggering errors.

I thought about Rolf Bae waiting below the summit for his wife—forever waiting now.

I thought of Pasang Bhote, doing his duty by his clients and climbing back along the Traverse to reach Jumik Bhote and the other trapped men.

Some had emerged from the ordeal; others had perished. All had burned brightly in their lives.

ACKNOWLEDGMENTS

I owe a debt of gratitude to the many people who graciously gave me many hours to tell me their story or the stories of their loved ones who died.

In particular, I thank Cecilie Skog, Annie Starkey, Mine Dumas, and Raphaele Vernay.

For historical discussions of the Himalayas and technical climbing descriptions I am grateful to Phil Powers, Kurt Diemberger, Agostino da Polenza, Maurice Isserman, and Qudrat Ali as well as to the following books: *Fallen Giants*, by Maurice Isserman and Stuart Weaver; *K2: The Story of the Savage Mountain*, by Jim Curran; *Going Higher*, by Charles S. Houston; *The Avalanche Handbook*, by David McClung and Peter Schaerer; and *Wilderness Mountaineering*, by Phil Powers. These books are all good introductions to the mountains and their dangers.

I would also like to thank the following people: Halyna Freeland; Andrea Kannapell, who worked side by side with me on the foreign desk at the *New York Times* on the day I wrote the first story and is such a wise adviser; and Andrew Ensslen, who risked his life by venturing with me north past Concordia and was flown out by helicopter from the mountains. I am also indebted to my excellent editors Jennifer Barth and Joel Rickett, and to my wonderful agent Andrew Wylie.

Thanks as well to: John Makinson, Mary Boies, David Boies, Bruce Nichols, Gillian Blake, Rick Gladstone, Greg Winter (for the better intro), Susan Chira, David Gillen, Jim Roberts, Chris Conway, Mike Nizza, David Smith, Marc Charney, Dexter Filkins, Alberto Zerain, Patricia Prevost Zarate, John Elsen, Mick Sussman, Mark van de

Walle, George Semler, Hannah Semler, Santiago Lyon, Rob Lerner, Kim Jae-soo, Go Mi-sun, David Hamilton, Peter Truell, Jerry del Missier, Rosa Shipley, Alan Cowell, Su-jin Chu, the families and friends of Philippe Vernay and Hugues d'Aubarède, Hervé Perouse, Nick Rice, Roeland van Oss, Jelle Staleman, Lars Flato Nessa, Bjorn Sekkesaeter, Tom Sjogren, Alisa Dogramadzieva, Predrag Zagorac, Milivoj Erdeljan, George Martin, Chuck Boyd, Andy Selter, Virginia O'Leary, Judy Aull, Natalka Chomiak, Chrystia Chomiak, Anne Freeland, Justine Simon, Eric Meyer (for many things, especially the many hours he gave me and his good-natured patience), Fredrik Strang, Chris Klinke, Chhiring Dorje, Marco Confortola, John Fisher Burns, Wilco van Rooijen, Cas van de Gevel, Tilak Pokharel, Donatella Fioravanti, Enrico Dalla Rosa, Barbara Baraldi, Asghar Ali Porik, Sajjad Shah, Erika Koning, Alan Terry, Douglas Bowley, Audrey Hintzy, Nicolas Mugnier, Yan Giezendanner, Nazir Sabir, Dirk Grunert, Jacek Teler, Paulo Roxo, Daniela Teixeira, Michael Kodas, Maarten van Eck, Jon Yellen, Jack Reilly, Elisabeth Rosenthal, David Roberts, Mike Farris, Pat Falvey, and Gary Landeck.

Also, Chris Warner of Earth Treks (who helped me care), Bruce Normand, Len Kannapell, Liz Alderman, Miguel Helft, Carol Bowley, Matt Ericson, Alexis Gelber, Bill Brink, Stuart Emmrich, Jawaid Iqbal, Anup Kaphle, Jerome O'Connell, Eelco Jansen, Paul Golob, Mike Oreskes, Paul Walters, Julian Curnuck, Karrar Haidri of Saltoro Summits, Chhiring Bhote, Tim O'Brien, Christian Trommsdorff, Yannick Graziani, Captain Shan-ul-Haq, Katarzyna Sklodowska, Pavel Wojas, Serge Civera, Alex Friedman, Salman Masood, Jane Perlez, Katherine Ensslen, Elettra Fiumi, Peter Chang, Choe Sang-hun, Joe Bowley, Jane Bowley, Anya Stiglitz, Tilak Pokharel, Jason Sack, Alan Arnette, Au Bon Pain at the Port Authority Bus Station in New York (for the table in the corner), Natalka Freeland, David Goodhart, and John Lloyd. Last, but not least, my children, Natalka, Halyna, and Ivan. And most of all, I thank my wife Chrystia Freeland.

NOTES

In researching *No Way Down*, I relied heavily on interviews with the climbers and their families, friends, and colleagues. Unless indicated otherwise, all of the following interviews were conducted in person:

Qudrat Ali, Skardu, Pakistan, June 2009, also by email, April, June 2009; Judy Aull, by telephone, February 2009; Alan Arnette, July 2009; Barbara Baraldi, Rome, Milan, Valfurva, November 2008, and by telephone, January, March, June 2009; Chhiring Bhote, interview by local stringer, Tilak Pokharel, Kathmandu, January 2009; Chuck Boyd, by telephone, December 2009; Serge Civera, by phone, April 2009; Marco Confortola, Rome, Milan, Valfurva, December 2008, also by telephone, August 2008, and by fact-checker Elettra Fiumi in New York via telephone, December 2009; Agostino da Polenza, by email, December 2009; Kurt Diemberger, by telephone December 2009; Chhiring Dorje, New York, January 2010, and Kathmandu, January 2009, with local stringer Tilak Pokharel, and by telephone, December 2008; Mine Dumas, Lyon, France, January 2009; Milivoj Erdeljan, interview by email, December 2008, and in Belgrade, Serbia, by local reporter Alisa Dogramadzieva; Mike Farris, January 2010; Pat Falvey, Ireland, August 2008, and by telephone, July 2009; Donatella Fioravanti, by email, May 2009; Yan Giezendanner, Chamonix, France, January 2009; Go Mi-sun, and in Seoul, January 2009, by local reporter Peter Chang (Islamabad, June 2009) Yan-nick Graziani, by telephone, December 2009; Maurice Isserman, by telephone, April 2009; Kim Jae-soo, Seoul, 2008, by local reporter Peter Chang, and Islamabad, June 2009; Chris Klinke, interviews by phone, November 2008, August, September, October, November, December 2009; Michael Kodas, by telephone and email, October 2009; Eric Meyer, Denver, Colorado, December 2008, and by phone and email, December 2008, and April, October, and December 2009, January 2010; Nicolas Mugnier, Chamonix, France, January 2009; Lars Flato Nessa, Stavanger, Norway, January 2009, and by telephone and email, October, November, December 2009 and January 2010; Bruce Normand, by email, January 2010;

Jerome O'Connell, Kilcornan, Ireland, August 2008; Virginia O'Leary, New York, April 2009, and by telephone and email January, July, and December 2009; Asghar Ali Porik, Islamabad, Pakistan, June 2009; Phil Powers, Denver, Company, December 2008 and by telephone and email, May 2009; Nick Rice, interviews by phone, from K2 Base Camp, August 5, 2009, and by phone November 2008 and January 2009; Nazir Sabir, interview by email, December 2009; Bjorn Sekkesæter, interview by email, December 2008, December 2009; Andy Selter, by phone, December 2009; Sajjad Shah, Islamabad, June 2009; Cecilie Skog, Denver, Colorado, December 2008; Jelle Staleman, by telephone, December 2008; Annie Starkey, by email, October and November 2009; Fredrik Strang, interviews by phone, December 2008, April 2009, June 2009; Christian Trommsdorff, by phone, December 2009; Cas van de Gevel, Utrecht, the Netherlands, January 2009 and by email and phone, December 2009; Maarten van Eck, Kilcornan, Ireland, August 2008, and by phone, December 2008; Roeland van Oss, Lyon, France, January 2009; Wilco van Rooijen, Voorst, the Netherlands, January 2009, and by email, December 2009; Philippe Vernay, Lyon, France, January 2009; Raphaele Vernay, Lyon, France, January 2009; Paul Walters, by email, December 2009; Chris Warner, by telephone, February 2010; Predrag Zagorac, by telephone, December 2008, and in person with local stringer/reporter Alisa Dogramadzieva, Belgrade, Serbia; Alberto Zerain, Subillana-Gasteiz, near Bilbao, Spain, January 2009, and by email, December 2009.

For perhaps understandable reasons, two of the climbers, Pemba Gyalje and Pasang Lama, did not agree to an interview. Pemba's friend Gerard McDonnell had died and Little Pasang had lost friends. As a result, some parts of the story are weighted away from them more than I would have liked, especially in the case of Gyalje, who was a pivotal figure. However, I managed to see filmed video evidence Gyalje gave in Islamabad in August 2008, and which was provided for me by Annie Starkey.

PROLOGUE

The confused departure from Camp Four in the early hours of August 1 was described to me by many people, including Eric Meyer, Nick Rice, Alberto Zerain, and Chhiring Dorje. These moments, and other parts of the story, were captured to differing degrees by some early and excellent magazine treatments of the 2008 accidents. These early accounts include: Michael Kodas's "A Few False Moves," *Outside Magazine* (September 2008); Freddie Wilkinson's "Perfect Chaos," *Rock and Ice* (December 2008); and Matthew Power's "K2: The Killing Peak," *Men's Journal* (November 2008).

Meyer's Talus cold-weather mask warmed and added moisture to the air he was breathing—important because at altitude the air is especially cold and dry.

The volume of air breathed per minute increases with altitude, and this also adds to the dryness of a climber's airways—causing mountaineers' well-known "Khumbu cough."

The description of the ropes situation is drawn from interviews with Wilco van Rooijen, Chris Klinke, Cecilie Skog, and Lars Nessa, among others.

Meyer and Fredrik Strang provided details on their climb up the Shoulder, and their deliberations about whether to turn back, which are also captured on Fred Strang's film, *A Cry from the Top of the World* (Mastiff AB, Stockholm, Sweden, 2010).

The description of their return to Camp Four is based on interviews with Strang, Meyer, and Rice.

The documentary film *Disaster on K2*, shown on the Discovery Channel in March 2009, provides a good setup for the climb, and includes footage from the weeks surrounding the final ascent, as well as interviews with the climbers.

For climbing statistics, I relied on data from adventurestats.com or www .alpine-club.org.uk; explorersweb.com; 8000er.com, and the Himalayan Index.

CHAPTER ONE

Details of the journey into the Karakoram from the Pakistan side come from my own trip to K2 in June 2009. For historical treatments of K2, I relied on: Jim Curran, *K2: The Story of the Savage Mountain* (Seattle: Mountaineers, 1995); and Maurice Isserman and Stewart Weaver, *Fallen Giants: A History of Himalayan Mountaineering from the Age of Empire to the Age of Extremes* (New Haven, Conn.: Yale University Press, 2008). Another overview is provided by Kenneth Mason's *Abode of Snow* (New York: Dutton, 1955).

For further details on the Duke of Abruzzi's early expedition, see Mirella Tenderini and Michael Shandrick, *The Duke of the Abruzzi: An Explorer's Life* (Seattle: Mountaineers, 1997).

For insights into the 1954 successful summit attempt, Lino Lacedelli and Giovanni Cenacchi's *K2, The Price of Conquest* (Seattle: Mountaineers, 2006), provides Lacedelli's account. David Roberts also provides a considered assessment of that expedition in "K2: The Bitter Legacy," *National Geographic Adventure* (September 2004); Ardito Desio provides an account of his climb in *Victory Over K2* (New York: McGraw Hill, 1956); as does Walter Bonatti in *The Mountains of My Life* (New York: The Modern Library, 2001).

Kurt Diemberger supplies a great overview of the attraction and challenges of K2 in *The Endless Knot* (Seattle: Mountaineers, 1991).

Sivalaya, Explorations of the 8000-meter Peaks of the Himalayas, by Louis C. Baume (Seattle: Mountaineers, 1979), is a good handbook of the world's biggest mountains.

CHAPTER TWO

The details of Dren Mandic's climb in the Bottleneck are from Predrag Zagorac. His life and weeks on the mountain are based on interviews with Zagorac, Milivoj Erdeljan, and on the team's blog reports. Zagorac's thoughts and comments inform my description of Dren's point of view. The account of the team's ascent from Base Camp is drawn from interviews with Zagorac and Qudrat Ali, and from the Serbian expedition report:

http://www.vojvodineanexpedition.net/index.php/K2-2008./REPORT-OF-THE-EXPEDITION-SERBIA-K2-2008.php4

Details of conditions and events in the Bottleneck were provided by Lars Nessa, Cecilie Skog, Zagorac, Wilco van Rooijen, Marco Confortola, and Chhiring Dorje.

There is some dispute about whether Mandic stood up or not before falling a second time.

CHAPTER THREE

Eric Meyer, Nick Rice, and Fred Strang described the scene at Camp Four after Mandic's death. Some of these moments are also shown in *A Cry from the Top of the World*.

Strang's ascent, his meeting with the Serbs, and confrontation with Jahan Baig were related to me by Strang and Predrag Zagorac. Along with Eric Meyer, Strang and Zegorac also provided an account of Baig's death. Again, there was some divergence in accounts: Strang insisted Baig had an ice axe, but Meyer reported that Baig had no axe to arrest his fall. Nick Rice provided insight into Baig's possibly hypoxic state at Camp Four, as well as background on Baig's behavior around Base Camp. Baig's background is from Qudrat Ali, both an interview in Skardu and several email exchanges. Details of the return to Camp Four are based on interviews with Strang, Meyer, Zagorac, and Paul Walters.

Charles S. Houston, David E. Harris, and Ellen J. Zeman's *Going Higher: Oxygen, Man and Mountains* offers an excellent overview of the effects of high altitude on the body.

CHAPTER FOUR

The story of Fritz Wiessner's attempt on K2 is told brilliantly in the aforementioned books *K2: The Story of the Savage Mountain* and *Fallen Giants*. See also Andrew J. Kauffman and William L. Putnam's *K2: The 1939 Tragedy* (Seattle: Mountaineers, 1992).

CHAPTER FIVE

The conditions in the Bottleneck and the Traverse on K2 appear to have changed somewhat over time. A few decades before the teams arrived in 2008, snow was so heavy on the Traverse that in some years expeditions required no fixed rope at all, only their ice axes, and ascended to the summit and descended without fixed lines, according to Chris Warner, an experienced American climber who summitted in 2007.

The definition of what constitutes the Traverse and the Bottleneck has also shifted. Earlier in the mountain's history, "Bottleneck" may only have referred to the very narrow passage at the top of the couloir, but by 2008 most people understood it as the entire part of the route rising from the Shoulder to the Traverse. The Traverse proper is the short but steep horizontal crossing beneath the serac. The name, however, is also often extended to include the rising but less steep diagonal that climbers follow around the edge of the serac up to the top of the hanging glacier.

There are differing accounts about the amount of time spent considering whether to continue to the summit. Marco Confortola, Lars Nessa, and Wilco van Rooijen described the frustration experienced by the climbers who had to wait in the Traverse. Confortola's book, *Giorni di Ghiaccio* (Milan: Baldini Castoldi Dalai editore, 2008) conveys this, and also provides an overview of his climb. As Michael Kodas pointed out to me, the groupthink that leads expeditions onward often happens and is regularly cited as a cause of accidents in the mountains. For insight into the South Korean team, I relied on interviews with Go Mi-sun and Kim Jae-soo. It is a feature of many mountaineering seasons that some expeditions arrive late to take advantage of the resources put in place by the bigger expeditions. The wait for the Koreans was related by, among others, Lars Nessa, Van Rooijen, and Alberto Zerain. The dynamics of the Norwegian team, and details of Rolf's life, were drawn from interviews with Cecilie Skog, Bjorn Sekkesaeter, and Lars Nessa. Jelle Staleman, Chhiring Dorje, and Lars Nessa contributed the story of the yak. Lars Nessa and Marco Confortola provided details about Hugues d'Aubarède's condition; d'Aubarède's blog, maintained by Raphaele Vernay, also served as a terrific resource on Hugues's time on the mountain. Other information about Hugues came from Yan Giezendanner, Serge Civera, and Nicolas Mugnier. For physical descriptions of the Traverse, I am grateful to Nessa, Van Rooijen, Confortola, Phil Powers, and to Chris Warner. Details on the Dutch team were provided by Cas van de Gevel, Roeland van Oss, Jelle Staleman, Maarten van Eck, Nick Rice, and Van Rooijen. Insights into its dynamics were also drawn from the Norit blog and from Nick Rice's blog, http://www.nickrice.us/index_files/k2dispatch.htm, which

provided good exposition on the weeks at Base Camp. Additional information on Marco's life was provided by Donatella Fioravanti and Enrico Dalla Rosa.

Information about Gerard McDonnell at this point on the climb was supplied by Lars Nessa and by Van Rooijen. Details on McDonnell's early life and preparation for K2 were drawn from interviews with Van Rooijen, Annie Starkey, Pat Falvey, Jacek Teler, Alan Arnette, Chris Warner, and Jerome O'Connell.

CHAPTER SIX

Details on Alberto Zerain's ascent and his background are drawn from an interview at his home, and from his wife, Patricia Prevost Zarate. The order of the climbers he passed on his descent varies in other accounts.

CHAPTER SEVEN

Information on the Norwegians' ascent to the summit was provided by Cecilie Skog and Lars Nessa. The account of the South Koreans' summit was drawn from an interview with Go Mi-sun in Islamabad. For the Dutch team's arrival, I drew on interviews with Wilco van Rooijen, Cas van de Gevel, Maarten van Eck, and the Norit blog, and from Van Rooijen's book, *Overleven op de K2* (Netherlands/Belgium: National Geographic/Carrera, 2009). Gerard McDonnell's call from the summit was confirmed by Annie Starkey. Hugues d'Aubarède's conversations at the summit were related by Raphaele Vernay, Mine Dumas, Chhiring Dorje, and Agence France Presse. Virginia O'Leary and Go Mi-sun provided background on Jumik Bhote's call from the summit. Marco Confortola and Cas van de Gevel described their last-minute picture-taking.

CHAPTER EIGHT

Good detailed descriptions of avalanches are provided by David McClung and Peter Schaerer's *The Avalanche Handbook* (Seattle: Mountaineers, 2006); Phil Powers's *Wilderness Mountaineering* (Mechaniscsburg, PA.: Stackpole Books, 1993), is a great account of the dangers of the mountains. Details of the Norwegians' descent are drawn from interviews with Cecilie Skog and Lars Nessa.

CHAPTER NINE

The 1953 expedition is recounted in Curran's *K2: The Story of the Savage Mountain,* Isserman and Weaver's *Fallen Giants,* as well as in Bernadette McDonald's *Brotherhood of the Rope: The Biography of Charles Houston* (Seattle: Mountaineers, 2007).

See Jim Curran's *K2: Triumph and Tragedy* (New York: Mariner Books, 1987) for the full story of the 1986 tragedy. See also Kurt Diemberger's *The Endless Knot,* a view of the 1986 events from a different angle.

CHAPTER TEN

Eric Meyer and Fredrik Strang provided the account of their time spent in the tent at Camp Four; Chris Klinke provided details of his strobe light. Chhiring Dorje and Meyer supplied information on Dorje's descent, and on his background. Chhiring Bhote offered an account of his climb up the Shoulder with Pasang Bhote; details of Chhiring Bhote's life were drawn from interviews with him, as well as with Virginia O'Leary and Judy Aull. Details of Kim Jae-soo's climb came from interviews with Kim and Chhiring Dorje and from reports in the South Korean press.

CHAPTER ELEVEN

Cas van de Gevel's descent from the summit and his encounter with Hugues d'Aubarède on the Traverse was described to me by Van de Gevel. I am indebted to Raphaele Vernay for the use of the blog as a source. Nick Rice, who was with d'Aubarède for many days at Base Camp, and Serge Civera, who visited him at Base Camp, gave insights into his character and state of mind, as did Mine Dumas. Qudrat Ali also offered background and insights. Chris Warner described the death of Stefano Zavka. Van de Gevel described his sighting of Hugues's fall. His description of the encounter with the two Sherpas or HAPs matches Chhiring Bhote's account of his ascent toward the Shoulder with Pasang Bhote. The phone conversation between Cas and Roeland van Oss was related by both men. For details on the effects of high altitude, I consulted Charles Houston's *Climbing Higher* and Mike Farris's *The Altitude Experience: Successful Trekking and Climbing Above 8,000 Feet* (Guilford, Conn.: Globe Pequot Press, 2008) as well as other medical experts.

Details of Pasang Bhote and Chhiring Bhote's rescue of Go Mi-sun were related by Go and Chhiring Bhote.

CHAPTER TWELVE

The description of Jumik Bhote's leading the Korean team from the summit was drawn from interviews with Go Mi-sun and Chhiring Dorje. Marco Confortola described what is likely the collapse of the serac or an avalanche that caught Bhote and the remaining Korean climbers. Both Wilco van Rooijen and Confortola offered descriptions of the Korean climbers and the likely series of events that led to their being trapped in the ropes. Virginia O'Leary and Judy Aull provided insight into Jumik's life and his character and his relationship with the Korean team. O'Leary's blog was another wonderful resource: http://ginnynepal.blogspot.com On the blog, she described the actual puja ceremony for Jumik in Kathmandu, on which my own description was based.

CHAPTER THIRTEEN

Details of Marco Confortola and Gerard McDonnell's bivouac were related by Confortola and Agostino da Polenza. Wilco van Rooijen provided the account of his meeting the other two men and their decision to stay overnight above the serac. Annie Starkey, Sajjad Shah (the Norit team's Base Camp manager in 2008), Eric Meyer, Cecilie Skog, Wilco van Rooijen, Cas van de Gevel, Roeland van Oss, and Jelle Staleman all offered insight into McDonnell's time on K2, as did his brief blog.

CHAPTER FOURTEEN

The details of Wilco van Rooijen's descent were drawn from my interview with him in Voorst, his conversations with my own fact-checker, Mark van de Walle, as well as from interviews he gave to wire services and magazines in the wake of the disaster. He also outlines his long climb down in his own book. Maarten van Eck, Roeland van Oss, and Chris Klinke provided descriptions of his telephone calls from the mountain.

CHAPTER FIFTEEN

The description of Gerard McDonnell and Marco Confortola's struggle to save the trapped Korean climbers and Jumik Bhote was provided by Confortola's official post-accident statement, his book, and several interviews I conducted with him. For the controversy surrounding Confortola's account, please see the Epilogue.

CHAPTER SIXTEEN

The scene at Camp Four on the morning of Saturday, August 2, was drawn from interviews with Eric Meyer, Fredrik Strang, Paul Walters, Lars Nessa, Cas van de Gevel, Chhiring Dorje, Chris Klinke, and Roeland van Oss. Meyer also provided insight into Pemba Gyalje's condition and conversation. Various climbers, including Walters and Dorje, recalled seeing the figure above the serac. The decision by the five climbers to go down to Base Camp was recounted by Meyer.

Cas van de Gevel provided the account of the return up the Shoulder with Pemba Gyalje. Chhiring Bhote and Pasang Bhote's progress up the Shoulder and Bottleneck was described by Chhiring Bhote and Chhiring Dorje, Pemba Gyalje offered an account of his discovery of Marco Confortola, which Annie Starkey backed up with records of the radio calls; she also offered insight into Pemba's thinking at the bottom of the Bottleneck. For the descriptions of the avalanches, I relied on testimony by Gyalje, and interviews with Chhiring Bhote and Marco Confortola. Confortola detailed the return to Camp Four.

CHAPTER SEVENTEEN

The scene at Base Camp, and the location of the climber in orange on the south face of the mountain, was drawn from interviews with Chris Klinke, Roeland van Oss, Jelle Staleman, and Maarten van Eck. The various climbers' descents came from Alberto Zerain, Nick Rice, Cecilie Skog, Lars Nessa, Mike Farris, Chuck Boyd, and Andy Selter. Jerome O'Connell and Pat Falvey provided information on the McDonnell family's vigil in Ireland. Eric Meyer described his fall above Camp One.

CHAPTER EIGHTEEN

The description of Wilco van Rooijen's further attempt to descend, and the effort by Cas van de Gevel and Pemba Gyalje to locate him, was based on interviews with Van Rooijen, Van de Gevel, Roeland van Oss, Chris Klinke, Jelle Staleman, and Maarten van Eck. Chuck Boyd and Andy Selter also provided information on the rescue effort at Base Camp.

CHAPTER NINETEEN

The account of Wilco van Rooijen's rescue was related by Van Rooijen, Cas van de Gevel, Chris Klinke, Roeland van Oss, and Maarten van Eck. Marco Confortola provided details of his descent. The description of Cecilie Skog in Base Camp was based on interviews with Skog, Lars Nessa, Chuck Boyd, and Andy Selter. The descent of Van Rooijen, Van de Gevel, and Pemba Gyalje was described by Roeland van Oss, Jelle Staleman, Van Rooijen, Van de Gevel, and Sajjad Shah.

Details of the scene in the medical tent were drawn from Eric Meyer, Chris Klinke, Lars Nessa, Wilco van Rooijen, Sajjad Shah, Fredrik Strang, and Strang's film, *A Cry from the Top of the World*.

CHAPTER TWENTY

For the account of the climbers' departures from the mountain, I relied on the Norit team's blog, and on interviews with Roeland van Oss, Wilco van Rooijen, Cas van de Gevel, Chris Klinke, Eric Meyer, Chuck Boyd, and Andy Selter. Lars Nessa, Sajjad Shah, and Chris Klinke described the visits to the Gilkey Memorial. For the account of the Koreans' departure, I drew from various Korean press reports, as well as on my interviews with Eric Meyer, Lars Nessa, Chuck Boyd, and Andy Selter. The description of the helicopter journey and the military hospital in Skardu (where Gerard McDonnell recovered in 2006, and Wilco van Rooijen, Cas van de Gevel, and Marco Confortola were treated in 2008) was based on my experiences in the Karakoram in 2009.

INDEX

ABOUT THE AUTHOR

Graham Bowley grew up on a farm near Leicester in the English Midlands. He was a foreign correspondent for the *Financial Times* and the *International Herald Tribune*. A reporter for the *New York Times*, he lives in New York with his wife, Chrystia Freeland, and their two daughters and son.